SLIDES

Planning and Producing Slide Programs

Written for Kodak by Ann Bishop

TABLE OF CONTENTS

3

FOREWORD

WHO IS THIS BOOK FOR?

If this is your first show . . .

This book will teach you everything you need to know to produce a professional-quality production.

If you've already produced a few shows . . .

This book will teach you about aspects of production you may not have tried before.

If you're a writer, a photographer, or a graphics artist . . .

This book will tell you what you need to know to work with audiovisual producers or become a producer yourself.

If you're an administrator . . .

This book will help you identify the right objectives, content, and audience. It will also help you select an effective format and even a suitable producer.

If you're a professional producer . . .

This book will help you train new staff and prepare clients to provide the information and resources that you will need.

If you want to become a professional producer . . .

This book will provide you with an inexpensive way to learn the basic planning, scriptwriting, and production management skills required for any medium.

If you're an audiovisual instructor . . .

This book will help you design a comprehensive teaching course and also serve as a text for your students.

If you just want to entertain your friends . . .

This book will show you how to select your best slides and assemble a show that won't bore your audience.

HOW THE BOOK IS ARRANGED

Because this book is designed to be both a step-by-step production manual and a quick reference for those who want to produce slide shows of varying complexity, we have divided the book into the following major sections:

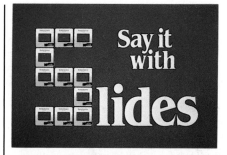

Introduction

In the INTRODUCTION, we list all of the communication advantages of slides and even try to sell you on the idea of producing a simple slide-tape show. However, if you are sure that slides are the best medium, you can still use this section to convince others in your organization.

Planning

Planning is the most important, and often the most time-consuming stage of production. The time that you spend in planning relates directly to how well your show achieves its objectives, meets its deadlines, and stays within budget. To save you time and money, we list in this section all of the questions that should be answered before actual production begins. We also describe a painless method of writing a script, provide guidelines for hiring outside professionals, discuss planning an effective production schedule, and list a variety of factors you will need to consider in preparing a budget that will make the most of your resources.

Photography

Slide shows require a special kind of how-to for AV photography. In this section, we tell you how to make sure that your slides are properly composed, exposed, and fit together to give your show continuity. If you decide to hire a professional photographer, you will find an outline of important, necessary qualifications and a list of your responsibilities as a producer.

Preparing the Graphics

You don't have to be an artist to prepare professional-looking illustrations and title slides. Here, we explain how to plan your graphics for legibility, describe a number of simple production techniques, and indicate how to use a copy stand. Reverse-text slides and optical titles are also covered.

Putting the Show Together

Editing a multitude of slides to match your script requires a systematic approach. Here, we describe how to select your best slides and show you how to organize them. Then, when you have put the visuals together and the script has been finely polished, we help you choose a narrator and a recording studio. If you decide that you want to produce the sound track yourself, we guide you through the important stages and even show you how to add cues to the sound track.

Postproduction

Once a show is completed, there are still a lot of details to look after. Pilot testing the show, arranging distribution, and preparing copies are just a few of the details covered.

Of all the audiovisual media currently in use today, the single-projector slide-tape presentation is the most cost-effective and easiest to produce. Although professional-quality scriptwriting and photography for slide programs require as much skill as that needed for motion pictures and video, an inexperienced producer should get more effective results with this medium.

Unlike motion picture and video photography, slide-show photography usually does not require a large production crew and rarely requires additional lighting. A slide show can be shot more rapidly than either a motion picture or video because the equipment is easy to use and, with today's fast films and variable focal length lenses, extremely flexible.

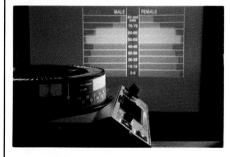

The images shot for a slide show are also more versatile. Slides can be converted into color or black-and-white prints for brochures and annual reports, photocopied in color, and used as stock images for future production. Because slides can easily be transferred to video tape and broadcast over television, they're an excellent choice if you're looking for inexpensive ways to reach a mass audience.

Updating a slide show is as easy as unlocking the tray ring and replacing an outdated slide with a current one.

The visual material in slide shows is the easiest to update. It's as easy as unlocking the ring on a slide tray and replacing a few outdated slides. Updating a motion picture film or a video tape requires the time, effort, and expense of reshooting and editing the production and preparing of new copies of the entire show.

SAYING IT WITH SLIDES

Slides can help you communicate effectively and efficiently. They can add drama, interest, excitement and can make a complex subject easier to understand.

Slides make it possible for large or small groups to receive your message at one time, in one location; and as a result, slides save you time, money, and headaches.

Slide shows project and build an image. They can tell an audience you're creative, innovative, and confident.

Improve Safety

Slide shows can simplify and strengthen your safety and training programs. Use them to teach personnel what to do if a machine breaks down, a co-worker gets injured, or there's a fire or some other accident. Show your people how to avoid accidents without exposing anyone to the actual hazards.

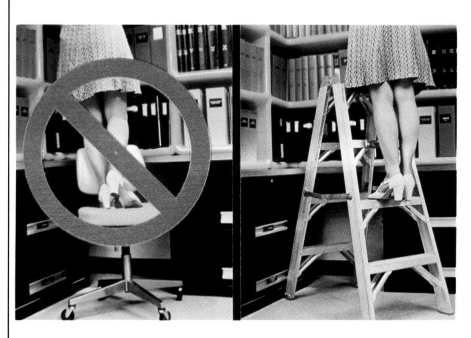

Cost-Efficient Training

Slide shows work well for cost-efficient training. Use them to compare the right and wrong way to do a job, explain new procedures, or discuss company policy. If you design an individualized production, employees will be able to view it on their own, allowing personnel or training staff to carry on with other work.

Build Sales With Slides

A slide show can sell heavy industrial equipment in a busy office, or sunny beaches to the snow-bound, and snow-swept slopes to those at the seashore, or

the magic of the West to Easterners and vice versa. Slide shows can sell just about anything, just about anyplace. You can present an entire selection of merchandise with a single tray of slides or follow your product through manufacturing

and point out to potential buyers the workmanship that is built in throughout the process.

Once you own a comprehensive library of slides, you'll find many ways to use them:

- Trade shows
- Conventions
- Window displays
- Point-of-purchase displays
- In-home demonstrations
- Desk-top presentations
- Sales meetings

Slides in the Classroom

Today, more and more slide shows are being prepared for use *inside* the classroom. They can offer information on careers or provide guidance counseling. If they're designed for self-contained projection equipment, students can view the shows at their own convenience.

Slide shows can also help teaching facilities at all levels improve student recruiting. They can provide more than just facts and figures about courses and buildings; they can convey the "character" of the school and all its programs.

If you're a teacher, why not ask your students to prepare low-cost slide shows in place of term papers. You might be surprised at how enthusiastic they'll be about the project, and how much "mileage" you can get from their colorful presentations.

Slides can be used in education for

- Teaching aids
- Student reports
- Career guidance
- Student recruitment
- Fund raising
- Campus activities

Public Relations

Decisions are sometimes based on a lack of information, or misunderstanding of the facts presented. A programmed slide show lets you present your message with clarity, consistency, and completeness; it diminishes your chances of being misquoted or misunderstood.

Slides can help promote understanding when used in

- Stockholder meetings
- Lobbies

- Public hearings
- Shopping malls
- Press conferences
- Airports, bus terminals
- Window displays

As the demand for slide-tape shows increases, so has the need for a comprehensive reference book and a step-by-step guide to all aspects of production.

Although this book has been written specifically about slide-tape production, the chapters on planning, script development, graphics, sound production, evaluation, and distribution can be applied to any medium.

While we can't teach you how to write imaginative scripts or shoot

spectacular slides, we can provide the technical information and production management skills that will make your job much easier and allow your inherent creative abilities to emerge. To accomplish this, we've pooled the knowledge of many of the best producers and technical experts and have written the text in simple language that is easily understood.

Even though we have provided you with enough information to undertake most aspects of production on your own, don't hesitate to get some professional assistance if the need arises. Producers with many years of experience contract out those aspects of production requiring complex technical skills or equipment.

To develop your skills as a producer, pay attention to the media around you. You can learn much about photography and graphics if you study the images in magazines. You can learn about script development and editing from motion pictures and television. Pay particular attention to the commercials and notice how much information they pack into just a few seconds.

Watch other slide shows and learn from their successes and mistakes. Attend conferences and festivals sponsored by groups such as The Association for Multi-Image International, Inc., (AMI) 8019 North Himes Ave., Suite 401, Tampa, FL 33614, and trade shows such as COMMTEX, sponsored by the International Communications Industries Association (ICIA— formerly NAVA), 3150 Spring St., Fairfax, VA 22031, and the Association for Educational Communications and Technology (AECT), 1126 16 St. NW, Washington, DC 20036.

Take the first step and join that ever-widening group of people and organizations who have come to rely on audiovisual media when they find the need to inform, instruct, or influence.

AV ILLUSTRATED SCRIPT—"HOW-TO"

When learning a new skill, it helps if you have an overview of what is involved before you begin. For this reason, trainers in industry often introduce a new procedure or process by showing employees a short slide show summarizing all of the steps that they are about to learn. We felt that this would be an excellent opportunity to do the same thing. On the next few pages, you will find a simplified script with narration and images describing the various steps for producing a slide show.

Producing a good slide show is easy, and in many instances, can be fun. The pages following the script provide detailed information that will help you plan and produce successful slide shows.

VISUAL **NARRATION**

MUSIC FADES UNDER AS NARRATION BEGINS.

Are you sometimes called upon to welcome new employees and visitors to your organization?

Do you find yourself repeating the same speech over and over?

Do you find yourself wishing you could SHOW them what you mean?

PAUSE

VISUAL	NARRATION	VISUAL	NARRATION

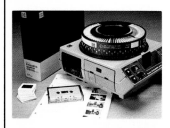

If you're suffering from any of these problems, it's possible you need a slide show.

When you've completed your production, you'll have a library of images you can use for future shows, along with publications and displays.

A good slide show will take your message to places where you can't always send a speaker and make sure it's delivered exactly the same way—each time.

With a slide show, you can present your message to large or small audiences, or to just one person at a time.

A slide show can also save you a lot of unnecessary talking and make your words persuasive.

Slide shows are relatively quick and simple to make; however, good productions require *careful planning*.

You don't have to spend a fortune renting equipment and facilities when producing a slide show. All you need is a 35 mm camera, a few rolls of film, lenses . . .

Before you type a single word of script or shoot a single slide, these are some important questions you'll need to answer.

. . . a projector, a tape recorder with programming capability, and possibly a dissolve control.

Objectives

What are your *objectives*?

How do you want the audience to respond once they've seen your show?

And with a slide show, you have the added advantage of being able to update the show easily.

**Objectives
Subject**

What is your *subject*?

If you're not already familiar with it, how will you gather the information you need to write the script?

VISUAL	NARRATION	VISUAL	NARRATION

**Objectives
Subject
Audience**

Who's in the *audience?*

How old are they? Are they familiar with the subject? Will they attend by choice or will they be required to attend?

. . . you can submit to your clients for their feedback and approval.

**Objectives
Subject
Audience
Distribution**

Who will *distribute* the show?

Is playback equipment available? Will the show reach the intended audience?

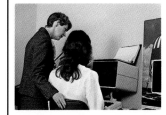

When the proposal is approved, begin your research. Start by reading everything available. Talk to everyone who knows anything about the subject.

**Objectives
Subject
Audience
Distribution
Budget**

How much *money* is your organization willing to spend on the show?

Do you have a photographer? Is there an artist on staff?

Look at all available visual material. The pictures in these publications can give you inspiration for planning the shots in your show.

**Objectives
Subject
Audience
Distribution
Budget
Deadline**

Finally—what is the *deadline?*

Visit the locations where you expect to shoot the show. Check to see if you'll need additional lighting. Take some pictures to use for reference in planning the visuals.

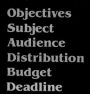

The answers to these questions will help you determine if you have enough time, money, and other resources to produce an effective show for the audiences and the objectives you have identified.

PAUSE

When you're completely familiar with the subject, brainstorm with colleagues to determine the best way to treat the subject.

Before you go any further, summarize your plans in a one- or two-page proposal . . .

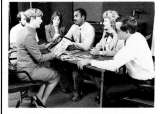

Some producers put each idea on a separate file card and construct their treatment by organizing and reorganizing the cards.

11

VISUAL	NARRATION	VISUAL	NARRATION

When you have organized all of your ideas, you may want to submit this outline or treatment, as it is called, for approval before you go on to refine the script.

. . . and close-ups; approximately six visuals per page.

Create the script by defining the outline in greater detail.

When you've decided what visuals you need, plan a production schedule . . .

This is what it should look like—narration on the right—a description of visuals on the left. Typically, one double-spaced typed page equals about 1 minute of narration.

. . . and figure out how much you're going to spend on each part of the production.

Don't worry if you can't find just the right words for the narration. You'll want to revise them later anyway when you edit the slides.

If you are not going to shoot the show yourself, make all the necessary arrangements for the photographer.

When planning visuals, use a variety of shots—long shots . . .

You'll save time and money if you arrive at each location ahead of the photographer, to make sure that everyone is ready and understands what they are supposed to do.

. . . medium shots . . .

If you need graphics—like title slides, cartoons, or charts, start producing them as soon as possible.

VISUAL	NARRATION	VISUAL	NARRATION

When your slides are processed, review them and discard any unusable ones. Arrange the slides to match the script and load them into trays.

Add the slide synchronization signals (pulses) to this tape, or have it done at the studio. Screen the show for approval.

Then read your script aloud to hear how it sounds. If you want to see how the show will look, make a trial recording of the narration and synchronize it with the slides.

Finally, make copies of the slides and the sound track so that you don't risk losing your original show, and make arrangements for distribution of the materials.

If the slides don't fit as you expected, don't hesitate to rearrange them.

Check on the copies from time to time to make sure the show is still running properly and review the production at regular intervals to see if any of the slides require updating.

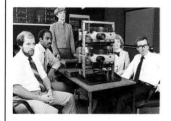

When you're satisfied with the way the show looks and sounds, bring in your approval committee and show it to them.

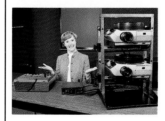

If you have allowed yourself enough time to produce the show properly and you have followed the steps outlined in this script, your first slide-tape show has to be a success.

MUSIC UP

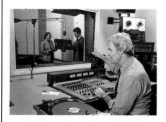

Now make your final recording. If possible, use a professional narrator and record the sound track in a sound studio.

The recording studio will give you the final mixed sound track on a cassette or a reel, depending on your preference.

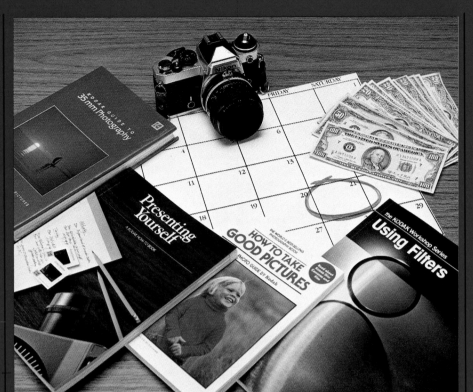

This section of the book covers all those activities that producers should undertake before shooting any slides, preparing any graphics, or recording any sound. Although the amount of time spent on these activities will vary with each production, wise producers spend at least a third of the time allotted for production on planning.

The importance of all the planning steps described in this section can't be emphasized enough. If you carefully analyze what you intend to accomplish with your show and plan each step along the way, you stand a much better chance of achieving your goal. If you don't have much time, careful planning will help you make the best use of the time available. Finally, if you have plenty of time but limited money, following the steps outlined in this section will keep the cost of production down to minimum.

ANALYZING YOUR REQUIREMENTS AND RESOURCES

Requirements are the objectives of your show, the audience to be reached, and the content that should be covered. *Resources* are facilities, equipment, money, and the personnel available to work on your show. If it is necessary to obtain advice or approval from anyone outside your immediate environment, we recommend that you establish an advisory/approval committee and work with them in determining requirements and resources.

This chapter is designed to help you assess your requirements and resources. By the time you have finished answering all of the questions listed in this section, you should be able to identify the objectives that you expect to achieve, the content you intend to cover, and the audience that you want to reach. With this information gathered, you'll then be able to determine if you have adequate equipment, effective distribution arrangements for the show, and enough time, money, and other resources to undertake a successful production.

To help you easily assess your requirements and resources, and to prepare a proposal that summarizes this information, we've listed all of the important questions you will need to answer on the form that follows. Copy this form and use it to gather your answers. A section follows this form that explains the significance of each question in detail.

- WHAT IS THE OBJECTIVE?
- THE DEADLINE?
- THE BUDGET?
- WILL IT HAVE TO BE UPDATED?
- WHO WILL SEE IT?
- WHERE?
- UNDER WHAT CONDITIONS?

OBJECTIVE
- Define

INITIAL ANALYSIS FORM

ANALYZING YOUR REQUIREMENTS

What Are Your Objectives?

- What problem does your organization intend to solve with this production? _____
- What do you want the audience to do once they have seen your show? _____
- How do you plan to evaluate the production to make sure the objectives are going to be met? _____
- How will others in your organization know the show has achieved the intended objectives? _____

Who Is Going to Be in the Audience?

- Who are they? _____
- What are they looking for or expecting from this presentation? _____
- How much do they know about the subject? _____
- What are their educational and occupational levels? _____
- What is the age level of the group? _____
- Is there an attitude toward the subject or possibly toward the speaker? _____
- Does the group have a predominant discriminatory attitude? _____
- What standard of production is the audience used to seeing? _____

What Content Should Your Show Cover?

- How should complex material be presented? _____
- Will people learn faster if they are actively involved? _____

How Will the Show Be Distributed?

- How many copies and what additional materials will be required? _____
- What playback equipment is available? _____
- What type of facility will be used to screen the show? _____
- How large will the audience be? _____
- Who will run the show? _____
- What other activities will take place at the time the show is being screened? _____
- Who specifically will be responsible for distributing the show? _____

WHAT RESOURCES ARE AVAILABLE TO PRODUCE THE SHOW?

What Budget Is Available? _____
Could You Use an Existing Production? _____
Could You Sell or Rent Copies to Other Organizations? _____

OTHER CONSIDERATIONS

When is the Show Due? _____
Has Your Organization Any Previous Experience With Audiovisual Media? _____
How Long Will the Show Be Used Before Replacing or Updating it? _____
Who Will Review and Approve the Show? _____
How Will You Select and Brief the Approved Committee? _____

What Are Your Objectives?

What problem does your organization intend to solve with this production?

If you are like most people, you probably have to justify why your organization should spend money on this production rather than on some other project. Putting it bluntly, what is the production going to do for your organization? Will it sell more products? Will it attract new employees? Will it train employees more efficiently? Will it improve employee attitudes? Will it improve the company image?

When describing how the production is going to benefit your organization, make sure that you state the benefits explicitly. For example, if your training program allows learners to study at their own pace, describe how that feature *benefits* the organization: "By allowing employees to study material on their own, supervisors presently responsible for training will spend fewer hours per year designing and conducting training sessions."

If your show is intended to change audience attitudes, you may not be able to supply figures showing direct savings to your organization, but you should be able to quantify the costs of alternative methods of communication.

What do you want the audience to do once they have seen your production?

It's important to state objectives as clearly as possible. If you put objectives in terms of audience behavior and the standards you expect them to meet, you'll find it much easier to determine if your objectives are being *achieved*. Although it's becoming more and more common for sponsors and producers to specify objectives for their shows, they don't always state

them in measurable terms. Here is a sample objective that is not stated explicitly.

At the conclusion of this show, the audience should be familiar with our product.

At first glance this may seem like a suitable objective; however, it does not go far enough. "Familiar" is too vague a term. Getting sponsors of the show to define "familiar" wouldn't solve the problem either, even if audience members would submit to being tested to see how "familiar" they are with the product, and passed with high marks.

The objective should therefore read: *At the conclusion of this show, 15% of the audience will buy the product.*

By restating the objective as specific behavior, sponsors will be able to determine if the objective is achievable and whether the cost of the production will be worth the expected benefits. If they decide that 15% is a reasonable figure and go on to produce the show, they'll be able to measure their success after each screening. On the other hand, the show may fail to meet the intended objectives and sponsors will have to modify either the production or some aspect of the way that it is presented.

Identify exactly what you want audience members to do once they've viewed your production, because audiovisual media will be used differently in each case. You'll find that their actions fall into one of three broad categories of behavior:

- Retain information
- Change attitude
- Develop a new skill

Retain Information

An audiovisual production can do an excellent job of presenting a half-dozen major points, but if you have to present a great deal of complex information, or you want to be sure that the audience remembers the information you present, consider developing additional print materials for the audience members to keep.

Change Attitudes

Audiovisual media can be a powerful tool in persuading people to change their attitudes but you should take into account these principles if you're going to be successful:

- No matter how persuasive your message, you aren't likely to change the attitudes of people whose viewpoint is radically different from the one you're proposing. If you're trying to develop support for your case, you'll get better results if you design the show to mobilize people already sympathetic to your viewpoint instead of designing it to convert your opponents.

- You're more likely to influence people about an issue if they have no prior opinion on the subject.

- If audience members are trying to make up their minds about an issue, present your side as well as the arguments of your opponents. By presenting both sides of an issue, you innoculate your audience against the persuasive power of your opponents.

- When you try to persuade a hostile audience to see your point of view, start your presentation by pointing out those issues on which you both agree. Having demonstrated common ground, the audience should be more receptive to your position.

- Don't rely on your slide show alone to persuade the audience. Involve the audience in a discussion after the show and allow them to air their reservations and to discuss those things that stand in the way of their adopting a new attitude and behavior.
- Don't try to intimidate your audience into accepting your point of view. If you intimidate them, they'll dismiss your viewpoint entirely.
- If the message in your production is presented by a speaker who is respected by the audience, your presentation may have more impact than content presented by an anonymous narrator.
- Provide your audience with suggestions for concrete action. If you want them to sign a petition, pass it around; if you want them to donate money, pass a hat; if you want them to volunteer, let them know exactly what you want them to do and have a sign-up sheet available.

Develop a New Skill

A slide show can be used to provide audience members with an overview of what's involved in performing a skill; but if you want them to perform the skill successfully, they'll need practice and someone who can correct their mistakes. Correct practice is particularly important when learning a new skill.

By carefully defining your objectives, you may discover that they can't be achieved with an audiovisual production. Rather than try to boost employee productivity, you may decide that a profit-sharing plan would be more effective. Rather than stress safety procedures to employees, you might decide to modify working conditions. Or maybe you'll realize that your show is aimed at the wrong audience. In place of producing a show to convince your opponents, you may decide you'll have more impact if you design a show to rally your supporters.

How do you plan to evaluate the production to make sure the objectives are going to be met?

Along with stating your objectives in terms of audience behavior, you also need to consider how you're going to measure the achievement of those objectives. Otherwise, how will you know if audience members are doing what you intended?

If you've defined your objectives in terms of audience behavior, it should be quite easy to determine if they're actually doing what you expect. For example, if a slide show was produced to explain the production capability of an organization and engineering and administrative staff now spend less time explaining those procedures, your show is a success. If people fill up the collection plate after they've seen your audiovisual appeal, you'll know that you have hit the target.

One very important caution: Make sure that you measure the results at the right point. If you want employees to learn new skills, remember you want them to apply the knowledge back on the job, not just pass a test after they've seen your presentation. Remember, too, that this may mean some skill practice after the show.

Your show should be evaluated and, if necessary, revised at various points during production to make sure the objectives are achievable and that the production is developing on target. Don't wait until a production is finished to test how well it achieves the intended objectives, because revisions will be much more costly. Remember, aircraft designers don't wait until a plane is ready to fly before they test it for the first time.

How will others in your organization know the show has achieved the intended objectives?

Keeping track of the achievement of objectives is becoming more and more important as organizations seek proof that their money is being well spent. By stating your objectives in behavioral terms with a clear standard of measurement, under a given set of conditions, you shouldn't have much trouble determining if the show actually achieves the intended objectives. Just make sure others in your organization know how well your show achieved the intended results.

Who Is Going to Be in the Audience?

With the communications objectives clearly defined, it is time to look closely at your intended audience. *Who are they and what are they looking for or expecting from this presentation?* You have already considered them when developing the communications objectives. Now you must try to determine the factors that will make them listen and understand your message. If, as you prepare your presentation, you think of the audience as one person with specific questions and concerns, you can make the listeners feel that the communication is aimed directly at them.

In each case where the target audience is not well known, it is wise to find out as much about them as possible. *How much do they know about the subject? What are their educational and occupational levels? What is the age level of the group? Is there an attitude toward the subject or possibly toward the speaker? Does*

the group have a predominant discriminatory attitude? When all of this information has been compiled and analyzed, you can then determine if the presentation and the audience are compatible. A word of caution: Never underestimate the intelligence of your audience. That can lead to potential disaster. Therefore, the more that is known about the audience, the firmer the basis for planning the content of the presentation.

People are most likely to learn when the message is relevent to their current needs. For example, to help people fill out their income tax forms properly, you should

present the show in January and February, just before they need the information—not 6 months earlier. If you want to help people stop smoking, present your show to people who are trying to quit, not confirmed smokers.

What standard of production is the audience used to seeing?

If your trade show production was put together in a couple of weeks by inexperienced staff working on a shoestring budget, you may be at a disadvantage when your

competitors in the next booth have spent $100,000 on an elaborate multi-image production.

On the other hand, if yours is a voluntary agency trying to raise funds, an elaborate and obviously expensive production may lead donors to think that you don't really need their money.

If it is necessary to present the information to expert as well as lay audiences, try to segregate the audience into homogenous groups. In this way you can tailor the show to appeal to different audiences.

What Content Should Your Show Cover?

If you're not already familiar with the subject to be covered by the production, consult someone who is. Ask them to list the six or eight main points they want covered, to explain each point in as much detail as possible, and to explain how this content will help achieve the intended objectives.

Consultation with individuals familiar with the subject material will save time and money.

You may have to do more research to determine the best way to approach the script, but initial research should give you enough information to decide if the subject is suitable for an audiovisual presentation. In gathering information about the subject of your show, consider the following points:

How should complex material be presented?

If you're explaining a process or a procedure, begin by going quickly over all the steps to give the audience an overview of the material you plan to present. Then go back over the same process, explaining each step in sequence, beginning with the simplest ones. Once you're sure the audience has grasped the basics, explain your subject in greater and greater depth.

For example if your plan is to present the basics of operating a new office copy machine, first quickly run through all the steps required to operate the machine and produce copies. Having

introduced the steps, go over them again, presenting detailed instructions for actually operating the machine. Once the audience has grasped the basics, then go on to show them how to fix the machine if it jams and how to add the necessary chemicals. When they've assimilated all this material, then introduce them to the advanced capabilities of the machine.

Will people learn faster if they're actively involved?

If you want audience members to retain the content 6 months later, get the audience to do more than just watch your show. If you want them to develop new attitudes, get them involved in a discussion. If you want them to learn a skill, give them a chance to practice it under the supervision of someone who can correct their mistakes.

In most cases someone from your organization or a suitable representative should be on hand to answer questions, lead a discussion, and hand out reference material. Even carefully-designed individualized training materials will get better results if there's an expert on hand to provide additional information.

If you can't provide someone from your organization to present the show, design a detailed guide that users can follow. Pilot test the presentation to make sure the guide provides all the information the audience needs.

How Will the Show Be Distributed?

Distribution is an aspect of production that is often overlooked by inexperienced producers, and as a result an otherwise excellent production is never used because there is no money left in the budget to pay for copies, renting or purchasing playback equipment, and other necessary distribution expenses.

How many copies and what additional materials will be required?

You'll need at least one set of duplicates of your show because you don't want to risk damaging or losing your original slides.

Two copies would be even better because if one copy gets lost, you won't be tempted to use the orginal slides.

If the copies are going to include study guides, handouts, and other materials, you'll have to budget for preparing and printing these materials.

What playback equipment is available?

Before you begin production, you should determine what playback equipment will be necessary to present the show. There are a variety of different tape recorders on the market and not all of them are compatible (signals recorded on one machine may not play back on another).

In some communities, slide-tape playback equipment may not be available at all. In these cases, if you can't send the equipment along with the show, you should consider transferring the show to 16 mm motion picture or video cassette. Motion picture projectors are available in many communities and video-cassette equipment is becoming more common. For more about transferring slide shows to 16 mm motion picture film and video cassette, see the section on "Postproduction—Transferring a Slide Show to Another Medium."

Whether you're going to rent or purchase equipment, here are some questions you should answer in order to select the most suitable system:

What type of facility will be used to screen the show?

It's important to make sure your production always gets shown to its best advantage. If your audiences are always going to be small (five to eight people) and you can't be sure the room will always be dark enough, consider using a rear-screen unit.

How large will the audience be?

With very large audiences, you'll have to rent or buy special high-intensity projectors and auxiliary loudspeakers because most amplifiers and loudspeakers built into slide-tape systems aren't powerful enough.

Who will run the show?

Qualified technical personnel should be available to set up the equipment and supervise its operation. At times, other, less qualified, personnel may have to perform this function, and we suggest that you keep your playback system as simple as possible. Two projectors and a dissolve control may even prove too complicated to operate for people unfamiliar with the equipment.

Whatever playback system you use, make sure you always enclose detailed instructions and perhaps a diagram which explains how to set up and operate the equipment. For guidelines to consider in selecting playback equipment, see page 31. For more information about distribution in general, see page 138.

What other activities will take place at the time the show is screened?

This is an important consideration because all too often organizations expect more from audiovisual productions than they are capable of delivering. Your production is likely to be much more effective if the show is properly introduced and followed up with activities and handouts which reinforce the objectives of the presentation.

Who specifically will be responsible for distributing the show?

Unless someone takes responsibility for distributing your show and checks periodically to make sure it's running properly and is being used correctly, it may sit on the shelf gathering dust.

WHAT RESOURCES ARE AVAILABLE TO PRODUCE THE SHOW?

What Budget Is Available?

One of the first questions sponsors usually ask a producer is "How much is this show going to cost?" Answering that question accurately is nearly impossible in the early planning stages of a production. Until you've researched the show and written it, or at least

"How Much Will the Show Cost?"

thoroughly outlined the script, you won't know how much time it's going to take to shoot and edit the show. Without that information, you can't estimate production time—the major expense of a production.

Like everything else in this world, you'll get what you pay for. Just as cars range in price from "no frills" subcompacts to luxury limousines, so do slide shows. Rather than *ask* a producer how much a show is going to *cost*, sponsors should *tell* a producer how much they're willing to *spend*. Producers can also work with sponsors to set objectives and the objectives can help to determine what a show is worth.

Although you may not have more than a few hundred dollars to spend, you can still produce a first-rate production if you have enough time and you use the time

effectively and efficiently. It takes as long as 2 or 3 months to complete a synchronized slide show. If you have to finish the job much sooner than that, and you don't want to sacrifice quality, you can expect to pay anywhere from 25% to 50% more for a quality production.

If you take the time to plan and script the show thoroughly, and you design each visual in advance to make sure it's going to fit with all the other slides in the show, you can produce a high-quality production for well under $5,000. If you're not an experienced photographer or you have a hard time putting words on paper, look around your organization for assistance. The file clerk may turn out to be an excellent photographer and the personnel manager an experienced cartoonist. Another staff member may be a good writer and someone else may have the skills and equipment needed to produce a professional-quality sound track.

Could You Use an Existing Production?

Organizations often embark on production without checking to see if the show they want has already been produced. If you need a show in a hurry and you don't have a lot of money to spend, you may get better results by adapting an existing show to your requirements. Even if you decide you still need to produce a new show, a look at similar productions can provide a wealth of good ideas and suggest mistakes to avoid.

Could You Sell or Rent Copies to Other Organizations?

If you're having problems finding the necessary funds to pay for the production, maybe another part of your organization might be willing to share production costs. Maybe you'll be able to recoup some of your production costs by selling or renting copies to other organizations with communications or training needs similar to yours. For example, a hospital seeking funds may use a show produced by a medical supply firm. Or a show produced for environmental protection might be used by a garden club.

OTHER CONSIDERATIONS

When Is the Show Due?

State the date and indicate why the show has to be ready by that date. For example, is it being prepared for an exhibit or conference and therefore MUST be completed by the specified date, or is the date just based on how long sponsors think the production should take?

Knowing how much time you have is important because a rush job will probably cost quite a bit more than one that can be completed at a more leisurely pace. If the deadline for a conference or exhibit is only a few weeks off, and you don't have much experience or thousands of dollars to spend hiring an expert producer, you may have to scrap your plan to produce a synchronized show and settle instead for a "live" lecturer with a set of slides. Or maybe you'll have to cancel the show altogether. After you set the final deadline, set intermediate deadlines for script, photography, recording, and other major aspects of the show.

Has Your Organization Had Any Previous Experience with Audiovisual Media?

If your organization has never been involved in audiovisual production before, either in-house or on contract, staff responsible for commissioning the production may find it difficult to decide what they want. They also may have an unrealistic view of what high-quality production costs or how much expertise it takes to do a good job.

How Long Will the Show Be Used Before Replacing or Updating It?

If the information contained in the production is going to be out of date every 6 months, make sure your organization is willing to pay the cost of revising the show. You can minimize revision costs by keeping changeable facts such as statistics and prices out of the sound track and presenting the information instead on the slides alone. It's much easier to replace a few slides than redo the sound track and reprogram the show.

Who Will Review and Approve the Show?

One of the first steps you have to take in planning any audiovisual production is to determine who has final authority to approve your production. It's possible that several senior administrators in your organization plus the client will have to give their approval before your show can be released for distribution. To save yourself the pain and considerable expense of revising a completed production, you should identify everyone who

has to approve the show and involve them right from the early planning stages of the production. Along with helping you gather some important preliminary information about objectives, content and intended audiences, your advisors can assist you by reviewing the show as it develops.

In determining who has to approve the production, don't just think of senior administrators. Also ask for suggestions from those staff members who will actually present the show. If you include these staff members in planning and reviewing the production, you may find their needs are quite different and even in conflict with those identified by the administrators responsible for commissioning the production.

If you don't know much about the subject covered in the production, ask someone who does to help you determine the content. When the subject matter is unfamiliar, an expert advisor can save you a great deal of research time and help you avoid costly mistakes.

You should also consider having the production reviewed by someone from outside your organization. As the producer or sponsor of a show, you may be too familiar with the content to be a realistic judge of its effectiveness. Even members of your organization not directly involved in the production may be prevented from evaluating the show realistically because even they know too much about the subject or they don't want to offend you.

One last group of potential reviewers is the audience. If the production deals with controversial subject matter, or is designed to convey critical information the audience has to remember, you may want to have the initial proposal, the script, and the show itself reviewed by a sample group of the people you've identified as the audience. (For more information about how to pilot-test the production with sample audiences, see pages 137–138.)

Although you should have the production reviewed by all the people we've listed, getting approval from so many people could be a very time-consuming process. If everyone suggests one or two minor changes, you could spend a great deal of time revising the show. To simplify matters we suggest you have your reviewers meet as a group and that you limit the size of this group to no more than seven people. Groups larger than that are rarely as effective, and a smaller group may not include all the people you should involve.

How Will You Select and Brief the Approval Committee?

Select people who can give you the most assistance. If possible choose people who know something about audiovisual media, who work well in groups, and have previous experience as reviewers. When reviewers with media experience are hard to find, ask the people you select to prepare themselves by reading this book. The more committee members understand about the process of production, the more they'll be able to help you and the less they're likely to make unreasonable demands.

In selecting members for your approval group, make sure they understand what's expected of them. Tell them how many meetings you expect them to attend, when meetings will be held, how long meetings will last, and what preparation you'll expect them to undertake at each stage of production.

When your reviewers have to read material such as the proposal or your script before meeting with you, give them ample time to do so and let them know how much you'll be willing to revise. In the early stages of production, you can revise your ideas quite substantially. As the work progresses, you won't be able to make major revisions without incurring considerable expense. If some of your reviewers think the show should be produced on video instead of slide-tape, you want them to say so *right at the beginning*, not 2 months later after several hundred slides have been shot and edited. If someone wants to change words in the script, they should realize the time to do so is BEFORE you've hired a narrator and recorded the sound track complete with music and sound effects.

Keep the meetings with the committee as short as possible— people are rarely productive for more than 2 hours and shorter sessions would be even better. Make note of all suggestions offered and decisions made, summarize these after each meeting, and send each participant a copy of these minutes for their approval.

CORNING GLASS WORKS

Meeting the growing audiovisual needs of a company like Corning Glass Works, with a staff one-third the size it once enjoyed, was a challenge for audiovisual center supervisor Martin J. Rome and his three colleagues in The Communications Division, Audiovisual Center.

It meant, among other things, getting more mileage from the various sound-slide programs the group was responsible for producing.

"The long-term use of a sound-slide program has to be an important consideration in planning and production," explains technical supervisor Stanley Weisenfeld. "We can't afford the luxury of producing something that will only be shown a few times and then sit on a shelf. Of course, we want our nine-projector multi-screen production to entertain, impress, and hold the attention of our stockholders. But at the same time, we want to know we can take those same 600 slides and put several simpler shows to use for marketing, training, recruiting, or employee orientation."

In May 1980, the center completed work on a special AV program entitled "Corning Capabilities," a sound-slide program that looked at the company's technological capabilities worldwide and focused on all five major operating divisions. The production was the result of a compilation of photographs from various sources, including slides from existing multi-image presentations and ones already on file.

Designed for use with either one or two projectors, the 14-minute sound-slide program serves many functions. Covering the entire company, it can be used by sales representatives in all divisions.

"The program is an excellent way to introduce a prospective customer to the company and set the stage for a sales presentation," says Rome. "After the main program is finished, the sales representative can show another set of slides dealing with specific products."

New Corning VISIONS® top-of-the-range cookware. (Courtesy: Corning Glass Works)

Spacecraft windows with special electrically conductive coating. (Courtesy: Corning Glass Works)

Television bulb funnels. (Courtesy: Corning Glass Works)

High-intensity operating room lights with reflectors by Corning that transmit the heat upward and away from the patient. (Courtesy: Corning Glass Works)

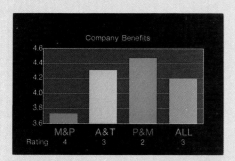

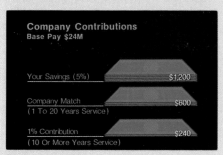

Examples of slides produced on the Autographix computer system by David R. Bliss, Corning Glass Works.

The presentation can be shown using a self-contained *KODAK EKTAGRAPHIC* AudioViewer/Projector for small groups or with dual projectors for larger groups. One show, "Corning Capabilities," has been transferred to video tape and filmstrips for people who prefer those formats.

Nearly 100 sets of the sound-slide program have been distributed to the company's field organizations so far. Cassettes also are available in French, Spanish, and German. "The program is probably the most impressive piece we have for introducing the company to people who may not know much about us," says Rome. "Although designed to be used in conjunction with the distribution of printed material, it is definitely a stand-alone presentation if need be."

Much of the actual production work on programs generated by the center is created on their Autographix system. While the majority of presentations are designed for two-screen, four-projector configuration, in-house facilities include a screening room with 15 *KODAK EKTAGRAPHIC* Slide Projectors, Arion programmers, and audio recording and mixing facilities. Two *KODAK* 16 mm Sound Projectors are also used on certain multi-image presentations as well as for routine viewing of motion picture films.

The center also produces some sound-slide programs to help train new employees in manufacturing plants overseas.

"While we have to contract out our sophisticated video programs, internally produced sound-slide programs continue to best meet our needs under many circumstances," Rome points out. "The ability to combine photographs, line art, charts and graphs makes this format well suited to so many programs and we don't expect that to change.

"Except for the annual meeting presentation, we try to be as basic and simple as possible with our programs. If a single projector suffices, then that is all we'll use. We rarely use more than four projectors for a routine presentation.

"Sound-slide programs are particularly important to a corporate AV center like ours where budgets are limited and the staff is small. Being able to update a program simply by changing slides can make all the difference in the world and everybody benefits."

THE PROPOSAL

The project proposal is usually a one- or two-page creative document that producers use to summarize everything they know about their client's requirements and resources. While there's no exact formula for what should be covered by a project proposal, it usually summarizes everything the producer knows about the client's objectives, intended audience, content to be covered, distribution plans, budget and other resources, deadline, and personnel responsible for approving the production.

If you've been able to answer most of the questions listed on page 16, writing a project proposal should be a simple matter. When you've completed your proposal, present copies to others working with you on the project to make sure they agree with information you've gathered. Even if you're the only person working on the show and you don't need approval from anyone else, you should still produce a project proposal, because preparing it will help you form realistic objectives and plans for the production.

BRAINSTORMING

Brainstorming is a critical part of developing your show. Whether you brainstorm on your own or with several other people, the method is the same. Focus on the communications objectives of your show for a predetermined amount of time—20 minutes to an hour maximum. Voice every verbal and visual idea that comes to mind, no matter how ridiculous it seems at first. Some of the best ideas come from suggestions that everyone laughed at the first time they were brought up.

Brainstorming sessions are an excellent way to develop ideas for your presentation.

Write down all of the ideas in the order they come. Don't impede the creative flow by criticizing the ideas or trying to organize them. A brainstorming session should be conducted in as relaxed and unrestrained an atmosphere as possible. To aid in organizing ideas later, write each suggestion on a separate file card. The file cards can be organized at a later time. Remember that good ideas can come any time so always carry a notebook while you're engaged in this brainstorming process.

The brainstorming process should be undertaken several times in the course of developing both the show and a script:

- When you meet with the people who've commissioned the production, use a brainstorming session to determine the six or eight most important points that should be covered in the show.

- After you've done some preliminary research, use a brainstorming session to select a production style, outline the script, and prepare a treatment.

- When you've developed the words for the script, brainstorm again to develop ideas for the visuals.

After doing this a few times, you'll be amazed at the great ideas you and your associates can develop in less than an hour.

You, and any others brainstorming a show, may or may not be visually "fluent." In either case, it is important to work imaginatively with them to build on any facts, attitudes, opinions, and understandings they may express about their needs and wants.

For example, once you know who the audience for a presentation will be, see if any of these leading questions elicit visual ideas: If you could have anything you wished in this presentation without regard to cost . . . what would you wish people to learn, feel, or do as a result of seeing this presentation?

Some key feeling or attitude words might be open, serious, enthusiastic, passive, accepting, defiant, constructive, responsible.

Then ask yourself . . . what do you wish the presentation could include to make your first set of wishes come true?

Make a note of such easily visualized things as demonstrations, locations, graphs, maps, and faces. Also make note of references to background information, shared experiences, or something else your clients assume the audience has—or will need—in common.

You may be able to visually identify and clarify an underlying supposition that is the key to the presentation.

Visual creativity is largely a function of visual awareness. If you want to develop your awareness, pay conscious attention to the great number and variety of visual messages around you.

See what you can learn from the ways in which thoughts, commands, emotions, and facts are constantly being presented. Signs, billboards, traffic signals and gauges are all indicators that help us get through the day. Television commercials present the most sophisticated visual messages of all.

Try a little experiment: look at several TV commercials with the picture on and the sound turned completely down. Then turn the sound up so you can hear it, and position yourself so you cannot see the picture. Try a few more commercials that way. Which is the more important element, sound or picture? Probably when you heard the sound, you supplied the visual imagery yourself, but when you watched the visuals, you didn't really need the sound.

Cultivate a relaxed and fresh view of the world so that you can see familiar sights, images, and words in new and special relationships to your audiovisual objectives.

Expand your creative horizons a bit. Try new activities. Read in a new area of interest, see a creative art film, take in an art or graphic design show. The visual ideas in tomorrow's audiovisual project may be at least as much a product of your leisure time as of the time you spend on the job.

Some creative people have found relaxing or mind-liberating techniques to be effective in nurturing visual creativity. They use meditation, jogging, deep breathing, mininaps, warm showers, and music. Find what works for you through trial and error and use it.

RESEARCH

Once you've analyzed the requirements for a production and identified resources, summarized these elements in a proposal, and had the proposal approved, the next major step is research.

Research helps you get to know your subject well enough to begin developing your show and the script. Read up on your subject, look at any visuals available, interview experts, visit locations, and set up a filing system to categorize and keep track of all the information you're gathering.

Audiences want to hear more than just general statements about an issue—they want facts and figures—statistics, case histories and quotes from reliable sources. Not only will these add credibility to your production, but audiences will have an easier time remembering your message if it's backed up by facts they can recall.

In researching a show, there are four main sources of information:

- Existing Productions
- Printed Materials
- Interviews with Experts
- Visits to Locations

Existing Productions

Find out if there's a production on a similar subject that you can view. For example, if you're supposed to prepare a production to orient new employees, take a look at similar shows produced by other organizations.

If you've been asked to adapt someone's illustrated lecture into a synchronized show, don't make the mistake of taping the unedited lecture and synchronizing it with the slides the lecturer uses. The delivery of a slide lecture and the pacing of the accompanying slides is usually much slower than that required for a synchronized production. Because the audience has the lecturer to watch as well as the slides, they will tolerate a much longer presentation; if the lecturer is a good speaker, they may not notice if some slides are of less than professional quality.

While the words and the images used in a slide lecture can save you a great deal of research, be prepared to write a much shorter script and shoot new visuals if you need a professional-quality production.

Printed Materials

Begin gathering printed reference material—pamphlets, newspaper and magazine clippings, press releases, annual reports, surveys, copies of speeches—just about any document that covers your subject.

These materials should give you a general understanding of the subject, as well as specific facts—names, dates, statistics, examples, case histories, and leads to people you'll want to interview. You may also find slides, photographs, and graphics which will help you "picture" the subject you're researching.

In looking over these materials remember the 5Ws and the H used by journalists—WHO, WHAT, WHEN, WHERE, WHY AND HOW. Categorize everything you find and set up a filing system that will help you keep track of the materials you've gathered. Collecting this material can save you hours of research, thinking, and even writing, if you're allowed to lift words as well as ideas.

Interviews With Experts

Once you've looked over all the reference material available and have a basic understanding of the subject, talk to those people who can provide the more detailed information you need. Take a tape recorder along when you conduct these interviews to collect useful phrases that will come in handy when you write the script.

When preparing a production which is supposed to teach people how to perform a skill, then as part of your research ask a trained person to demonstrate the skill for you. If you're not familiar with the subject yourself, have the demonstrator explain what she or he is doing as they go through the various motions. By taping this explanation and taking shots of the procedure, you'll have material to guide you as you develop the script. In taking these slides, shoot from the viewpoint of the person demonstrating the procedure as well as the viewpoint of an observer.

Select the right equipment. Use a cassette tape recorder with a condenser mike. People who aren't accustomed to being interviewed will feel more relaxed and willing to talk if you use the condenser mike instead of a hand-held mike that you must hold up to their lips. Provided you don't plan to use the tapes as part of your sound track, the condenser mike built into most cassette recorders should give you satisfactory sound.

If you want to use segments of the interviews to add authenticity to your sound track, you must record these with a professional-quality tape recorder and a hand-held or lavalier microphone. If you don't have experience recording and editing professional-quality interviews, and you can't hire someone who does, stick to scripted production and use interviews for research purposes only.

When conducting an interview, relax. People really like to be interviewed; it makes them feel important. However, when you need to interview an important person, such as the president of your organization, underestimate rather than overestimate the amount of time you'll need. Once the questions have begun, few subjects are clock watchers. If they have to leave, at least they'll leave with an interest in your project and they should be eager to finish the interview when time is available.

If you have to interview several people on the same topic, it's generally a good idea to interview each person separately. You're likely to get more candid answers.

Ask the questions your audience would ask. If they won't know much about the subject, your questions should be very basic; if they are quite familiar with the topic, the level of your questioning should reflect that familiarity. Whatever level you use, begin with questions that will be easiest to answer. This will help establish the rapport you'll need to get candid answers to the tough questions you're saving for last.

Unless your subjects need time to research specific topics, don't submit your questions ahead of time or you'll take the spontaneity out of their answers. Simply tell him or her the subject areas you plan to discuss. Keep your questions short and listen carefully to what your subject is saying. Remember you're asking the questions—not providing the answers.

Visits to Locations

Once you're familiar with your subject, get out and have a look at it. Visit the sites where the show will be shot, observe the people and the operations covered by the show.

While gathering facts, you also should be gathering visual impressions. Make notes about people, places, events, and objects that will illustrate the ideas you want to convey. In many ways these visual impressions of your subject are more important than the verbal because an audiovisual presentation is predominately a visual medium.

When visiting locations, photograph scenes that can be used in the presentation.

Along with making notes about visuals, take some shots of the locations you might use in your show. These slides will be useful when you're planning the visual part of the script. Use a light meter to check the suitability of the available light. If you plan to turn the shooting over to a professional photographer, the slides you shoot in the research phase of the production will help you and the photographer plan the visuals and an efficient strategy for shooting the production.

Researching your show will provide you with information for making technical and creative decisions.

MAKING TECHNICAL AND CREATIVE DECISIONS

When you've finished researching the content of your show, you should be able to

- Determine the length of the show.
- Select the appropriate playback equipment and format.
- Select a suitable creative approach.
- Choose a visual style.

You may have made some of these decisions when you analyzed your requirements and resources, and prepared your proposal; however, some additional research may be necessary before you can finalize all of these decisions.

Determine the Length of the Show

Limit the length of a synchronized slide show to a maximum of 20 minutes. If you have more material, produce two shows, and give the audience a break in between shows for discussion and questions. Remember, the human attention span drops off after 20 minutes—often less. The length of your show is also limited by size of your slide tray. It is difficult to change slide trays easily in the middle of a show. Therefore, if you're planning a single tray show with a *KODAK EKTAGRAPHIC* Universal Slide Tray, Model 2, you're limited to a maximum of 80 slides. If you're dissolving between two projectors, your show can include 160 slides.

As a guide for your first show, don't hold your slides on the screen for more than 10 seconds. At this rate, a single-tray synchronized show shouldn't last any longer than 13 minutes, and a two-projector dissolve show shouldn't run longer than 26 minutes.

While you can leave a slide on the screen for 10 seconds or longer, most slides don't contain enough detail or information to keep the audience members interested for even this much time. Many professionally produced single-tray synchronized shows are designed to run through 80 slides in 8 or 9 minutes. Two-projector dissolve shows with 160 slides usually don't run longer than 15 minutes.

Lectures illustrated by slides can last much longer because there's a live speaker to look at as well as the projected slides. If the speaker allows the audience to ask questions and contribute their ideas during a lecture, this involvement can maintain audience attention for periods longer than 20 minutes. A lecturer can also change slide trays smoothly, without disturbing the flow of the lecture.

Select the Appropriate Playback Equipment and Format

Before you can decide what creative approach to use in writing your script, you should decide what playback system you're going to use. There are many different playback alternatives to choose from, and the equipment you select may have to be considered when you write your script and plan and prepare the visuals.

Will you just use a "live" lecturer with a set of slides, or do you want a synchronized show? One projector or two?

What about rear-screen projection for those occasions when you don't want to turn down the lights? Would the show get wider distribution if you transferred it to 16 mm film or video cassette?

It's important to decide these issues before you finish drafting your script and begin production, so you don't limit your options.

Listed below are capsule discussions of the various slide show formats, ranked in order from the simplest and least expensive to the most complicated and costly.

Lecture Slides

Years before slide-tape shows became common, speakers used slides to illustrate their lectures. Not only did slides help to explain hard-to-describe material, they provided visual cues speakers used to remind themselves of the main points of a speech. Now that slide-tape equipment is readily available and comparatively inexpensive, organizations frequently overlook the many advantages lecture shows have to offer.

- It is by far the easiest type of show to assemble and the least expensive.

- Because the speaker's words are the primary channel for information, technical perfection and continuity between slides is usually less important than it is with synchronized productions.

- The lecture slide show is far more flexible than a synchronized show. A speaker with a set of slides can easily tailor a presentation for the specific needs of each new audience. If the slides are carefully prepared and the speaker entertaining and informative, this kind of show can be every bit as effective as an automated production.

Silent Exhibition Show

This type of production is the ideal choice for public displays where you can't seat an audience to watch a lengthy synchronized production, and where the show's sound track would be drowned out by productions of nearby exhibitors.

To produce this type of show all you need is a projector and a tray of slides. Since audiences watching this type of show are getting your message through their eyes, the visuals in this type of show have to be understood at a glance. If you want to "say" something to the audience, condense your sentences to a few strong words and put these on the slides.

To operate this type of show, all you need is a projector such as a KODAK EKTAGRAPHIC III Projector with a built-in timer. If you don't have a full tray of slides, insert some blanks to fill up the tray. If your message is short, you might want to prepare several copies of the same slide set to fill up the tray.

Set the projector up behind a rear screen or use a self-contained rear screen projector such as a KODAK EKTAGRAPHIC AudioViewer/Projector. (Rear projection permits you to project the slides in bright indoor light.)

To operate the production, set the timer for the required number of seconds, and turn on the projector. When the circular tray reaches the end, it will automatically continue to repeat the show again and again.

This type of slide show can be produced quite inexpensively, especially if it's adapted from an existing production. Although the approach is simple compared with the elaborate synchronized systems used by many exhibitors, this type of production can have more impact. People automatically read any print that is flashed before their eyes and the changing slides and words in this show will attract their attention.

Keep this kind of show quite short (1–3 minutes) so visitors won't have to watch very long to see the whole show. You also might consider putting up a sign to tell visitors how long the show lasts—then, if they walk by when the show's in progress, they will know they won't have to wait long to see the show from beginning to end.

Front Projection Versus Rear Projection

Choosing between these two projection formats is not a simple matter of flipping a coin. But neither is it always a strictly objective matter where specific sets of circumstances dictate the use of one approach over the other. As with all of the creative decisions you'll have to make, choosing a projection format will require sensitivity to the physical as well as the aesthetic requirements of your presentation.

Front-screen projection usually offers greater quality of projected images. They're brighter, with more even illumination, than most rear-projected images. Contrast is better because the image is projected onto a screen, not through it. There is, however, one qualification to this statement. If, in trying to avoid the placement of a projection booth in the middle of an audience, you decide to use a long-focal-length lens, it may have a slower lens speed (resulting in a dimmer image).

Rear-screen projection equipment is set up behind the screen, out of sight of the audience. The images are projected onto a translucent screen (for viewing from the other side). With this arrangement, there's no booth to interfere with the openness of the seating area. And because the projection equipment is out of sight, there's no need to spend time or money to drape it.

Some people also feel rear-projection offers the advantage of reduced projection distance. While it is true that projection distances can be somewhat shorter—because you can move the projectors closer to the screen—this is often accomplished through a trade-off in image quality. The trade-off is a product of the projected image's "bend angle"—or the angle at which the light from the projector must bend to reach the viewer's eyes. (See diagram.)

To correct this problem, the projection equipment must be moved away from the screen. To do this, however, nullifies the so-called advantage of short projection distance. (You can also "fold" your projected images using mirrors. See diagram for one method.) Rear projection has one major disadvantage. Its images, from light projected through a screen, are generally less sharp, less bright, and have less contrast than those of front-screen projection.

Rear-screen projection is also used extensively in presentations for displays and exhibits. In these applications, the projector is usually contained within an exhibit structure. The image projected is usually small, and very bright, so a lens with a focal length as short as 1 inch often can be used without creating dark areas from the "bend angle," a problem related to larger images. For further information, write to Eastman Kodak Company, Dept. 412L, 343 State Street, Rochester, NY 14650, and ask for a single copy of *Self-Contained Projection Cabinets*, KODAK Publication No. S-29.

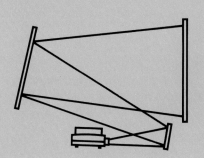

The One-Projector Slide-Tape Show

This type of slide show consists of two parts, a sound track and a tray of slides synchronized to match it. It's the simplest type of synchronized show to produce and if you've never produced a synchronized show before, this is the best place to start.

There are several different ways to synchronize slides and sound track. If the intended users of your show have playback equipment compatible with yours, an inaudible signal recorded on part of the sound track will automatically change the slides. (See section on "Synchronizing the Slides and Tape," page 129).

For users who don't have slide-tape equipment that senses inaudible slide-changing signals, you can record an audible tone just loud enough to be heard on the sound track that will cue anyone running the production to change each slide manually.

If you think users won't have a tape recorder available, provide them with a script they can read aloud which has been marked with cues for changing the slides.

The Two-Projector-Dissolve Slide Show

This type of production uses two projectors and a dissolve unit, such as a *KODAK EKTAGRAPHIC* Programmable Dissolve Control, along with a compatible tape recorder. The "dissolve" effect is created when the inaudible signal on the sound track triggers the dissolve control, which dims the lamp in one projector while turning up the lamp in the other. Since the images from both projectors are superimposed on the screen and change gradually, without any "black-out" between slides, the visual effect is much smoother than with a one-projector show.

The dissolve effect is easier on the eyes. It can create the illusion of movement and other special effects.

Because you're using two projectors and two 80-capacity slide trays, you can have up to 160 slides in a show instead of 80.

If you're not sure whether to produce your show for one or two projectors, read the section "Shooting Techniques" on pages 83-86.

Documentary

The sound track for this type of show is made up from recorded interviews, unlike other shows that are prepared from a written script. Recording and editing interviews requires professional quality sound equipment and a fair amount of skill to operate the equipment and edit the interviews. In addition, it's not always easy to get candid comments from people.

If you don't have time to learn these skills, or funding to purchase the assistance of someone who has them, stick to scripted shows. Documentary productions usually cost more than scripted productions, but if you need to motivate people, testimonials from the converted can be very effective.

One word of warning: don't try to fake off-the-cuff comments by scripting them. The results usually sound phoney. If you can't get the real thing, write a regular script and use a narrator.

Issues to Consider When Purchasing Equipment

Read Before You Buy! Check reliable trade publications for evaluations made on equipment you're planning to purchase. These magazines will also have reviews of new equipment coming on the market that may be better than the machine you're planning to purchase. Ask other producers about their choice of equipment. Go to trade shows and see what is being said in product display areas.

Who Will Operate the Equipment? If equipment is going to be used by a number of different people, buy the most durable models available. They will cost more, but in the long run you'll spend less on repairs. If the equipment you're buying is expensive and complicated to operate, budget for the additional cost of hiring a qualified specialist or training a member of your own staff to maintain and operate the equipment.

Where Will the Equipment Be Used? If you plan on shipping equipment around the country, make sure it will stand up to repeated rough treatment. If necessary, budget in the cost of shock-proof shipping crates. Renting the equipment you need at the locations where you plan to use it may be less expensive and risky than shipping it. If you have to carry equipment long distances by hand, check to see that carrying handles are strong enough for this purpose.

Can the Equipment Be Repaired Quickly? You may save money buying an obscure brand, but you'll lose in the long run when something breaks down and you have to wait 6 weeks for parts to come. Make sure you can rent replacement equipment if necessary while yours is being repaired. Make sure that you buy from a manufacturer who has a widespread distribution organization for backup.

Rent Before You Buy! You'll be better able to compare brands and models if you're familiar with the operation of any equipment you're buying.

Don't Buy Used Equipment Without a Warranty! Most reliable dealers will give you a 90-day warranty with any used equipment you buy. Make sure that covers parts AND labor! Use the equipment as much as you can within the warranty period to make certain it's operating properly.

Do Business With a Reliable Dealer. If you plan on buying a variety of equipment in the next few years, see if you can find a dealer who stocks most of the things you will want. By patronizing the same dealer, the sales staff will get to know you and your needs; you'll get better service and useful advice when you need it.

Insure Your Equipment! If you plan to use equipment outside your home or office, make sure you have a floater insurance policy that covers your equipment against loss and theft.

To Buy or to Rent

How often do you plan to use the equipment? If the answer is only two or three times a year, you may be better off renting. If you're not sure, apply this simple formula. Begin by estimating how often you think you'll use the equipment each year. Then multiply that figure by the number of years you expect to use the equipment before replacing it. Four years is considered average.

(Equipment will usually function for more than 4 years but it may become obsolete sooner than that.) Then divide the purchase price plus 20% for maintenance and repairs by the number of times you plan to use the equipment. If the cost per usage comes out substantially higher than the rental fee, rent the equipment. (Be sure to include the programming time *during* production in your calculations.)

Example:

machine costs $500 + 20% = $600

annual use (30 times)(4 years) = 120 uses

$600 divided by 120 uses = $5 per usage

cost per usage = $5

daily rental fee = $20

If the cost of renting equipment turns out to be slightly cheaper than the cost of buying, it still may be less expensive to purchase. Remember your time is worth money. If you add up the time you spend picking up and returning rental equipment, buying may be cheaper.

Select a Suitable Creative Approach

An approach is a plan of action. It's also another word for a concept or theme—the way you plan to reveal the subject of your show.

Some producers write the script as a straightforward lecture to be delivered by an announcer. Some reveal the subject through a discussion between several characters they've created. Other producers present the comments and testimonials of people they've interviewed.

Begin developing your "approach" by asking yourself, what theme, idea, or concept will help unify the elements of my presentation while holding the audience's attention?

No matter what your message, the first thing your approach has to do is get your audience's attention. You do that by giving them something they relate to. You could be very direct. For example, "Today we will discuss the new inventory control system." But let's consider some more imaginative ways to approach the subject of your show.

Analogy

Everything in the world is like something else. Find the core idea of your presentation—the one word or phrase that describes the essence of your message—and relate it to something else. Are you talking about cooperation? Relate it to a symphony orchestra or a sports team. Are you talking one-stop service? How about using the analogy of an old country doctor or an old general store?

Modification

In the course of its development, a product goes through a number of modifications to look and operate as it does. Was it once bigger, smaller, a different color? Was it actually many separate products?

Projection

If you turn the "modification" technique 180 degrees, you get "projection." Projection is a "what-if" technique. Just ask yourself, what if this product or this concept is just the beginning? What will we be looking at in the next 20 years? Can you imagine a totally computerized home? A car that drives itself? A car that submerges? What if Watergate never happened?

Reversal

Imagine that your product, building, or some inanimate object could tell you its impressions of life. Consider doing your presentation from its point of view. How does a camera feel about its users? What would a roll of film think of its life from emulsion to projection?

Context

If the subject of your presentation is a part of something larger, you might try a "context" approach. Put your product or concept into its proper context. An historical approach often works well. So does an overview of a business. How does any one of Kodak's marketing divisions fit into the Kodak family?

Choose a Visual Style

In selecting your visual style, you should consider what you want the visuals to do. In some cases, most of the message is delivered by the narration. The slides are just there because the audience wouldn't accept audio on its own and the pictures focus their attention. In other cases, the main message may be visual. The narration says little of any significance. This is frequently the case in commercials and other productions designed to sell.

In some cases, less-than-perfect visuals aren't a problem. For example, if your show is designed to teach basic first aid, and the visuals are technically accurate and help explain the concept, your audience probably won't mind if a few slides could have been better composed. But if your show is designed to sell a product, an organization, or an idea, and the audience is used to seeing top-quality media, your show will have to be just as good.

If you're not sure what standard you have to achieve, try to match the standard your audience is used to. Improve upon it if you can, but don't go too far. A slick production may turn people off or your message may get lost in the special effects. If you're trying to raise funds, elaborate production may lead donors to believe you don't really need their money.

On the other hand, knowing that your audience is used to substandard productions is no excuse for giving them yet another one. Remember people make a lot of judgments with their eyes. If they don't like the look of something, they often dismiss it. That's why manufacturers spend so much on product styling and packaging.

Commercials, TV programs, and movies have set such high production standards that audiences may subconsciously use these as a basis for comparison when they view your program. Therefore, you should strive to produce first-rate slides and a well-coordinated production.

If your objectives, subject matter, and audience indicate you need a professional-quality production, and you have the budget to hire an outside writer or producer, review the guidelines we suggest on pages 43–46 for selecting and working with outside professionals.

After selecting an approach for the subject of your show, you also have to decide what type of visuals to use. These are the alternatives you have to choose from:

- Original slides
- Stock slides
- Stock photographs
- Photographs in printed materials
- Graphics

When reviewing stock slides, graphics, and original slides shot for the show, consider the following questions:

- Does this image help me achieve my communications objective?
- Is there good continuity between this slide and the previous one?
- Has the photographer/illustrator eliminated all unnecessary elements without destroying the one main thought in this slide?

Which of the following alternatives you'll choose depends on your objectives, the intended audience, the subject of your show, the budget, and your skill as a photographer or illustrator.

Original Slides

If you produce your show using original slides, it will be much easier to develop visual continuity between one slide and the next. When you plan each shot carefully in detail before you or your photographer start shooting, you can make sure every slide will fit with the ones that come before and after it in the show. If you don't plan to shoot the show yourself, consider preparing roughly sketched cards for each slide so your photographer has something to follow when he or she shoots the show. (See page 39 for directions which explain how to prepare these sketches or storyboard cards.)

If you or your photographer has the necessary experience, and the style suits the subject of your show, you could use candid or photojournalistic photography. By capturing life as it is, the slides in your show will have a realism and persuasiveness not found with carefully planned visuals.

Because a slide show photographer usually has little or no influence over the people or the environment being photographed, it takes a great deal of skill to grab shots on the run and produce slides that are properly exposed, composed, and that blend together as smooth sequences. It also takes a great deal of money. Good candid photography requires a lot of film. The shooting ratio (slides shot compared with slides used) for a photojournalistic show can run as high as 20:1.

Stock Slides

If you have a choice, shoot new material. If you have to rely on stock shots, chances are you won't be able to get the exact images you need, the technical quality may be poor, and if the images come from a number of different sources it will be hard to develop a show with good visual continuity. Searching for the right stock shot can take even more time and money than that required to shoot original slides.

How do you judge stock slides? As with all the other slides in your show, the images you select should be HORIZONTAL. Viewers find it distracting when slides in a synchronized show switch back and forth from horizontal to vertical. Some viewing situations will not allow for both horizontal and vertical slides, and if you have your show transferred to 16 mm film or video (page 142), the tops and bottoms of vertical slides will be cut off.

Sometimes you may get a good horizontal shot from a vertical by duplicating the vertical slide in a horizontal format but in most cases the results will be substandard.

Criteria for Judging Stock Shots

- Is the slide adequately exposed? Avoid overexposed shots if possible since this fault will be magnified in subsequent copies. Slightly underexposed shots can be lightened when duplicated. If artificial lighting has altered colors, this too can be corrected if the slides are custom duplicated. (See page 141 for details.)

- If possible, select slides with a minimum of contrasting light and dark areas such as that produced by a combination of bright sunshine and shade. When slides with extremes of contrast are duplicated, important detail may be lost.

Stock Photographs

As with stock slides, don't use stock photographs unless you have to. A slide taken of a photograph doesn't have the same depth and realism as an original slide. If you have no alternative, select stock photographs using the criteria given for judging stock slides. If negatives are available for the photographs you plan to use, consider having your slides produced from these because you will get better quality.

Don't plan a production that specifies historical photographs without making sure that the photographs are available and you can obtain the rights to use them. If the photographs you want to use are black and white, consider using a brown filter when you

photograph them or use daylight film and incandescent lighting. Both these methods will produce a brownish or sepia-toned slide that will blend in better with other colored slides in a show.

Photographs in Printed Materials

When researching your show, you may come across pictures in magazines, brochures, or other publications. If they meet the criteria given for stock slides, make sure you can get permission from the publisher of these visuals before you make plans to use them.

Graphics

"Graphics" is a term that covers a wide range of different visual styles. Carefully drawn illustrations, cartoons, title slides (slides with words or numbers on them), graphs, charts, and all other symbols including those produced by a computer all come under the label "graphics."

Illustrations can be elaborate or they can be as simple as stick figures. They can be made from original artwork, commissioned by the producer, or copied—with permission—from art books, gallery collections, and historical texts.

Illustrations are often used, when the presentation deals with complex visual subjects such as human anatomy or the components of a computer. In the first of these cases, existing graphics may prove too detailed to photograph, so artwork is used to illustrate and highlight relevant details. In the second case, the subject matter—memory chips—is too minute and complex to photograph, so illustrations are used to focus on key elements of the subject.

Mixing Visual Styles

Dividing these visual styles into categories may give the impression that they are used exclusively—if you begin with one style, you must stick with it to the end.

That's not necessarily so. While one visual style should dominate a presentation, you can use elements of other styles. But this mixing of styles must be done carefully. You should have a purpose—a definite reason for altering your visual *look*. If you mix different styles of photography with a variety of illustrations, cartoons, and graphic symbols, you're demonstrating why presentations using slides from dozens of sources—some old, some new, some original, some dupes—are rarely effective. They are stylistically inconsistent— analogous to a man dressed in top hat, tails, and sweatpants.

THE TREATMENT

The treatment is a document producers use to summarize the technical and creative decisions they've made after thoroughly researching a subject and brainstorming to decide on the best creative approach to take in developing the script. Along with explaining why a particular approach suits the audience and is likely to achieve the clients objectives, the treatment also includes an outline for the actual show. In addition, the treatment usually explains what playback equipment will be used, when the show will be completed, and how much it is likely to cost.

Like the proposal that summarizes a client's requirements and resources, the treatment is a tool producers use to organize their ideas and present them for client feedback and approval. Even if you don't need approval from anyone else, you should still prepare a treatment because in doing so, you'll produce the outline you need to begin writing your script.

Although the format of your treatment will vary with each production, here's a structure to use as a guide.

Background

Background "sets the stage". It describes the objectives established for a presentation and explains how the show will fit into the total marketing or training strategy of the organization. This section may also describe the playback equipment to be used, and if necessary give a justification for using a particular playback system.

Theme

The theme, or "concept," includes the title and describes briefly the creative approach you plan to use in presenting the subject of your show. If you plan to use some unusual narrative or visual techniques, describe them and your reasons for doing so. Be creative! Help your client "see" and "hear" the show. Turn the client into a believer.

Script Outline

The bulk of the treatment describes the show—how it will sound and look from beginning to end.

The "beginning" describes the techniques you'll use to grab the attention of the audience, the "middle" explains how you plan to develop the theme you've chosen, and the "end" shows how you intend to wrap up the presentation and bring it to a strong conclusion.

Along with describing the kinds of visuals you plan to use in each section, also indicate how long each section will be, and whether or not the show will lead naturally into some type of follow-up activity.

Who Writes the Treatment

The responsibility for writing a treatment should be allocated to the writer/producer. The slash shows that this responsibility may be allocated to one or two persons. In the case of a simple slide show, this will probably be you.

You don't need to be a writer to create a treatment. You should know what you want to accomplish and how you plan to do it. When you have written your ideas on paper, you'll have created a treatment.

Writing a successful treatment depends upon selling your ideas; to sell your ideas you must believe in them fully. So put those beliefs on paper, and you will have an effective treatment.

TREATMENT

WHAT ENERGY SHORTAGE?

Changing Attitudes

In the last 20 years research has shown that before people will make major changes in their behavior they must be adequately informed by a reliable source, positively motivated and given opportunities to put their new knowledge into practice.

Recognizing these and other important psychological factors involved in changing attitudes, we propose to develop the following program:

Four AV Productions

A series of four 10-minute slide-tape shows featuring four different families that have been challenged to see if, for a limited time (say 2 weeks), they can cut their energy consumption down to meet a specific goal.

The first family would be asked to cut down on gasoline, the second to cut its electricity consumption. The third family would reduce the amount of garbage they throw out each week, and the fourth would agree to buy food only, giving up the routine and often unneccesary purchase of consumer goods.

The attitudes and opinions of each family would be recorded on tape before, during, and after the 2-week experiment, and their comments used to make up the final sound track. Appropriate visuals would be shot to match each family's comments.

The four productions would be made as slide-tape shows. Video-tape production is not recommended since playback equipment is not readily available. However, copies of slide programs could be transferred to video at low cost for playback by community cable TV broadcast and educational institutions with video equipment.

Instructional Kits

A kit would be developed to accompany each show, providing organizations and groups with everything needed to conduct a successful conservation workshop. Together with the audiovisual production, the kit would contain guidelines on how to motivate an audience, how to conduct an effective discussion, plus all the conservation information and forms people need to carry out their own project.

Distribution Strategy

A distribution strategy would be developed to ensure that kits reach as wide an audience as possible. Community groups most likely to undertake a conservation project would be identified and executives invited to attend an introductory workshop. These groups might include service clubs, consumer groups, fraternal, labor and environmental organizations, and education institutions operating night-school programs. Groups who agree to participate in conservation projects would be encouraged to publicize their efforts through the local media.

Conclusion

Implemented on a nationwide basis, this conservation program would appeal not only to the practical common sense of North Americans, but also to their competitive spirit.

By being presented as a challenge and conducted as a game, the program would demonstrate conclusively that conservation practices don't require sacrifices and will even *improve* a family's way of life.

Ⓒ See Hear Productions

WRITING THE OUTLINE

When you're ready to develop the "outline," begin by reviewing the notes that you made during the brainstorming sessions. During those sessions, we suggested that you write down every idea suggested, no matter how crazy, on an individual file or planning card. Now is the time to review these cards and determine five or six major subject headings that cover all of these ideas. Next, organize the cards under the major headings and eliminate the redundant cards. When you put these major headings in order, you will have the first draft of the outline. At this point, it is a good idea to number the cards so that they can be easily rearranged should they get out of order. For ease of handling, the cards can also be assembled on a planning board like the one illustrated. Once you have the cards arranged and assembled on a planning board, they can be easily moved about until you are satisfied with the order. Writing the outline should be easy because all you have to do is follow the order of the cards.

When you're satisfied with the outline and the rest of your treatment, give co-workers and sponsors a copy to make sure that they agree with the creative approach you've chosen and the content that you plan to cover. Approval of this outline is necessary before going on to develop a script.

Organize your planning cards under the major headings and eliminate the redundant ones.

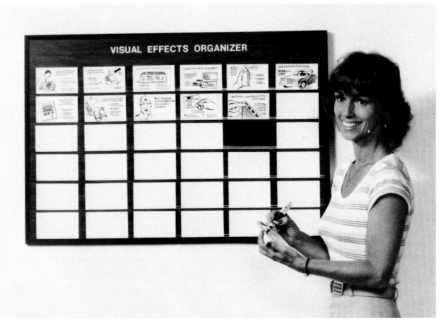

A storyboard is an easy way to visualize and assemble a slide show at the initial stages of the presentation.*

STORYBOARD

A storyboard is another way of visualizing and assembling a slide show. Storyboards borrow from the art of the film animator and strip cartoonist. Instead of developing your script in linear form on sheets of paper, you present one idea and image per storycard, and combine these with a sketch and short description of what the slide should look like. Use your "planning cards" as a starting point for the "storycards."

From initial planning to shooting script, the entire script can be assembled in this manner. Producers doing many shows can get the storycards preprinted with a frame for the sketch and basic information.

Once you've determined the basic purpose of the slide show, done the necessary research, developed ideas with colleagues and sponsors, and had the treatment approved, you can begin developing your storyboard.

If you've done your homework, you should be completely familiar with your subject and the people and locations involved. On your first card, jot down an appropriate couple of opening lines of narration. On the upper left side of the card, in a frame about 2 x 2 ³/₄ inches, sketch in what you want the first visual to be. Your sketches don't have to be artistic or even accurate; stick figures will do. Sketching will make you visualize each scene as a camera will photograph it and help you describe the scene more accurately.

When you've made your sketch, write a short description to go with it and arrange cards in order on the storyboard. Then, continue to write and sketch on each card, developing shots and narration into smoothly flowing sequences.

If you're producing an 80-slide show, you should end up with somewhere between 70 and 90 cards mounted on your storyboard, running from top left to bottom right.

*For additional information, write to Magna Visual Inc., 9400 Watson Rd., St. Louis, MO 63126

When the storyboard is complete, then edit the cards. Add to them, discard, rearrange, and rewrite until the storyboard resembles the audiovisual elements of your slide-tape show as closely as possible. Only then should the card numbers be inked in. (Don't forget to add these numbers—if the cards get mixed up, you may have difficulty in getting them back in the right order.)

When completed, each card will have

- a pencil sketch of the intended image;
- a brief written description of that image;
- a couple of lines of narration appropriate to the image, and a number to indicate its place in the sequence.

Professionals often add the name or title of the show and the job or production number. You can add a touch of class to your show by making copies of blank storycards with the client's name and production title on them.

The Advantages

Preparing a storyboard can help you visualize the slide show as a physical reality rather than just a collection of ideas on paper. This, in turn, will help you make sure each image fits with the ones that precede and follow it and all of the images fit with the script.

Because each idea and sketch is on a separate card, the cards can easily be shuffled, changed, or discarded.

- A storyboard helps outsiders such as clients and sponsors visualize the final show.
- A completed storyboard can be viewed and discussed by a group.
- A client-approved storyboard can be used to produce a simple show.
- A finalized set of cards can be used by a photographer as shooting instructions.

The Disadvantages

Planning and preparing a storyboard can be a lengthy process and the explicit instructions of a storyboard may inhibit you or another photographer from taking an even better shot. The photography required for some shows cannot be planned in advance.

Most professionals don't produce a storyboard unless they want client approval before planning complex and expensive graphics or special effects which have to be planned on paper to see if they'll work.

WRITING THE SCRIPT

If you've never done much writing before, the prospect of turning out an entire script may be quite terrifying. If so, relax. Writing is easy if you tackle the job in stages, and allow enough time. If you get a few others involved, the process might even turn out to be fun. Allowing yourself enough time is vital—there is nothing like a fast-approaching deadline to induce panic and an acute case of writer's block. Given ample time, you can limit your working sessions to an optimum 2 or 3 hours and spread the job over several days. Every producer adopts a slightly different

approach when writing a script. Some think first about content and the words that will be used to present each point. Others think first about the images and produce a series of sketches called a storyboard. Some producers even skip that step and start shooting the slides before they've developed anything.

If this is your first slide show and you have followed our advice and produced a "treatment" which includes an outline for your show, you'll probably find it easiest to develop the verbal part of your script first. Most people have had some previous experience writing letters and reports, so words usually come more easily than images.

We suggest that you take your outline, retype it leaving five or six blank lines between each major heading, add in as much relevant detail as you can under each heading, and then try turning the points you've listed into sentences. If you have trouble finding the right words, ask yourself, what am I trying to say? When you can answer that question in a simple sentence, write it down.

When you're finished, put your script away for a couple of days. When you work on it again, you'll be surprised how little effort it takes to improve it.

As you work on your narration, remember the audience will be hearing your words at a speed of approximately 125 words a minute and, as listeners, they will have no opportunity to ponder what you have to say, or go back over material they missed.

If you were writing for readers, you could rely on paragraphs and punctuation to organize your thoughts into easily understood segments. If you wanted to emphasize a word or a phrase or even a paragraph, you could underline the text or print it in a different type face.

The audience watching and listening to your slide show cannot rely on these aids to help them and, as a result, you have to adopt a totally new writing style—you have to write for the ear. That means short, easily-understood sentences. Avoid unusual words, technical terms, and jargon unless the subject demands them and you're sure every member of the audience will know what you're talking about.

When you're satisfied with your narration, record it and then play it back to hear how it sounds. This serves as a double check. If you can read the narration aloud with no difficulty, the narrator you use should be able to read it easily too. If the people you ask to listen to the tape understand it, chances are your audience will understand it as well.

Script Format

When you've prepared a satisfactory version of the narration, type up a script like the one in the illustration. The commentary goes on the right two-thirds of the page and the visuals on the left—it's easier to type this way. If you double- or triple-space the print, you'll have room for the revisions you'll want to make later as you edit the slides. If you photocopy the typed pages, you can cut and paste in the changes without retyping the whole script. A glue stick is easier to use than glue or tape, and if you have access to one, a word processor will make the whole scriptwriting process a lot more productive.

OFF-THE-JOB SAFETY

VISUAL	NARRATION
1. Watch It! CHARCOAL FIRE	MUSIC FADES UNDER AS NARRATION BEGINS
2. Person with charcoal grill	It was a hot Sunday afternoon and we decided to barbecue some steaks.
3. Two people talking	My son was in a rush to go out on a date and asked me to start the fire.
4. CU—Hands/electric fire starter	I plugged in the electric fire starter and slipped it under the charcoal.
5. CU—Charcoal/starter	Usually we wait 15 to 20 minutes for the fire to start.
6. Two people dressed in shorts and T-shirts	My neighbor came over and we started talking—it was a hot day; perfect for Bermuda shorts and no shoes or socks.
7. CU—Son at door	Then my son came to the door, asked how the fire was coming, and said that he was in a hurry and had to get going. I told him to shower and the fire would be ready.
8. LS—Father at charcoal	But when I looked, the charcoal didn't seem to be lit . . .
9. CU—Father picking up	. . . so I decided to hurry things up a bit. I got the gasoline can out and . . . I have to admit this was a real dumb thing to do.
10. CU—Pouring gas on	I've preached to my kids . . . never put gasoline on a fire—but, of course, I wasn't thinking, just hurrying, and holy mackerel . . .
11. MS—Gas explosion in grill	PHOOM! The whole thing exploded. There was fire under the charcoal after all. It shook me up so badly that I just threw the gas can and . . .
12. LS—Burning gas can and bushes and bushes	. . . hit a nearby evergreen, setting it on fire. Then the flames headed toward my garage.
13. LS—Man extinquishing fire	My neighbor came over and beat the flames with some burlap while I ran for the hose.
14. LS—Foot kicking gas can	The can was kicked into the driveway where it started . . .

(continued)

OFF-THE-JOB SAFETY (continued)

15. LS—Burning can with car in background

. . . spilling burning gasoline toward my cars parked a few feet away.

16. MS—Man kicking can

I ran to kick it away, but got gas on my leg, setting me on fire.

17. MS—Man sprinkling other man

My neighbor grabbed the hose and soaked my leg down good, but it was already badly burned.

18. LS—Burning bush and garage

Meanwhile, the flames crept up the garage and down the driveway, and we were all trying to put them out.

19. MS—Fireman at truck

Then, all of a sudden, the firemen arrived to douse the flames.

20. MS—Son putting ice on burned leg

My son got some ice cubes and wrapped them around my leg. About then I began feeling dizzy and went into shock. They told me later that I had second- and third-degree burns.

MUSIC UP SOFTLY

I recovered in 6 weeks and had to use crutches for 3 weeks. I had to learn the hard way that gasoline should never be used to start a fire. You never know when there might be an ignition source present.

MUSIC UP FOR ENDING.

DEVELOPING THE SHOOTING SCRIPT

Develop the visual side of the script the same way you developed the narration. Do the job in short, relaxed sessions, brainstorming until you have a list of all the images that might work. Then go back over the list and eliminate images that aren't technically feasible or that would be too troublesome to shoot (distant or difficult locations). There is no point asking for a shot of your client's product sitting on a mountain peak if you don't have the budget to hire a helicopter. The more locations you have, the more time and/or money the show will consume (see page 48). That's why we suggest novice producers begin with a production which takes place in no more than one or two locations. If you plan to hire a photographer, include as much visual description as possible. (The storycards will help the photographer a lot.) Try to bring in the photographer once you've prepared a draft of the shooting script. He or she may be able to help you think of suitable sequences, and perhaps suggest ways of improving the script. Although we suggest novice producers write their narration first before they consider the visuals to illustrate it, you could use the following model which explains how to develop narration and visuals at the same time.

Step One—Mentally picture the idea that you want to communicate. For example, let's say that you wanted to tell your audience that "doing more with less is an effective way to beat inflation."

Step Two—Imagine a sequence of visuals that illustrates your idea. The topic of our example—beating inflation—is abstract, and an effective audiovisual presentation should be concrete and specific. Therefore, you must select visual examples of "beating inflation" that the audience will easily understand. Your selection of scenes might include people growing and preserving their own food, sharing tools and transportation, making their own entertainment, and helping each other with household repairs and maintenance. Actual scenes will depend on the "script approach" that you use. (See pages 34–35.)

Step Three—Write a segment of narration—if needed—to emphasize the visual idea expressed on the screen. With our example, it might not be necessary to add words. The visuals show pretty clearly how to "beat inflation". But maybe you want to emphasize a visual sequence by using a quote from a government official or someone who's succeeded on living on less.

Continue with this three-stage approach until you've prepared your script.

USING AV PROFESSIONALS

A slide-tape show can be produced entirely by one person, or it can involve the work of dozens. If you've never produced a slide show before and you don't have much time to get the job done and your organization expects a professional-quality production, then consider hiring some expert assistance. Budget permitting, you may decide to contract out the entire production. On the other hand, if you want to develop production skills yourself, you may prefer to hire professionals only for the more difficult aspects of production.

Just what you'll find difficult depends on your previous experience, but as a general rule those jobs that require the use of complex equipment are likely to be the most difficult.

If you've never shot a picture before and the images in your show have to be perfect, hire a professional photographer. If the show requires a powerfully written commentary, then hire a writer. You may want to turn over the production of illustrations and superimposed titles to an experienced professional. You could narrate the show yourself, but you'll get a much more polished sound if you hire an experienced announcer.

Even experienced producers don't usually process their own film or mix the final version of a sound track if there are companies nearby to handle these jobs for them.

Specialists on Call

When preparing any slide-tape production you will likely need the services of some form of specialist. To help you determine which aspects of production can be attempted by a novice and which require considerable training and experience, here's a list of all the major steps in a production and the rated difficulty of each one.

Reasonable for novices to attempt:

- Preproduction planning
- Research
- Budgeting
- Basic scriptwriting
- Production of simple illustrations and titles
- Slide editing
- Single-projector slide-tape programming

Require previous experience or guidance from someone with experience:

- Location photography
- Production of complex illustrations

Production of complicated pieces of art should be given to professionals for best results.

- Recording and editing of interviews used in preparing the sound track
- Narration
- Programming of two-projector shows

Require expensive equipment and/or considerable skill:

- Studio photography
- Production of optical titles, computer graphics

Rochester After Dark

- Studio recording
- Slide duplication
- Transfer to 16 mm film or video tape
- Programming multi-projector (three or more) shows
- Staging

Related experience may not be enough; hire people with previous slide-tape experience. Writing for print is not the same thing as writing for audiovisual production. Print photography is not the same as slide-show photography. Graphics artists, recording technicians, and radio announcers all require some additional information if they're going to work on a slide-tape production. Suggest they read the sections of this book that apply to the work they're going to do for you.

Develop a Pool of Reliable Talent

If you expect to hire a variety of audiovisual services, ask other producers whom they would recommend and try people out on small assignments. Then, if a rush job or a larger, more complex assignment develops, you'll have a list of qualified people you can call on.

When viewing samples of previous work, make sure most of it was done by the person you're interviewing. Ask for the names of several previous clients and phone them to see if the job was done smoothly, on time, and for the originally estimated budget. Remember, however, that delays and budget overruns could have been the fault of the client.

In other sections of this book we've provided guidelines to follow when hiring specific services.

1. Processing lab (page 62)
2. Photographer (page 57)
3. Graphics artist (see left)
4. Recording studio (page 125)
5. Narrator (page 126)
6. Programming (page 133)

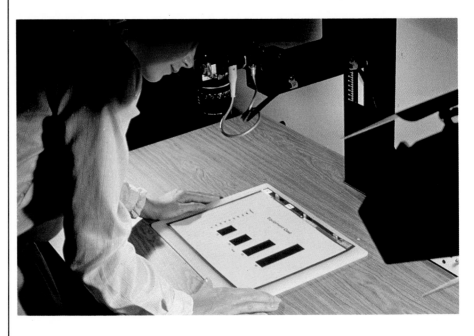

HIRING A PRODUCER

For many decision-makers and department heads, the question may not be, how do I produce a slide show, but whom do I get to do it? Some large communities have a selection of professional AV producers and a methodical search should soon put you in touch with just the right person or group to work with your company or organization.

Before you start looking outside of your organization for an AV producer, look around for possible candidates inside your own company first. Is there someone on staff who can be trained to become the company AV producer? An imaginative promotional writer, or possibly a good amateur photographer? There may be someone who is ready to develop their skills by taking AV production courses and assuming responsibility for company AV productions. With an in-house AV producer, you'll have greater control over the programs that you want to present. For those occasions when you may need to hire an outside producer, your in-house specialist will be able to select the right person and subsequently act as liaison and control on the commissioned project.

Should it become necessary for you to go outside for an AV producer, you should first identify the skills and talents you're looking for, know precisely the objectives of the assignment, and decide whom the producer will work with. Some producers may be expert in slide-tape presentations on industrial subjects, others may specialize in slick sales-oriented productions, while others may work exclusively on slide shows about social issues. It is most important that you choose the producer with the right qualifications for the job.

Begin at the Beginning

When you've hired your producer, start with a clean slate. Producers should not have to face unresolved problems or try to determine what your needs are—unless, of course, you've specifically hired a producer as a troubleshooter.

First, look for someone in-house that can be trained to become company AV producer . . .

Once the producer is signed up and ready to work with you, what is the best way of handling the working relationship?

Spell out your needs and objectives in as much detail as possible. Know the response you want to get from your audience and who the audience will be.

Who's in Charge?

Make sure that the producer know's who is in charge. Is it you, or is there someone else authorizing expenditures and giving approval? If there's a committee concerned about the script, it is your responsibility to let the producer know which criticisms and suggestions to be concerned with. It's your concern to make sure that your committee members don't turn into self-appointed executive producers, *all* telling the producer how to do the work.

. . . or look outside for a person with the necessary skills.

Pay attention to deadlines—they are something that you, as well as the producer, must respect. If you're 5 days late with treatment approval, your producer is going to have to catch up or start missing deadlines, too.

Where to Find Them

Many AV "companies" are actually just one person, usually with photographic and writing skills, and this person will bring in others such as a sound engineer or graphic artist as required. Usually you're looking for the proven skills of one person, and you have to consider the track record of individuals to determine if they're right for your job.

You will find producers by recommendation, at conventions, by checking the Yellow Pages under Audiovisual Producers, through trade magazines, and through professional AV organizations such as the Association for Multi-Image International, Inc., 8019 North Himes Ave., Suite 401, Tampa, FL 33614, and the International Communications Industries Association, 3150 Spring St, Fairfax, CA 22031. The latter will supply you with names of producers.

Check the Yellow Pages under Audio-Visual Production.

Writing a Contract

Once you've hired an individual or a production company, be prepared to do the advance planning necessary to make sure it is understood exactly what you want. Let them know how much you can afford to spend for a specific service and what deadline you expect them to meet. If the job is worth more than a few hundred dollars, draw up a contract that clearly specifies deadline, amount and terms of payment, duties to be performed, and cost of any materials which have to be purchased. The contract should also establish who holds the copyright for materials produced, who owns leftover materials, and what happens if you're dissatisfied with the quality of the work. Be aware, producers may not be working exclusively on your project; he/she may have several other assignments to complete for other clients.

If your producer is doing a show specifically concerned with your company's operations, make sure the appropriate departments are aware of the producer's assignment and that he/she has access to all areas of the operation.

There's nothing more frustrating for an AV producer or photographer than arriving at a location only to be told "no photographing allowed" by some supervisor or security guard.

Let the Producer Get on With It

Have confidence in your AV producer. AV producers don't want to be nagged by an anxious sponsor constantly fussing over the script, the photography, or the narration. If you really believe that your decisions are best, then you should be the producer.

WORKING WITH PROFESSIONALS

Whether you're working with audiovisual professionals who are already on your staff or hiring them from outside your organization, here are some tips which will make the job go much smoother:

- Work out your objectives in advance and put them and any other directions specified during the course of production in writing. Remember to keep copies for your own reference.

- Make sure the people who requested the production and those who expect to actually use it take part in the initial planning and have an opportunity to evaluate the production while it's still possible to make changes.

- Keep your approval committee to as few people as possible.

- Don't set unreasonable deadlines—chances are they won't be met and if they are, it may be at the expense of quality. Even an experienced production company will want several months to complete a complex production. If you rush the job through faster, you won't allow enough time for planning, evaluation, and changes while the production is in progress.

- Test a producer, photographer, or graphics artist on a small job before you commission an entire production worth thousands of dollars and your reputation.

- If you plan on hiring people on an hourly basis, find out what their minimum rate will be. Some professionals will charge you for a minimum number of hours whether you use the time or not.

PLANNING A PRODUCTION SCHEDULE

Look over your script and figure out where you'll get each shot specified in the script. If you intend to use stock slides, estimate how long it will take you to find these. If you're shooting original slides, count up all the locations you'll have to visit and estimate how much time you'll need to spend at each location. Then figure out how much time you'll need to prepare graphics, edit the slides, record the sound track, and program the show. When you have the answers to all these questions, develop a production schedule with dates for completing each activity to guide you and anyone else working on the show. See page 50 for a suggested production schedule form.

These are some factors which can increase the time required to complete a production:

- The organization has never had an audiovisual production prepared for it, and as a result the staff takes longer to agree on the objectives and content to be covered.

- People from the approval committee may be unavailable or out of town at points during production.

- Photography for the production requires specific weather or events.

- People being interviewed and photographed for the production are reluctant or even unwilling to participate.

- Program content is unfamiliar to the producer and therefore requires considerable time to research.

Make sure that you have accurate estimates for the amount of time each phase of production is going to require.

- Program content is extremely controversial and therefore requires extra time to make sure everyone agrees with choice of words and images.

- The production is designed to achieve complex or difficult objectives and therefore extra time is required to test the production with sample audiences and make changes if required.

- Photography requires the producer to research and photograph in a number of different locations.

Client Meetings

A simple, easily produced production will require a minimum of four or five meetings between a producer and the individual or committee responsible for planning and approving the production.

- Meetings 1 and 2 should be spent brainstorming and refining the objectives and content.

- Meeting 3 will be held to approve a draft of the script.

- Meeting 4 will take place after the slides have been roughly edited with the narration.

- Meeting 5 will be held when the completed production is premiered for the rest of the organization.

Each meeting should be limited to a maximum of 2 hours. Meetings that go on longer are rarely more productive. Allow people to express opinions but try to keep the meeting on track.

Try to keep criticism constructive. Encourage critics to suggest what they would like to see instead of simply expressing general negative feelings. Additional meetings may be held if the approval committee wants substantial changes in the content.

Research and Scriptwriting

Estimate at least 3 working days to research your subject if you're writing your first script. When research requires visits to other locations, add travel time. Estimate half a day minimum for each place you visit.

Once you've done the initial research and gathered together all the written and visual material you need, depending on the complexity of the subject, you might spend a total of 20 to 30 hours drafting the script. An experienced scriptwriter may estimate 2 hours to research and write each minute of the show; a 10-minute show requires 20 hours, etc. If possible limit your scriptwriting sessions to no more than 3 hours at a time. Figure on another two or three short sessions near the end of the production to revise and refine the final narration.

Preparing a Shot List

Even if you plan on shooting the show yourself, or you have a clear idea about what shots you want, you should still prepare a shot list that will identify those shots which have to be taken at each location. Prepare this by going through the script and listing the locations required for each shot. Then make another list of the locations, and write down all the shots which have to be taken at each one. Prepare several copies of this list for use during the shooting. If you have been specific with your shot description—medium shot, long shot, low angle, high angle—your shot list is easier to prepare and will be more helpful to your photographer.

Shooting on Location

Allow a half-day minimum for shooting in any location away from your office. It will take that long to pack up your gear, drive through traffic, search for a parking space, shoot, and get back again.

Plan your shooting for as few locations as possible. You have to pay for the time it takes personnel (photographer, director, models) to get from one location to another. It's hard to estimate exactly how long it will take to photograph at each location because it depends on the number of shots per location. Here are some factors which may slow things down:

- You need time to survey each location and confirm your arrangements with those in charge.
- It takes time to set up and put away camera gear and travel between locations.
- Allow extra time to relax between locations if you will be shooting under difficult conditions— extreme heat, cold, etc.

If you're planning a shooting schedule which will last several weeks, schedule a half-day break every 4 or 5 days. This is particularly important if the locations require extensive travel. Getting on and off planes and driving a car through unfamiliar streets can be even more tiring than working.

Allow time for reshooting. Figure on redoing 10% of your shooting (20% to 50% if you're an inexperienced photographer or working with unpredictable conditions, that is, documentary-style shooting). For every 10 days of shooting, allow an extra day or two for reshooting. Don't forget to allow for the time it takes to buy film, take it in for processing, and pick it up.

How Much Time per Scene?

Even when you're shooting on home ground or have your work confined to a few locations, allow 30 minutes for each separate scene in the show, even if each only requires one or two shots. Increase the time per scene if

- you're a novice photographer and producer;
- your subjects are NOT professional models or actors;
- your subjects are reluctant to pose;
- lighting conditions are poor and you have to use a tripod or extra lighting;
- you're shooting in an unfamiliar part of town or another community, and need extra time for finding your way;
- you're not entirely sure what you want and have to survey the location in order to plan the shots.

If you're taking pictures of a hard-to-recreate event, allow extra time for planning each shot and/or shooting extra shots at different exposures to guarantee results (bracket exposures). In case there's more than one person in the shot, you'll also have to shoot extra pictures. When you photograph three people, expect that only one shot in three turns out (with 10 people, only 1 shot in 10).

Advance Planning Saves Time

Don't push yourself or your photographer too hard or you'll get poor results. You can save time and reduce your shooting schedule if you

- prepare a detailed shot list or storyboard which provides clear direction for each shot;
- shoot according to location, not in the order in which shots appear in the script;
- shoot in familiar locations;
- use models (professional or otherwise) so you don't have to spend time persuading people to pose and getting them to sign release forms;
- obtain permission to photograph a location in advance so you don't have to spend time making arrangements while you're shooting;
- provide the photographer with a camera assistant who can drive the car, load film, carry equipment, check the shot list, run errands, and make travel arrangements.

Editing

Editing time is one of hardest aspects of production to estimate. If you've shot to match a detailed storyboard and all your shots turned out as planned, you may spend barely a day on editing. If your show is made up entirely from drawn-to-order graphics, you may be able to put the show together in even less time. On the other hand, if you have to search through 15 different slide collections located all over the country and wait for duplicates to be prepared, you could spend more than a month editing.

Preparing and Photographing Graphics

The amount of time that you schedule for graphics generally depends upon the number of graphics in the show and complexity of each one. Simple titles and drawings will take much less time to prepare than multicolored illustrations.

It should take approximately 1 to 2 days to prepare and photograph the half-dozen titles and illustrations required for most productions. If the titles have to be "burned-in" to other background slides, allow another half day or a day for this additional process. Budget in more time if you require complicated special effects.

Sound Track

When possible, use a trained announcer. The time required for recording the final narration will vary. A short show should only take an hour or two at the most if you use a professional and work in a recording studio. If your narrator only makes a few mistakes and you have sound effects and music chosen and ready to mix with the narration, you might be able to produce the final sound track in less than a day.

Music

If you plan to use a number of different pieces of music and you're choosing them from library discs, figure on a half day to a full day to make your selection and dub the segments.

Programming

Once you have your sound track dubbed onto a cassette, it shouldn't take you more than an hour or two to dub in the synchronizing signals for a single-screen show. If you have to borrow or rent equipment, allow for traveling time.

Distribution

Once you've prepared your master set of slides and synchronized sound track, you'll have to allow time to prepare the copies— number the slides, load them into trays, label the boxes, and package them with detailed directions. If you have to produce study guides and print materials, allow another few days. It's generally a very good idea to field test your playback directions. Have an inexperienced operator try to set up and run the show using only the directions. If it can't be done, you may have to revise the instructions.

Evaluation

Additional time will be required for pilot-testing the show with sample audiences. Estimate at least a half day for each screening. Your show may only take 10 minutes but you'll need another 2 or 3 hours for traveling, setting up the equipment, and discussing the show with the audience.

How to Save Time

The best way to speed up a production is to hire a highly experienced production company and give them a budget large enough to put several researchers and photographers to work on the job. However, don't try to speed production up too much unless you're shooting a very simple and straightforward show. Good slide shows take time for reflection and this process doesn't usually work when it's rushed.

Remember to keep your approval committee down to no more than a half-dozen people. The fewer the better, because each person on the committee is likely to ask for something different. If you have six people to please, expect that you'll be asked to make at least that many changes every time you meet with them.

If your organization has never produced a slide show before, allow additional time for people to decide what they want. As producer, you may have to tear the show apart and revise it two or three times before the people who commissioned the production figure out what it is they really want.

Once you've added up all the time you expect to spend on your production, increase your estimate by 10% if you're experienced, and 20% to 30% if you have never produced a slide show before. Even pros need a 10% contingency to allow for traffic jams, equipment breakdown, strikes, illness, and small details that don't go as planned.

As you work on your production, keep track of the time you spend on each job. When you've finished the production, compare your estimated schedule to the time you actually spent. You'll learn a lot from the comparison.

PRODUCTION SCHEDULE FORM

	Due Date	Time Est	Time Spent
PLANNING			
Analyze Requirements and Resources			
Develop Proposal			
Approval Meeting			
Research			
Select Production Style and Playback Equipment			
Develop Treatment			
Approval Meeting			
Draft Script			
Prepare Storyboard (optional)			
Approval Meeting			
Schedule Production			
Develop Final Budget			
PRODUCTION			
Shoot Slides			
Edit Slides			
Prepare and Photograph Illustrations and Titles			
Assemble Slides and Narration			
Approval Meeting			
Reshoot Slides and Revise Narration			
Record Narration			
Select Music and Sound Effects			
Mix Music Narration and Sound Effects			
Synchronize Slides and Sound Track			
Approval Meeting			
DISTRIBUTION			
Pilot Test Show			
Prepare Copies of Production			
Prepare Discussion Guide or Handouts			
Arrange Distribution			

PREPARING A DETAILED BUDGET

By the time you've worked out the production schedule, you should know exactly how much time you and everyone else working on the production will spend and what other expenses you'll have to pay. By listing all expenses on paper, you'll have a guide to prevent you from spending more than you can afford.

To help you develop accurate budget estimates, we've listed all the major categories and indicated the factors that will affect the dollar amount you'll need to budget for each of them. Remember, however, this section just contains guidelines. Don't attempt to estimate a real budget until you've read through the entire book and understand all of the steps involved in completing a slide show.

Time Is Everything

Labor is always the most expensive item in a budget. It takes a great deal of time to plan a production, write a script, shoot the slides, and assemble the show. Remember you're really buying ideas, not simply physical objects. Expect to pay for thinking.

When estimating the time required to complete the production, don't forget to include such items as the time it may take you to travel to and from locations outside of your office. Also include such items as the time you spend attending meetings, buying film and supplies, taking film in for processing, picking it up, and running dozens of other errands that can add up to a substantial number of hours. To help you estimate time requirements accurately, see the section titled "Plan a Production Schedule" on page 47.

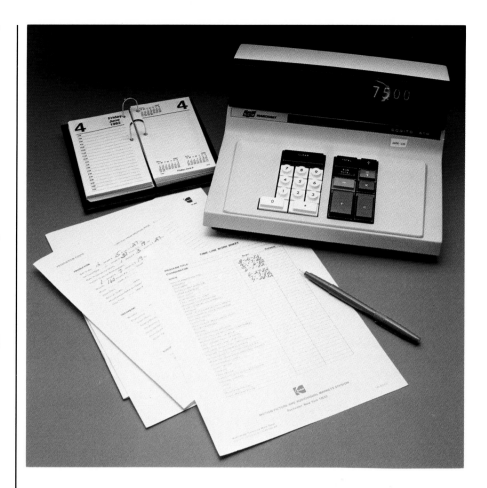

Then when you think that you have an accurate estimate for each aspect of the production, add a contingency allowance of another 20% or 30% to cover jobs you'll have to do over because of changes or possible errors. As you gain experience, this margin of error should be reduced to approximately 10%.

Film and Processing

After labor, the cost of film and processing is usually the next largest item in the budget. How much you'll spend on film and processing depends on the *type of production style you choose*. Whatever you do, don't scrimp on film. The cost of a few extra rolls is nothing compared to the cost of reshooting an entire scene because you didn't get adequate coverage of the subject. If you expect to shoot some or all your material in low light, budget for the additional cost of "pushing" the film during processing or renting lighting equipment.

Production Style

Scripted Production: This type of show can usually be planned in advance. The shooting ratio (slides shot versus slides used in the final production) can be as low as 3:1 or 4:1. Advance planning will also keep editing time to a minimum.

Documentary or Photojournalistic Style: This kind of show captures the action as it's happening and as a result very little planning can be done in advance. Shooting ratio for this style can run as high as 20 or even 30:1. This high shooting ratio considerably increases the amount of film used as well as the time required to shoot and edit the production.

Illustrated Style: This type of show is produced entirely from illustrations. While the shooting ratio can be as low as 1:1, the cost of preparing the illustrations may be very high.

Stock Slides

Although we don't recommend that you use existing slides or commercially available stock slides, because they sometimes make it difficult to develop a show with visual continuity, you may have no other choice. Remember to order duplicates if you plan to produce more than one copy of your show.

Models

Even if the people who pose for your production are friends or staff working for your organization, you should still pay them an honorarium if your shooting requires more than a few minutes of their time. If you hire professional models, the agency will tell you how much you'll pay on an hourly or daily rate. In any case, get a signed release.

Illustration and Title Slides

If you plan to produce these yourself, the only expense you'll have to pay is the cost of materials. When you hire an illustrator and the drawings you want are complicated and require the artist to spend time researching the subject, you could end up paying $100 or more per drawing.

Equipment Rental

Here is a list of equipment you may have to rent during the course of production. You can figure out an approximate cost for each one by estimating how long you'll require the equipment.

- Camera, lenses, lights
- Tape recorder and microphones for sound recording
- Projectors
- Copy stand
- Slide-tape recorder

Sound Track

If you plan to use a recording studio, the staff will tell you how much you'll pay per hour for the studio and the recording technician. If you use music from collections specially prepared for audiovisual producers, you'll only have to pay a few dollars for each cut you use. The company whose records you use can tell you how much per cut. The addition of a number of sound effects and pieces of music to your sound track can be time-consuming and therefore quite expensive. If you hire a professional narrator, as we suggest, include that fee in the budget as well.

Distribution Expenses

Budget for at least one duplicate set of slides so you can lock up your originals in a safe place. If you plan to produce study guides or other handouts, include the cost of developing and printing these. If you have to ship the production long distances, include the cost of extra packaging and postage or freight costs. You may have to pay someone to distribute and maintain the copies and playback equipment and pay someone else to actually present the show. For details about distribution requirements, see page 138.

Factors Which Could Decrease Your Total Budget

Ample Time—Plan sufficient time to complete the production. Rush jobs can add 30% to 50% more to your budget.

Minimum Number of Locations—Keep the number of locations down and you'll save on travel time and mileage costs.

Bulk Purchases—Some laboratories provide a discount when you buy film in large quantities and process a number of rolls at the same time.

EXPENSE FORM ESTIMATE

I. LABOR	$ COST
Content Expert	
Researcher	
Writer	
Director	
Photographer	
Camera Assistant	
Models	
Graphic Artist	
Copy Camera Photographer	
Technician for Recording Location Sound	
Sound Studio Engineer	
Narrator	
Music Consultant	
Evaluator	
Distributor	
Presenter	
TOTAL	

2. PRODUCTION EQUIPMENT	
Camera, Lenses, Lights, Other Accessories	
Recording Equipment and Microphones	
Editing Equipment—Light Table, Viewer, etc	
Projector(s)	
Tape Recorder with Programming Capability	
Dissolve Control	
Projection Screen	
Copy Stand	
TOTAL	

3. MATERIALS	
Film	
Processing	
Stock Slides	
Car Rental/Mileage	
Travel—	
Transportation	
Accommodations	
Per Diem for Food, etc	
Long-Distance Telephone Calls	
Typing	
Photocopying	
Record Library Fees	
Preparation of Copies	
Preparation of Handouts and Study Guides	
Postage/Shipping Costs	
TOTAL	

You may not require all of these categories when you estimate your first budget, but we have included them for future productions.

Common Mistakes Made in Budgeting

- Failed to check with suppliers to make sure the price quoted included all current and possible charges.
- Did not budget for the cost of extra copies asked for by others.
- Did not budget for the cost of distribution.
- Failed to budget for model fees.
- Did not include a contingency for unforeseen problems.
- Did not include cost (10%–15%) for revisions to the show.

Chemical Bank Vice President James H. Hillestad, Director of Creative Services (right), reviews a series of slides with the group's designer/illustrator Kurt Busch. (Courtesy: Chemical Bank)

BANK MARKETING

Chemical's Creative Group Markets with "Sight and Sound."

Banks are offering new financial services every day—automated teller machines, computerized cash management, and telephone home banking are examples. These new, often complex services present an exciting marketing challenge—how to communicate tremendous amounts of information in an easy-to-absorb format.

To meet this challenge, Chemical Bank established the Creative Services group in 1977. Functioning as an in-house sales promotion agency, the group consists of writers, graphic artists, typesetters, audiovisual specialists, and photographers. Our mandate is to communicate information about new marketing programs to our worldwide staff quickly and effectively.

One of Creative Services first jobs was to establish a vehicle for communicating. Should we use video tape? Teleconferencing? Filmstrip? 8 mm film cartridges? Or slide-tape programs?

We chose slide-tape, for four reasons: We could master slide-tape production skills quickly; we could produce and distribute information to audiences worldwide in a common, easy-to-use, cost-effective format; we could update presentations quickly at nominal cost; and the slide-tape format gives the advantages of both sight and sound.

It proved to be a good decision. Today our audiovisual programs are used worldwide to inform and motivate employee audiences as well as to support sales efforts. And we are often called on to produce slide-tape programs for not-for-profit groups as a public service. These programs are used in fund raising and provide a vehicle for bringing "the problem" to the doorstep of potential donor.

The audiovisual presentations we produce are played on slide-tape machines which we refer to as "black boxes." Chemical now has a network of 40 black boxes located in strategic offices. For branch offices where full-time hardware is not needed, moving a black box from one location to another is a one-person, one-trip move. It's flexible, too, because presentations can be seen by very large audiences, or thanks to the built-in screen, by a handful of people in a fully lit room.

Cost Advantages of Format

Both sound-slide equipment and software are inexpensive compared to video tape. A *KODAK EKTAGRAPHIC* AudioViewer/Projector (black box) costs about $650; an industrial quality television monitor and video-tape player cost about $1,800. So for hardware alone, there's a difference of $1,150 per location.

Then there's software. If you produce first-quality video in-house, you will be taking on a capital investment in excess of $100,000. In addition, you will need a studio, experienced technicians, and duplicating equipment. Or, if you have to go outside for video

production, you'll spend between $2,000 and $3,000 a running minute.

Sound-slide presentations are considerably less expensive. By producing in-house, we figure each original slide costs $10, and each duplicate costs less than a dollar. A 15-minute, 40-slide presentation costs between $400 and $1,000, depending on the complexity of the artwork and photography. Duplication of each presentation, including the cost of the audio-tape, is $45, or $1,800 for 40 sets of the same presentation. That gives you an original and 40 "dupes" for about $3,000.

A comparable length video tape, professionally produced, would run $30,000—just for the original.

And updating video presentations is expensive. You have to reshoot and repeat the entire postproduction cycle. In the sound-slide format, on the other hand, all you have to do is substitute updated slides and rerecord the audio-tape. The tape is "pulsed" to each slide so the entire presentation is automatically synchronized.

The 35 mm slide format has another advantage. It's an industry standard, the first step is to find a responsible manager, a person with managerial and creative skills and a basic aptitude for marketing.

Depending on your resources and requirements, you will want at least one and perhaps two audiovisual specialists—people who know what works audiovisually and what doesn't, and who understand the mechancial aspects of producing slides. Universities and audiovisual production houses are good sources of talent, and finding these staff members is the manager's first task.

Next you have to decide who is going to write scripts. Whether you use staff writers, people from other departments, or free-lancers will depend on the size and nature of the task facing you. Keep in mind that a good "visual" writer knows that the fewer words used to deliver the message, the better.

Narration should be as professional sounding as possible. An amateurish sound tells your audience that you don't think the information is important. The chances are good that you'll find one or more persons in your company who can do a good job of narration.

As for designing the slides and creating the artwork, your work load will determine whether to do this in-house or outside. Chemical's Creative Services group produces approximately 2,000 slides a month. With that volume it's worthwhile to bring this work in-house.

Two last words of advice. First, keep your message simple. Good communication is clear, to the point, and doesn't need a lot of expensive fancy effects. Second, sell, don't tell! We're not in the business of producing audiovisual term papers. Our goal, and yours, is to motivate the audience to a desired course of action. Every word, every visual, every piece of music must be carefully selected with that end in mind.

Audiences have limited time and limited attention. It's up to us to make the most of it!

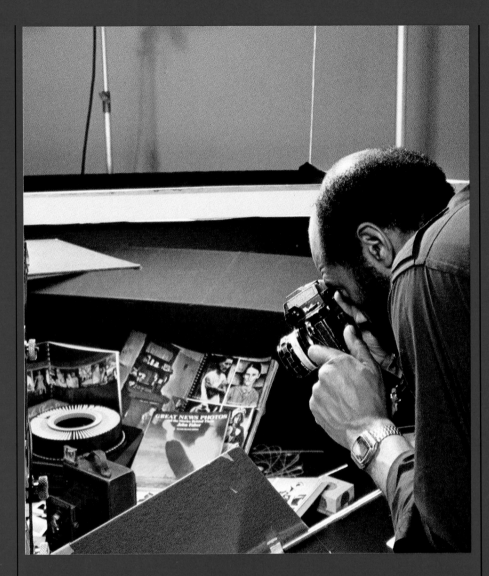

The images are frequently the weakest part of a slide show. Inexperienced producers often underestimate how much skill audiovisual photography requires. Because they took some good pictures on their last vacation, and everyone liked the snapshots of the office party, they assumed that they're fully qualified to undertake shooting for a slide show. They don't realize how much more demanding it is to shoot a complete set of slides that are properly exposed, composed, and fit well together to communicate.

Hiring a professional photographer is no guarantee of good audiovisual photography. Some professionals are *print* photographers, and unless they take some time to understand the differences between audiovisual and print photography, the producers who hire them end up with boxes of slides that they can't easily edit into smooth visual sequences and that usually don't show what is important.

This chapter is designed to outline the requirements of good audiovisual photography. If you're already familiar with the operation of a 35 mm reflex camera, this section will show you additional techniques required for shooting a slide show. If you don't have the experience, we suggest that you rely on books like *The Joy of Photography, More Joy of Photography, KODAK Films* and *How to Take Good Pictures* by Eastman Kodak Company to explain the basic material not covered here. If you plan to have someone shoot the slides for you, use the first section of this chapter to help you select the right photographer and the last section to guide you in planning the shots.

SELECTING THE RIGHT PHOTOGRAPHER

If you're not an experienced photographer, you have a tight deadline, or you require a professional-quality production in a hurry, consider hiring a professional AV photographer. If you plan your show so it requires a minimum number of locations, and you can communicate your requirements clearly, it shouldn't take an experienced audiovisual photographer more than a few days to shoot the slides.

On the other hand, if you have the equipment and enough time to learn from your mistakes, consider shooting the show yourself. You'll understand the requirements of audiovisual photography much better after you've done some shooting yourself. As with all other aspects of production, the more you know, the better your shows will be. Even if you plan to leave some aspects of the production to others, you'll produce much better shows by becoming familiar with all aspects of production.

Qualifications for Hiring an AV Photographer

When making the decision to shoot the show yourself or to hire a professional, here are some important points to consider:

Experienced audiovisual photographers who meet your individual requirements may be hard to find. Skilled in studio work and the technical requirements of print photography, most professional photographers have not had experience working on audiovisual productions.

Studio photographer.

Print photographers usually concentrate on the single image—a very different product from the sequential shots required for slide shows. They also have much more latitude with their images than slide photographers. If they over- or underexpose a shot, the problem can be corrected when the negative is printed. If they don't like the way they've framed a subject, they can "crop" the print (eliminate unwanted detail).

Slide photographers don't have nearly as much room to maneuver. While there's nothing to stop a slide photographer from shooting vertical shots, most producers restrict shooting to horizontals. It takes a lot of imagination to create good horizontal compositions continually. Slide photographers also have to be much more careful with their exposures. Although a slightly underexposed slide can be lightened up when it's duplicated, an overexposed shot usually has to be discarded. Slides can't be cropped and reframed to nearly the same extent possible with prints, and most important of all, slides have to be shot so that they can be used in well-coordinated sequences.

When making the switch to audiovisual photography, print photographers need to be aware of these differences between prints and slides.

Since most slide shows are shot on location, AV photographers have to be prepared to work in less than ideal circumstances. Lighting is often poor, and because subjects usually don't have much practice posing for pictures, they can be very difficult to photograph. To make the job even more difficult, sequences usually have to be composed on the run with no time to set up additional lighting, check exposures, or carefully frame each shot.

For all these reasons, a photographer who's always worked in a studio with trained models and cooperative subjects may not be a very good choice unless all the shots in your show are going to be staged and you need someone skilled with photographic lighting.

Of the many professional photographers on the market, a *photojournalist* may be a satisfactory choice since he or she will be used to working fast under difficult conditions. But like other print photographers, a photojournalist may have had little experience shooting color slides, may find it hard to visualize subjects in sequences, and may find it difficult to work without the opportunity to improve the shots back in the darkroom.

Someone with *motion picture* and *video* experience may turn out to be an even better choice than a

Photojournalist.

photojournalist. They're used to composing their shots in the camera, and they know how to shoot sequences which someone else has to edit together. Many of them also have experience setting up additional lighting. If they can make the transition required to shoot stills instead of motion, they may do the best job of all provided you can't find an experienced audiovisual photographer.

Motion picture photographer.

Here are some of the qualifications to look for when hiring an AV photographer:

- Owns and knows how to use a 35 mm camera, an assortment of standard lenses, filters, and additional lighting (if required)
- Experience shooting 35 mm color slides, indoors and out
- Experience shooting sequences
- Used to directing inexperienced subjects
- Experience shooting in a wide range of locations
- Easy-going and accustomed to working fast under pressure
- Available to reshoot material if required

Finding this paragon of excellence may not be easy. If you can't find or can't afford the services of a professional photographer, as a last resort you could use an experienced amateur who meets most of the previous criteria.

If you expect to hire audiovisual photographers on a regular basis, try out as many as you can. That way if you have to get a job done in a hurry, you'll have a file of reliable photographers from which to choose.

AV photographer.

Your Responsibilities to the Photographer

As producer, you're responsible for providing your photographer with adequate direction and assistance. It's up to you to provide the following:

- A shot list that identifies each visual required by location (see page 42)
- A detailed shooting schedule and directions for getting to any unfamiliar locations
- Proper approval if necessary for all locations and backup locations (in case a planned location doesn't work out)
- A letter of introduction which introduces the photographer and explains what the show is about
- A technical advisor, if required, to make sure that shots are realistic and accurate
- Any props that are required

It is generally good practice to involve the photographer in the development of the shooting script. However, if that's not possible, at least go over the script shot by shot to make sure you both agree with the plan. If you have any weak spots in the script, the photographer may be able to suggest a solution. Show the photographer a similar show and explain all you can about your audience and objectives. Make sure that your photographer knows you want horizontal shots only and understands about the cropping caused by TV cut-off if you plan to transfer your show to video. If you intend to use special masks, provide a set and explain how you expect to use them. Suggest to the photographer which film stock to use and possibly recommend the processing lab to use.

If you plan to shoot future shows yourself, hire photographers who are willing to share their knowledge. If the photographer is willing to use you as a camera assistant, you can learn a lot from the sidelines.

Using a Camera Assistant

Whether you serve as camera assistant or someone else performs that service for you, here are some of the useful jobs a camera assistant can do:

- Drive the car; make any travel arrangements required
- Carry and help set up equipment
- Load, unload, and label rolls of film
- Ensure that all subjects and props are in the right place at the right time
- Note all props used and clothing worn by subjects—in case some scenes have to be completed another day
- Pick up film and take it in for processing
- Be available to run errands
- Pass out and collect photo releases which have to be signed
- Cross off work done on the shot list
- Direct bystanders

SELECTING THE CAMERA FILM

If you've never produced a slide show before and you're not an experienced photographer, you may be overwhelmed when you realize how many different types of film there are to choose from. Kodak manufactures a wide variety of still films suitable for use in the production of your slide show.

Color or Black and White?

Color is always more effective than black and white for audiovisual presentations and is given preferential treatment in this description of how to produce slides. Also, color films provide the most convenient, quickest, and sometimes the least expensive way to make slides, even though the original material to be copied is not in color. The cost of 35 mm color film with standard processing and mounting, particularly in the case of slides, is usually less than black-and-white film.

Of the many types of film available, each has its own characteristics, not all of which are desirable for every application. A knowledge of these characteristics is recommended, since exposure and filter compensation sometimes can enable you to use films other than those normally specified for a particular situation.

Film Speed

The film speed indicates the relative sensitivity to light. The speed is expressed as an ISO speed number. The higher the speed, the more sensitive or faster the film; the lower the speed, the less sensitive or slower the film. A fast film requires less light for proper exposure than a slow film. As an example, a film with a speed of ISO 25 is slower—requires more light— than a faster film with a speed of ISO 100. To find the speed number for your film, look on the film carton, in the film instruction sheet, or on the film magazine. You set the ISO speed on exposure meters and on 35 mm cameras with built-in meters to obtain the correct exposure. Setting the ISO speed on an automatic camera programs the camera to automatically determine the proper exposure.

Color Reversal or Color Negative Films?

There are two types of color film to choose from, negative or reversal. Kodak reversal-type color films are designated by the suffix "chrome" in the product name, as in *KODAK EKTACHROME* Film and *KODACHROME* Film. The transparencies (slides) obtained from color reversal films are viewed on an illuminator or by projection. The slides can be duplicated by several methods.

Kodak color negative films are designated by the suffix "color" as in *KODAK VERICOLOR* and *KODACOLOR* Film. Negative color films yield color negatives from which positive pictures can be made in a variety of ways.

Although slides can be produced from negative film as well as from reversal film, most slide shows are produced with reversal film. For further information on which film or films best suit your needs, refer to the film characteristic table on the following page.

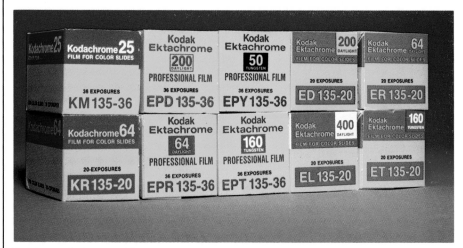

Kodak manufactures a wide variety of still films suitable for use in the production of your slide shows.

KODAK COLOR SLIDE FILMS

KODAK Film	Balanced For	Daylight Speed (ISO)	Daylight Filter	Electronic Flash Filter*	Photolamps (3400 K) Speed (ISO)	Photolamps (3400 K) Filter	Tungsten (3200 K) speed (ISO)	Tungsten (3200 K) Filter	Processing KODAK Chemicals
KODACHROME 25 (Daylight) (KM) (135-20 and 36 exp)	Daylight Electronic Flash	25	None	None	8	80B	6	80A	Processed by Kodak processing labs and by other photofinishers. Send to Kodak dealers or direct through mail with *KODAK* Processing Mailers (not for user processing).
KODACHROME 64 (Daylight) (KR) (135-20 and 36 exp)	Daylight Electronic Flash	64	None	None	20	80B	16	80A	
KODACHROME 40 Film 5070 (Type A) (135-36 exp only)	Photolamps (3400 K)	25	85	85 (ISO) 25	40	None	32	82A	
KODACHROME 25 Professional (Daylight) (PKM) (135-36 exp)	Daylight Electronic Flash	25	None	None	8	80B	6	80A	
KODACHROME 64 Professional (Daylight) (PKR) (135-36 exp)	Daylight Electronic Flash	64	None	None	20	80B	16	80A	
EKTACHROME 200 (Daylight) (ED) (135-20 and 36 exp)	Daylight Electronic Flash	200	None	None	64	80B	50	80A	By Kodak processing labs, other labs, or users. Send to Kodak through photo dealers or direct with *KODAK* Processing Mailers.
EKTACHROME 400 (Daylight) (EL) (120; 135-20 and 36 exp)	Daylight Electronic Flash	400	None	None	125	80B	100	80A	
EKTACHROME 160 (Tungsten) (ET) (135-20 and 36 exp)	Tungsten	100	85B	85B (ISO) 100	125	81A	160	None	
EKTACHROME 64 Film Press-Pac and **EKTACHROME 64** Professional (Daylight) (EPR) (120; 135-36 exp); 220 Also sheet sizes.	Daylight Electronic Flash	64	None	None	20	80B	16	80A	
EKTACHROME 200 Professional (Daylight) (EPD) (120; 135-36 exp)	Daylight Electronic Flash	200	None	None	64	80B	50	80A	
EKTACHROME 50 Professional (Tungsten) (EPY) (120; 135-36 exp)	3200 K Tungsten	32	85B	85B (ISO) 32	40	81A	50	None	
EKTACHROME 160 Professional (Tungsten) (EPT) (120; 135-36)	Tungsten	100	85B	85B (ISO) 100	125	81A	160	None	
EKTACHROME P800/1600 Professional Film† (EES) (135-36 exp)	Daylight Electronic Flash	800 1600	None None	None	250 500	80B	200 400	80A	

*With daylight balanced color slide film, no filter is usually required. However, if your electronic flash unit produces slides which are consistently too blue, use a *KODAK* Color Compensating Filter CC10Y or CC20Y.

†Requires push processing

Tungsten or Daylight Film?

On the surface this seems like a very simple question to answer—you use daylight film when the light source is the sun or electronic flash, and tungsten film when the light is coming from tungsten illumination. But what about fluorescent light? What if the light is coming from both sunlight and tungsten or fluorescent lighting?

As a rule audiovisual professionals use tungsten film when they're shooting with photolamps, and daylight film the rest of the time. Because ISO 400 daylight film is designed for shooting in low light, audiovisual photographers use it indoors even though the colors on the film will be affected by indoor lighting.

Professional or Amateur Films?

Kodak manufacturers both professional and amateur films. Your choice depends on your shooting requirements. The professional films produce a more accurate rendition of colors, but because they have to be refrigerated right up until the time they're exposed and then refrigerated again until they're processed, audiovisual photographers working on location usually prefer the "amateur" films that don't require refrigeration.

Should You Purchase Film in Rolls of 20 or 36 Exposures?

The price per image is slightly less if you buy film in rolls of 36 exposures, but you should have a selection of both lengths for those occasions when you'll want to change the film type or when you won't be able finish a 36-exposure roll before taking it in for processing.

Selecting a Processing Lab

As we've already explained, most producers find it easier to send their film to a commercial lab for processing. If you have several labs to choose from, here are some questions you ought to answer before you make your selection.

- How good is their reputation?—Ask professional producers which lab they recommend.

- How fast can they get the job done?—If you're shooting *EKTACHROME* Film you should be able to get the film processed the same day. Some labs may do the job in just a few hours.

- What kinds of financial arrangements can you make with the lab?—Will they allow you to set up a charge account? Will they give you a discount for processing large orders?

- Will the lab charge extra to date and number the slides? Although dates on the slides may not seem important now, if you use some of the slides in future as stock shots, you may want to know when they were shot. Numbers on the slides may help you when you're editing sequences together.

- What kind of mounts does the lab use?—Some plastic mounts allow the slides to slip sideways. As long as you get the master set of slides and the copies mounted in more secure mounts, these loose mounts shouldn't be much of a problem.

Handling Film on the Job

Buy a number of rolls of film at a time and you'll save unnecessary trips to purchase more film.

When you're out shooting, always carry more film than you plan to use. If you have film left over at the end of the day, you can always use it another time; if you run out of film on the job, you'll waste a lot of time getting some more.

Even if you expect to do all your shooting outdoors, carry some film suitable for shooting indoors just in case.

NOTE: For information on "Storage and Care of *KODAK* Films", see page 143.

SELECTING AND USING THE EQUIPMENT

Audiovisual photography requires specialized equipment. This section lists features to consider when selecting a camera, lenses, filters, and other basic accessories.

Cameras

Of all the production equipment you're likely to buy, a camera will probably be the most difficult item to choose. There's a tremendous variety on the market and the differences between one make and another are often more a matter of personal preference than anything else. If you've never used a camera before, we strongly recommend you rent or borrow one until you have enough experience to recognize the model you want. If that's not possible, then buy a fairly inexpensive model from a dealer who will agree, in writing, to give you a good trade-in price a few months later when you know what you want.

Cameras are sold in three main price brackets. The most expensive cameras are those designed for professional users. These cameras cost more because they're built to handle hundreds of rolls of film a year. The middle-priced cameras are designed for serious amateurs. They take just as good pictures as the professional models and many offer the same special features, but they're not quite as sturdy. The least expensive cameras on the market are designed for people who just want to point the camera and shoot.

We suggest you buy a camera from the middle-price range. Many of these models allow you to choose between manual and automatic metering. They're lightweight, easy to operate, and many of them take a wide range of lenses and other accessories. If you think you'll eventually use the camera enough to justify buying a professional-quality camera, then buy a brand that offers professional-quality camera bodies as well as less-expensive ones. Then if you buy a more expensive body, you'll be able to use the lenses and accessories you already own.

Most slide shows are shot with 35 mm cameras and the following criteria will help you narrow your choice down to a half-dozen different makes and models. Make your final selection by trying each camera. Most dealers will allow you to shoot a test roll or two in the store and outside on the street. In trying each camera, see how easily buttons operate when you have gloves on—an important feature in sub-zero weather. Make your final selection based on these criteria and your own particular needs:

- Reflex or rangefinder camera
- Price
- Through-the-lens light meter
- Manual or manual/automatic light meter
- Weight and size
- Range of lenses available
- Ease and speed of operation— changing lenses, focusing, available accessories
- Depth-of-field preview button
- Type of focusing screen and viewfinder display
- Repair service available

Lenses

Many of the 35 mm camera manufacturers offer an impressive array of accessory lenses that are interchangeable on their camera bodies. After you have learned to use the lens that your camera is equipped with and fully explored all of its potentials, you may find that you are ready to add an additional lens or two to increase your shooting versatility. These lenses may be a moderate wide-angle (28 or 35 mm), a short telephoto (85 mm), a moderate telephoto (180 or 200 mm) and possibly a macro lens (50 or 55 mm) for shooting close-ups and graphics. If your needs exceed this selection of lenses, other focal length lenses can always be rented for the occasion.

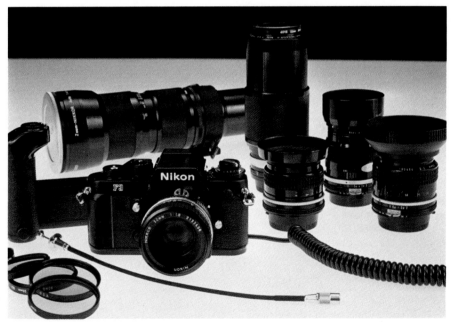

Learn to use the lens that is supplied with the camera.
Then, add additional lenses to increase your versatility.

Normal Lens—The normal lens, usually the one supplied with the camera, falls in a range of approximately 44 to 58 mm. This is the one that will probably be used for most of the shooting, primarily because it is designed to fill most of the average picture-taking requirements. Foreground, middle, and background elements photographed with a normal lens are reproduced with a perspective similar to that of a scene perceived by the human eye. One of the advantages that the normal lens has to offer is a large maximum aperture ($f/1.2$ or $f/1.4$) which means that photographs can be exposed in lower light than with other lenses.

Normal shot (50 mm lens).

Wide-Angle Lens—While the majority of scenes can be taken satisfactorily with a normal focal-length lens, certain scenes will require the use of a wide-angle lens. This is a lens of less-than-normal focal length, or approximately 28 to 35 mm for a 35 mm camera.

Wide-angle shots include more of the scene than the eye can concentrate on if you were standing next to the camera and viewing the scene. A wide-angle lens is especially useful when you want to include more in the scene than is possible with a normal lens and you can't move the camera away from the subject because of some physical restriction such as a wall or a body of water. The wide-angle lens is also excellent to use in your slide presentation for establishing a location.

You must be extra careful when using extreme wide-angle lenses because objects that are particularly close to the camera will appear changed in perspective and often appear distorted. This is because the camera is closer to the object being photographed than is proper for normal perspective. However, wide-angle shots have greater depth of field (range of sharp focus) than other types of shots, so that if you are very careful about the camera angle, you can photograph a scene with an element very prominent in the foreground and still have distant background objects in acceptably sharp focus.

Wide-angle shot (28 or 35 mm lens).

Telephoto Lens

A telephoto lens has a focal length that is longer than the focal length of the normal camera lens (70 or 90 mm, 105 or 135 mm, 180 or 200 mm). These lenses can be used to narrow or to concentrate the field of view without moving the camera closer to the subject. This type of shot is very useful when you want to increase the image size of the subject but cannot reduce the camera-to-subject distance.

A telephoto lens has less depth of field (range of sharp focus) than does a normal or wide-angle lens. Telephoto lenses should be focused very carefully, especially for close scenes. This limited depth of field can be used effectively to throw the background out of focus and in this way to help to put more visual emphasis on the subject of primary interest.

Telephoto shot (90 up to 200 mm lens).

Zoom Lenses

Photographers debate the advantages and disadvantages of zoom lenses, and as with any other lens, we suggest you rent one and use it for a week before you buy. These lenses offer several advantages. With one lens you get a range of different focal lengths (i.e., 35 mm to 85 mm or 80 mm to 200 mm). With two zoom lenses you can cover a range of 35 mm to 200 mm and you'll be able to use every possible focal length in between. You can also create special effects.

In terms of disadvantages, zoom lenses are heavier than fixed-focal-length lenses—which makes them harder to hold and focus—and substantially more expensive.

Macro Lens (50 or 100 mm).

Macro Lens

If you think you'll need close-up capability on a regular basis, or you want to photograph three-dimensional objects or flat artwork, consider investing in a macro lens. These lenses come in various focal lengths ranging from 55 to 200 mm, zoom, etc. These lenses function like other lenses of the same focal length, except they can be focused down to a much smaller area. Macro lenses are fairly slow. Their maximum aperture is $f/3.5$ or $f/2.8$.

Attaching a +1 close-up lens.

Close-Up Attachments

There are several different ways to take close-up pictures. If you plan to photograph flat artwork, you can turn a standard fixed-focal-length lens into a close-up lens by screwing additional +1-, +2-, +3-diopter lenses onto the front of your camera lens. You can also put a bellows attachment or extension tubes between the lens and body of the camera.

Shown below is information you'll want to use for taking close-up pictures. The left column shows different close-up lenses and lens combinations at various camera lens focus settings. The next column gives lens-to-subject distances for you to measure. The columns on the right give the field size (subject area) for the combinations shown at left. Just remember to measure the distance carefully from the front rim of your close-up lens to the subject. Aim the camera lens directly at the subject. Incidentally, close-up lenses require no exposure compensation.

Close-Up Lens Data

Close-up Lens and Focus Setting (in feet)		Lens-to-Subject Distance (in inches)	Approximate Field Size (in inches)	
			38–40 mm Lens on a 35 mm Camera	50 mm Lens on a 35 mm Camera
+1	Inf	39	23⅛ x 34½	18 x 27
	15	32¼	18⅞ x 28⅛	14⅝ x 21⅞
	6	25½	14⅝ x 21¾	11⅜ x 16⅞
	3½	20⅜	11½ x 17⅛	8⅞ x 13¼
+2	Inf	19½	11⅝ x 17¼	9 x 13½
	15	17¾	10⅜ x 15½	8 x 12
	6	15½	8⅞ x 13¼	6⅞ x 10¼
	3½	13⅜	7⅝ x 11⅜	5⅞ x 8¾
+3	Inf	13⅛	7¾ x 11½	6 x 9
	15	12¼	7⅛ x 10⅝	5½ x 8¼
	6	11⅛	6⅜ x 9½	5 x 7⅜
	3½	10	5⅝ x 8½	4¾ x 6½
+3 plus +1	Inf	9⅞	5¾ x 8⅝	4½ x 6¾
	15	9⅜	5½ x 8⅛	4¼ x 6⅜
	6	8⅝	5 x 7⅜	3⅞ x 5¾
	3½	8	4½ x 6¾	3½ x 5¼
+3 plus +2	Inf	7⅞	4⅝ x 6⅞	3⅞ x 5⅝
	15	7½	4⅜ x 6½	3⅜ x 5⅛
	6	7⅛	4⅛ x 6⅛	3⅛ x 4¾
	3½	6⅝	3¾ x 5⅝	2⅞ x 4⅜
+3 plus +3	Inf	6⅝	3⅞ x 5¾	3 x 4½
	15	6⅜	3¾ x 5½	2⅞ x 4¼
	6	6	3½ x 5⅛	2⅝ x 4
	3½	5⅝	3¼ x 4¾	2½ x 3¾

Filters for Color Photography

Ideally, the color film that you use in a given situation should always be balanced for the type of illumination available, but that's not always possible. The AV photographer will encounter many of these situations on shooting assignments and it is most important that the photographer be aware of the importance of using the proper filter to obtain the desired results. In this section, we'll cover some of the basic types of filters that are used to provide professional-quality results.

Daylight and artificial light differ from one another in spectral quality and are individually subject to considerable variation. Because it is not practical to supply color films that are balanced for every type of light, it has been necessary to standardize on films designed for use with the most common light sources (tungsten 3200 K and 3400 K and daylight 5500 K). When lighting conditions are encountered other than those specified for the particular film being used, correction filters can be used to adjust the color quality of the illumination to that for which the film is balanced.

Filters for use in front of a camera lens can be divided into three groups:

KODAK Color Compensating Filters (CC Filters)—change the overall color balance of photographic results obtained with color films, and also compensate for deficiencies in the quality of the light by which color films must sometimes be exposed.

KODAK Light Balancing Filters—change the color quality of the illumination so that you can obtain cooler (bluer) or warmer (yellower) color rendering.

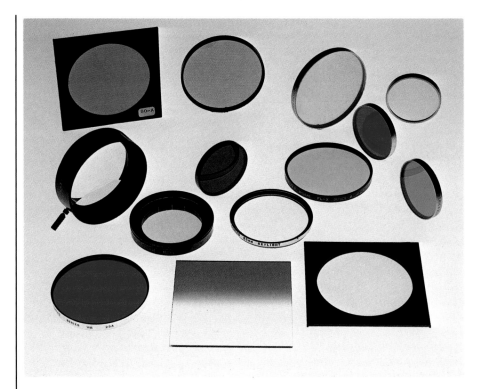

For example, high-speed *KODAK EKTACHROME* 400 Film is balanced for daylight, but many audiovisual photographers use it indoors because its high speed allows photography indoors without a flash. By adding the proper conversion filters over your camera lens, your slides will have the proper color balance.

KODAK Conversion Filters provide a significant change in the color-quality of various light sources, to match them to color films.

During the shooting of a production, you might find yourself in one of two situations. You might be outdoors on a sunny day with a half-exposed roll of tungsten-balanced film in your camera. Since unfiltered tungsten film produces a bluish image when exposed in daylight, you will need a No. 85B to correct this condition. It filters out the excess blues and strengthens the yellow-red hues. This filter should be used when shooting tungsten film with an electronic flash, since the flash has the same effect as daylight.

Photo taken in sunlight with *KODAK EKTACHROME* 160 Film (Tungsten) and a No. 85B Filter.

Photo taken in sunlight with *KODAK EKTACHROME* 160 Film (Tungsten) without the conversion filter. Note the bluish results.

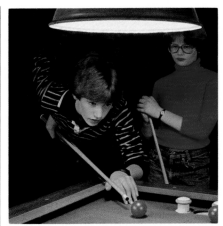

Tungsten illumination with daylight film and no conversion filter. Note the unnatural golden tone.

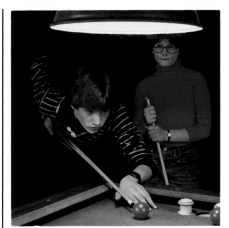

Add a blue-colored filter, No. 80A, for correct color balance.

The second situation is just the reverse—being caught indoors in tungsten light with daylight-balanced film. Without filters, the scene will appear unnaturally golden. The solution—a blue-colored filter, No. 80A, which absorbs some of the overly abundant yellows and reds and enhances the missing blues. This filter requires a two-stop increase in exposure. Therefore, if you anticipate shooting a roll of film half indoors and half outdoors, your best selection is a high-speed tungsten film ISO 160 that you can use unfiltered indoors where the light is low. Then when you go out in bright sunlight, the exposure increase required by the No. 85B filter, only two-thirds of a stop, shouldn't give you any trouble.

Table Instructions

Conversion filters change the color quality of a light source to match the quality of the light for which a color film is balanced. The table below shows which filter to use with various film and light combinations. The table also shows how much additional exposure to give for the filters listed.

Conversion Filters for *KODAK* Color Films

KODAK Color Films	Balanced for	Filter and *f*-Stop Change		
		Daylight	**Photolamp (3400 K)**	**Tungsten (3200 K)**
KODACOLOR VR-G 100	*Daylight, Blue Flash,or Electronic Flash*	*No Filter*	*No. 80B + 1²/₃ stops*	*No. 80A + 2 stops*
KODACOLOR VR 200, 400, 1000		No Filter	No. 80B + 1²/₃ stops	No. 80A + 2 stops
KODACHROME 25 (Daylight)		No Filter	No. 80B + 1²/₃ stops	No. 80A + 2 stops
KODACHROME 40-5070 (Type A)	Photolamps (3400 K)	No. 85 + ²/₃ stop	No Filter	No. 82A + ¹/₃ stop
KODACHROME 64 (Daylight) and *EKTACHROME* 64 (Daylight)	Daylight, Blue Flash or Electronic Flash	No Filter	No. 80B + 1²/₃ stops	No. 80A + 2 stops
EKTACHROME 200 (Daylight)		No Filter	No. 80B + 1²/₃ stops	No. 80A + 2 stops
EKTACHROME 400 (Daylight)		No Filter	No. 80B + 1²/₃ stops	No. 80A + 2 stops
EKTACHROME 160 (Tungsten)	Tungsten (3200 K)	No. 85B + ²/₃ stop	No. 81A + ¹/₃ stop	No Filter
EKTACHROME 100 (Daylight)	Daylight, Blue Flash or Electronic Flash	No Filter	No.80B + 1²/₃ stops	No. 80A + 2 stops
EKTACHROME P800/1600 Professional (Daylight)				

Note: Increase exposure by the amount shown in the table.

UV and Skylight Filters

The two most popular basic filters are the *colorless ultraviolet (UV) or haze filter* and the *faintly amber-tinted skylight filter.* Since neither of these filters affects the amount of light reaching the film, many photographers leave one of these filters on their camera lenses all the time because they protect the vulnerable coated surface of the camera lens. It's much less expensive to replace a scratched filter than it is to replace a scratched camera lens.

Daylight film, open shade, no filter.

Daylight film, open shade, No. 81A Filter.

The UV filter absorbs ultraviolet radiation—wavelengths shorter than the blue-violet end of the visible spectrum. Although we can't see ultraviolet radiation, the sun's rays are filled with it, and film records it along with visible light. Most often, it shows up in the background of distant shots as a bluish haze—much thicker than normal atmospheric haze—created by UV radiation reflecting off particles suspended in the atmosphere. When a UV filter is used to block out this ultraviolet radiation, the scene recorded on film looks more like the scene we actually see. The UV filter does *not*, as is often believed, permit you to penetrate visible haze. Because it is colorless, the UV filter makes an excellent base for certain special techniques, such as diffusion and vignetting.

The skylight filter also reduces the effects of ultraviolet radiation, but in addition, its slight amber tint reduces the bluishness of light in open shade and on overcast days. Unlike UV radiation, this coloration is actually visible as a bluish reflection on light-colored objects. We rarely notice this tint when simply looking at a scene, but a color photograph usually enhances it. In portraits expecially, it can make skin tones look slightly pallid. A skylight filter does not affect other colors noticeably.

Filter Factor

Filters generally require an exposure increase—a larger aperture or a slower shutter speed—because they reduce the light entering the camera lens. The change, although now frequently given in *f*-stops, is specified as a *filter factor*—a number that indicates the amount that you must increase your exposure. A filter factor of 2, for example, indicates that you must double the amount of light—the equivalent of one-stop change. A factor of 4 requires 4 times as much light—the same as a two-stop increase.

A through-the-lens exposure meter, or any other meter that reads light passing through the filter, may *not* give a correct reading when a colored filter is placed in front of the lens. Therefore, *before* attaching the filter, take a meter reading and adjust your *f*-stop to match the filter factor. For example, if your through-the-lens meter reads *f*/5.6 without the filter, and the filter factor is rated at 2, then you should open the aperture by one stop to *f*/4.

When you purchase a filter, make sure that it is the same size as the diameter (not the focal length) of your camera lens. You can also purchase adapter rings that allow you to attach filters of the same size to lenses of different sized diameters.

Polarizing Filters

For both black-and-white and color work, one of the most versatile aids you can own is a polarizing filter. Such a filter has multiple uses: It can reduce reflections, darken a blue sky, penetrate atmospheric haze, and add richness to colors.

Light reflected from nonmetallic surfaces, such as glass and water, becomes polarized—that is, it vibrates in only one plane. The polarizing filter, which rotates in its holder, is a screen with crystals aligned in parallel rows. As you turn the filter, it blocks light traveling in that plane. From the correct camera angle, this permits you to tone down the glare from water or to eliminate reflections in glass panes. To penetrate haze and darken the sky, the filter works by blocking the polarized light reflected by tiny particles in the air. Since this light is the source of the haze and of much of the sky's brightness, its elimination results in a deeper blue sky and diminished haze. The polarizing filter also enriches the color of many other

Daylight film without a polarizing screen.

Daylight film with a polarizing screen.

surfaces, ranging from foliage to skin, by eliminating reflections that lighten their tone. A polarizing screen usually has a filter factor of 2.5, which means you have to increase your exposure by $1\frac{1}{3}$ f-stops.

Neutral Density Filters

Neutral density (ND) filters are grayish filters that reduce the amount of light entering the lens. Since they do not change the hues or relative intensities of the colors in a scene, they can be used with any black-and-white or color film without altering the appearance of what you see. They are invaluable in situations that require you to reduce exposure. If you go on vacation and want to be able to shoot in varied conditions on the same roll of film, for example, you can put high-speed film in your camera and use it without filters for most lighting. When you want to shoot a very bright scene—a sunny beach, say—you can put on an ND filter and still use the high-speed film.

Neutral-density filters are also very useful for achieving certain special effects. If you want to use a large aperture, such as $f/2$, to blur out a background but find that you don't have a shutter speed that's fast enough, an ND filter will let you take the picture. Neutral-density filters can be used to prevent overexposure of the film during a time exposure. They also let you use slow shutter speeds to get blurred-motion photographs on bright days. As the chart on page 70 shows, ND filters are graded by their density, and the gradations translate into f-stop reductions. Using an ND 0.10 filter, for example, means you should increase your exposure setting by one-third stop.

The three handiest gradations of filters are 0.30, 0.60, and 0.90 as they represent full *f*-stops—1, 2, and 3, respectively. To increase the effect of neutral density filters, add two or more together. You can also use a polarizing filter as the equivalent of an ND 0.40 filter.

KODAK WRATTEN Neutral Density Filters, No. 96

Neutral Density	Filter Factor	Increase in Exposure (Stops)
0.1	1¼	⅓
0.2	1½	⅔
0.3	2	1
0.4	2½	1⅓
0.5	3	1⅔
0.6	4	2
0.7	5	2⅓
0.8	6	2⅔
0.9	8	3
1.0	10	3⅓

Color Correcting Filters

This table will help you determine the appropriate filters and exposure changes for different film and light-source combinations. As we already explained, make sure you remember to increase your exposure to match the decrease in light caused by the filter. A filter factor of 2 means you should double the exposure by one *f*-stop, *f*/5.6 to *f*/4.

For the other most common type of illumination, fluorescent lighting, color-conversion filters are helpful. Fluorescent tubes are too deficient in red to fit into the spectrum of colors for which film is balanced, and a strong addition of red and yellow is needed to make the image appear natural in tone.

The most widely used kind of fluorescent light, cool white, can usually be adjusted with two commonly available screw-in filters—FLD (fluorescent daylight) for daylight film and FLT or FLB (fluorescent tungsten) for tungsten film. Both filters require a one-stop increase in exposure. For other types of fluorescents you can use color compensating (CC) filters. These are made in graduated densities for the three primary colors—red, blue, and green—and for the three complementary colors—cyan, yellow, and magenta. Some suggested combinations for different kinds of fluorescent light are shown in the table below.

Color-compensating filters have many other purposes, related

EXPOSURE AND FILTER STARTING POINTS WITH FLUORESCENT LAMPS
Filter[a] and Exposure Adjustments[b] for *KODAK* Color Films

KODAK Films / Type of Lamp	Films With Daylight Balance[c]		Films With Tungsten Balance	
	Group 1	Group 2	Group 3	Group 4
	EKTACHROME 200, KODACHROME 25, VERICOLOR Commercial, Type S, KODAK VERICOLOR III Professional Film, Type S, KODACOLOR VR-G 100, KODACOLOR VR 200, 400, 1000, KODACOLOR II & 400	KODACHROME 64, EKTACHROME 400, EKTACHROME 64 Film Press-Pac and EKTACHROME 64 Professional, EKTACHROME P800/1600	EKTACHROME 160, EKTACHROME 50, EKTACHROME Professional 6118, VERICOLOR II Professional, Type L	KODACHROME 40, 5070, Type A
Daylight	40M + 40Y + 1 stop	50M + 50Y + 1⅓ stops	85B[d] + 40M + 30Y 1⅔ stops	85[e] + 40M + 40Y 1⅔ stops
White	20C + 30M + 1 stop	40M + ⅔ stop	60M + 50Y + 1⅔ stops	40M + 30Y + 1 stop
Warm White	40C + 40M + 1⅓ stops	20C + 40M + 1 stop	50M + 40Y + 1 stop	30M + 20Y + 1 stop
Warm White Deluxe	60C + 30M + 2 stops	60C + 30M + 2 stops	10M + 10Y + ⅔ stop	No Filter None
Cool White	30M + ⅔ stop	40M + 10Y + 1 stop	10R + 50M + 50Y + 1⅔ stops	50M + 50Y + 1⅓ stops
Cool White Deluxe	20C + 10M + ⅔ stop	20C + 10M + ⅔ stop	20M + 40Y + ⅔ stop	10M + 30Y + ⅔ stop
Unidentified[f]	10C + 20M + ⅔ stop	30M + ⅔ stop	50M + 50Y + 1 stop	40M + 40Y + ⅔ stop

Note:

a. *KODAK* Color Compensating Filter over the camera lens. Red or blue compensating filters have been recommended in some cases in order to limit the filters required to three.

b. Exposure increase required to compensate for filter.

c. Daylight films are divided into two groups for filter recommendations.

d. *KODAK WRATTEN* Gelatin Filter No. 85B.

e. *KODAK WRATTEN* Gelatin Filter No. 85.

f. Fluorescent lamps that are inaccessible or unmarked. Use of these filters may yield less than optimum correction.

For taking pictures under fluorescent
illumination without using a filter, best
results will be obtained with daylight film.
Although the pictures may be acceptable,
they may have an overall color cast
depending on the kind of lamps.
EKTACHROME 200 Film (Daylight) no filter.

For better rendition of color with subjects
illuminated by fluorescent light, use the
filters recommended in the table. With cool
white deluxe fluorescent lamps and
EKTACHROME 200 Film (Daylight) the
recommended filters are CC20C + CC10M.

either to correcting the color of light or to adding an overall hue to a scene. In using them, keep in mind that each additive primary color blocks the two other primaries—a red filter, for example, blocks blue and green. Each of the complementary colors blocks one of the primaries: A cyan filter blocks red, a magenta filter blocks green, and a yellow filter blocks blue. The extent to which they block the colors depends on their density, which is indicated by their number. Thus, a CC 30M (magenta) filter blocks 0.30 of the green in the scene. This filter might be useful if you are shooting through a green-tinted plate-glass window. A CC 30R, which blocks 0.30 of the blues and greens, may be helpful in underwater photography.

Motor Winder

If you plan to earn your living shooting slide shows, buy a camera that will accept a motor winder (even if you can't afford this accessory now). A camera with a motor winder mounted on a tripod permits you to shoot sequences of identically framed shots more exactly because you don't have to cock the camera shutter between shots. Some camera manufacturers also sell a higher speed motor drive, but unless you plan to shoot a lot of high-speed sequences, a motor winder is fast enough.

Tripod

Like the motor winder, a tripod is almost a necessity. If you put the camera on a tripod, you can shoot sequences without changing the framing. A tripod also allows you to shoot in much lower light, at much slower speeds than you could manage if you held the camera in your hands. Buy one that is sturdy, lightweight, and easy to set up and use. If possible get a quick-release head which allows you to put the camera on the tripod and remove it quickly.

Camera Bag

There are nearly as many bags on the market as models of cameras and the price range is just as varied. If you plan to do your shooting in public places, buy an inexpensive unmarked bag. An expensive camera maker's name on your bag just advertises the value of your equipment and promotes theft. The same problem occurs with aluminum camera cases. Unless you have to ship your equipment in the baggage compartment of a plane or you tend to drop things frequently, these expensive cases aren't necessary. They weigh more, and like the signature camera bags, they're an obvious invitation to be stolen. Many professional photographers prefer to adapt a flight bag or some other small piece of luggage.

Fanny Pack

This type of waist pack was developed by cross-country skiers who wanted a small pack they could open easily. These packs also make a great accessory bag when you're working fast and don't want the inconvenience of a shoulder bag.

Carve out a block of foam to hold a couple of lenses and you'll have room left for film, marking pens, and a small note book. If the pack is large enough, and your camera is small enough, you may have room for an extra camera body as well.

Cuban Hitch

This accessory allows you to distribute the weight of your camera evenly over both shoulders—a useful feature when you're shooting all day and you suffer from neck or upper back problems.

LIGHTING
Available Light Outdoors

Sunlight is great for plants and people who want a tan but professional photographers frequently find it a nuisance. Sunlight produces shade, and the combination of bright and dark areas in a slide means it won't duplicate very well.

If you can't wait until an overcast day to shoot an outdoor sequence, see if you can move the action into the shade, shoot tight close-ups, or use a reflecting board or fill-in flash (see page 74 for directions).

Backlit Subjects

Certain backgrounds cause exposure problems if you don't adjust your light meter. Even experienced photographers forget occasionally to adjust for a bright background behind a subject. Most light meters take an average reading of the whole scene, including the much brighter area behind the subject.

To correct for a bright background, open the lens another half stop or even another full stop (that is, if the meter reads $f/8$, then change it to $f/5.6$).

Increasing the lens aperture produces a properly exposed subject, but at the expense of the background exposure. Sometimes an overexposed background doesn't matter, but in some cases the effect is unpleasant.

If you don't want to sacrifice the background to expose a backlit subject properly, expose for the background and use a flash to illuminate the subject.

Backlit scene with an average meter reading.

For backlit scenes, make a close-up meter reading of the subject and set your camera manually for the correct exposure. Most meters record an average reading of the entire scene, including the bright area behind the subject.

Automatic Exposure Meters

One further word of caution: If your camera has an automatic exposure meter, you will have to put the meter on manual in order to compensate for a backlit subject or a bright background. If your camera doesn't have a manual setting, use the "backlight" button if your camera has one. This will open up the lens by a stop or more. If your automatic camera doesn't have a "backlight" button, read the instructions to see if there is some other way to achieve the same result. A strictly automatic camera is not a good choice for audiovisual photography.

Available Light Indoors

If you've never taken pictures before, you may not have noticed how many different colors of light illuminate our environment. Sunlight changes quite dramatically over the course of a day. You can see these differences in color with the naked eye, but they're more obvious on film.

Artificial light has an even more pronounced effect on film. Although fluorescent and tungsten lighting look relatively natural to the naked eye, if used to expose daylight film, the difference in color balance is quite substantial.

As we already explained (page 62) Kodak manufactures two types of reversal (slide) film. Daylight film is designed to be used with the light which comes from the sun or photographic flash. Tungsten film is balanced for use with the light cast by bright tungsten bulbs (3200 K or 3400 K)—the kind photographers use.

While these two films are suitable for many of our everyday environments, they won't do for all of them. Most offices, factories, schools, and public buildings are lit with some form of fluorescent light.

There are a variety of different ways to prevent a light source from changing the normal colors of a scene. Some are more complicated than others.

- If possible use film which is designed for the light source you're working with—daylight film with daylight or flash, tungsten film with tungsten light.
- If you have to use tungsten film in daylight or daylight film with tungsten, filter the lens with the correct color conversion filter.
- Fluorescent lighting will adversely affect both tungsten and daylight film. To maintain the correct color balance with fluorescent lighting, use color-correction filters. (See page 70.)

Tungsten film with available light—*EKTACHROME* 160 Film (Tungsten). Museum of Science and Industry, Chicago, IL.

- If putting a filter over the lens will reduce the exposure too much, accept the alteration in the colors. As we've illustrated, the effect of tungsten light on daylight film isn't too bad. The effect of fluorescent lighting is not as pleasant, but some producers are willing to accept the color shift. You can compensate somewhat for the greenish tones produced by fluorescent lighting by illusion. If you ask your subjects to wear bright strong colors, the greenish tones will not be so obvious.

- If you can't use color correction filters, but still want colors to appear as they do in real life, you can have the colors corrected at the time the slides are duplicated. Duplicate slides look as good as slides shot with color correction filters. The only drawback with this method is expense. Color corrected duplicates cost substantially more than duplicates produced without color correction.

- The light from flash or photographic flood lamps is strong enough to overpower fluorescent lighting in most situations. As we explain in more detail in the next section, the use of additional lighting requires considerable skill and creates a number of problems.

What the Professionals Do

Because audiovisual photographers often have to shoot in situations where light levels are so low they can't use color correction filters, and time constraints prevent them from using flash or photofloods, AND they want slides with accurate colors, they're willing to pay the cost of having colors corrected when the slides are duplicated.

Photographic Lighting

The use of photographic lighting requires considerable skill, adds extra time to the shooting schedule, and may inhibit subjects who are reluctant to have their picture taken. For these reasons most slide productions are shot with available light or electronic flash.

If this is your first show, if you haven't had much experience as a photographer, and if you have to use additional lighting, hire a professional photographer with the neccesary equipment and expertise. If you must do the job on your own, consult your local camera dealer about equipment, spend some time experimenting, and keep a careful log so you can learn from your mistakes.

If you're considering buying equipment, rent a variety of systems until you know what works best for your needs.

Ways to Work With Available Lighting

Because audiovisual photographers find the use of photographic lighting time-consuming and unpredictable, they've found other ways to make the most of minimal available light.

Fast Lenses—lenses with a maximum aperture of $f/2.8$ or larger allow photography at low light levels.

High-Speed Film—With an ISO rating of 400, high-speed *EKTACHROME* Film will produce an adequate exposure if there's enough light to be able to read comfortably. By using *EKTACHROME* P800/1600 Professional Film, you can shoot with even less light.

Tripod and Cable Release—The use of a tripod and cable release will allow you to shoot motionless people at speeds as slow as 1 second. Inanimate subjects can be photographed at even slower shutter speeds.

The combination of a fast lens, fast film, a tripod, a cable release, and motionless subjects means you can shoot indoors in fairly low light and still have an adequate depth of field.

Although audiovisual photographers work with available light, there are situations where the results will be worth the extra time and effort required to set up photographic lighting:

- Photographic lighting allows you to use slower film with finer resolution.

- If you plan to reproduce enlarged versions of some slides in a magazine, book, or other form of printed material, you'll get better results if you use a slower fine-grain film.

- Photographic lighting allows you to photograph with ample depth of field.

- Photographic lighting allows you to control the light.

Flash or Flood Lamps?

If you're considering multiple lighting, first decide whether you're going to use flash units or flood lamps. In the past photographers relied on flood lamps since flash units weren't as sophisticated as they are today. Whenever possible, they did their shooting in a studio where lights and accessories were easy to arrange.

Now, most professional photographers prefer to work with some kind of flash unit. Even under controlled studio conditions, flash units have their advantages over flood lamps.

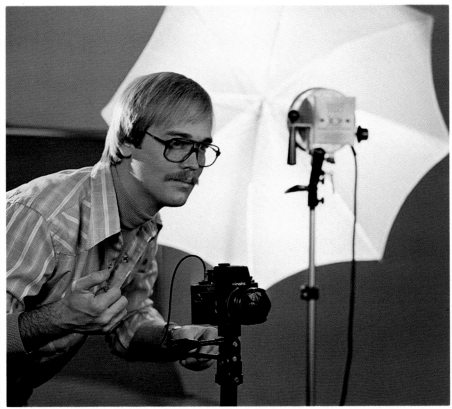
Most professional photographers prefer to work with an electronic flash unit because films are color balanced for these units and because they are more portable than flood lamps.

For location shooting, flash is clearly the better choice. Flood lamps require electrical power and convenient outlets aren't always available. Some buildings don't deliver consistent power levels so the color temperature of the lamps, and consequently the colors of the slides, may vary throughout the shooting session. Photolamps give off considerable heat and they can become uncomfortable to work under. On top of these drawbacks, the bulbs are fragile, expensive, and they may burn out at the wrong time.

Flash units solve many of these problems. Powered by batteries, flash units don't require electrical outlets and miles of extension cords. They provide so much illumination you can use daylight film, yet they don't give off any heat. As long as the batteries last, they'll put out the same intensity of light.

The main drawback with flash units is their cost. A sufficiently powerful and versatile flash unit is much more expensive than a flood-lamp stand and bulb. The other problem with flash is that it may not have a modeling light feature and it is difficult to judge the effect the lighting will have on your subject. Since the flash lasts only a fraction of a second, you can't see where the shadows are falling. To solve this last problem some professional photographers rely on an instant camera.

SLIDE-SHOW PHOTOGRAPHY

Most audiovisual producers would agree that it takes more effort to watch a slide show than a motion picture or video tape of equivalent length. If Marshall McLuhan, in his *Understanding Media*, had analyzed slide shows in relation to motion pictures, he might have noted that slide shows require more participation by the viewer. In a motion picture or video tape, the action of the camera and the subject's movements direct viewers' attention. With all the cues and clues given by the action, we quickly understand what's going on.

Because slides are still images, our eye must scan and search for the meaning of each image. If the meaning of a slide isn't immediately clear, it takes more effort to view the slide. If you don't want to put your audience through a straining experience, make it easier for them by clearly emphasizing the subject of each slide and eliminating any distracting elements. Light, focus, and color can all be used to make the subject of individual slides stand out.

Don't feel compelled to photograph things the way they are. If your subjects will look as realistic framed against one background as another, move them if you need better lighting or a less cluttered background. If you can't move the subject, don't hesitate to rearrange or remove elements from the background. If you can't physically reduce background clutter to make your subject stand out, reduce your depth of field.

Camera Angles

The term *camera angle* merely refers to the camera's view of the subject or its relation to the principal planes of the scene. Normally, the basic camera viewpoint should be from *eye level*. Variations are considered from this starting point.

How high or low should you position your camera to shoot a scene? The answer to that stems from another question. If a viewer were watching the actual scene, what would be the best vantage point? Would eye level be best? Or would it be better to look up or down at the action?

Eye-Level Shot

The camera is horizontal with reference to the ground. When long and medium objective shots are being photographed, the camera should usually be at a height of 5 to 5½ feet (1.5–1.7 m)—the height of the average unseen observer. Subjective eye-level shots should be made from the height of the person performing the action, whether the individual is standing, sitting, or on a ladder.

Eye-level shot.

Low-angle shot.

High-angle shot.

Low-Angle Shot

The camera is positioned below the point of primary interest and points upward. Low-angle shots tend to give strength and dominance, dramatizing the subject. Low shots will probably be used when dramatic impact is desired in pictures of massive machinery, church interiors, or football action. This angle shot is also useful for separating the subject from the background, for eliminating unwanted foreground and background, and for heightening the illusion of size, speed and depth.

High-Angle Shot

The camera is tilted downward at the subject. High-angle shots help orient the viewer because they show the relationship among all elements of the scene and can produce a psychological effect by minimizing the subject and its setting. High-angle establishing shots are useful if the scene has great depth, such as a jet liner discharging passengers or a fire engulfing a waterfront. High angles will help make the observer conscious of all the important elements.

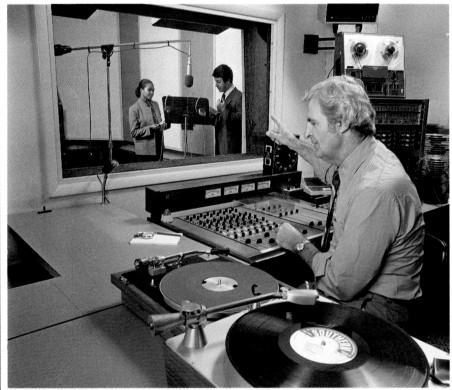
Objective medium shot.

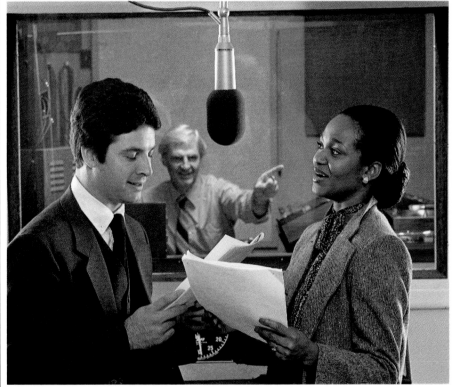
Objective close-up shot.

Audience Role

Before you put your ideas on film, a decision must be made on the role the audience will play. Will they watch from the sidelines as observers? Or will you give them the impression that they are participating? Which camera angles are best for your particular slide presentation?

Objective Shooting

Objective shooting shows the scene from a spectator's viewpoint—on an impersonal basis. The viewer is not brought into the scene; he or she views it from the outside. That is why camera angles for objective shooting provide an excellent way to show *what is happening*.

Subjective over-the-shoulder shot.

Subjective close-up shot.

Subjective Shooting

Subjective shooting brings the viewer into the activity. The camera lens assumes the eyes of the person performing. This camera angle is of special value in training presentations where small-scale hand operations are concerned, since the student sees the activity as he or she would perform it. The effect is usually achieved by shooting over the subject's shoulder to the hands and immediate surroundings.

Improving Your Composition

Pay attention to the professionally produced images around you. When you see something you like, find out what gives the picture its strength. Borrow photography books from the library and spend some time every day studying the images made by recognized photographers. You'll be amazed to discover how much you can learn just by looking. If you have time, consider clipping the good photographs from magazines or newspapers. A scrapbook of these can be a source of creative inspiration.

If you plan a shooting session, allow a few minutes for warm-up. Take a 10-minute walk around your office or neighborhood and pretend to shoot a roll or two of film. Try out each of the lenses you plan to use that day. To make your warm-up as realistic and effective as possible, click the shutter each time you compose an imaginary shot. You may feel foolish the first few times you try this, but after you realize how much film you save because you "warmed up," you'll make this a routine exercise.

To achieve good composition get into the habit of ALWAYS scanning around the frame of every shot just before you press down the shutter release. If you develop this habit, you'll be able to eliminate extraneous objects in the frame that detract from your subject.

The Importance of Visual Continuity

Along with emphasizing the subject of each slide, continuity is another important aspect of production that helps the viewer better understand your show.

Continuity is the word to describe the flow of events in a slide or motion picture film sequence. If each image in a slide sequence gives the viewer the impression that it flows out of the action and setting of previous images, then the sequence has continuity.

One of the easiest ways to understand continuity is to focus on a central character. If you follow the character duplicating the path traveled by your eyes, you should be able to achieve continuity quite easily. When shooting a sequence,

begin with an overall view or a *long shot*, then tighten to a medium view or a *medium shot*, then tighten to a *close-up* or even an *extreme close-up* of the action or scene. In order to make smooth transitions from one shot to the next, *change the camera angle slightly.* Move the camera up or down, to the side, or both.

With motion picture sequences, you would overlap the action of these scenes for smooth editing. In a slide sequence, it is not necessary to overlap action but to select only the most important highlights that reveal the essence of your message.

For example, let's say that you're shooting a sequence focusing on the opening of a new hospital in your community and the services that it has to offer. You could begin this sequence with a long shot of the new building (while the narration describes the facility). Your next shot might show a medium shot of a laboratory (while the narration continues with a description of the updated equipment). Next, you might use a tight shot of a technician at work and close with a medium shot of the director of the hospital.

No matter what the subject, your audience will follow your steps and fill in the gaps in this visual sequence—if you maintain continuity throughout the presentation.

You can reduce the number of gaps that the viewer must fill in by including additional shots of the computers, people working in the bank, etc. Also by varying these shots from wide to close-up, you'll have a number of alternative ways to edit the scenes together.

Your goal then is to consider both the length and detail involved in planning each sequence in the show. The length will represent the basic continuity—the action that will take a sequence from a logical beginning to a logical end. The detail represents the number of images that will give the sequence greater detail and meaning.

Another important aspect of maintaining good continuity is *screen direction.* This term is more often associated with motion picture filming but is important to slide filming as well. Screen direction is the direction of motion on the screen—the *direction of movement on the screen in relation to the camera.* If a subject is photographed moving into the scene from the left and the next shot shows the subject leaving to the right, confusion will result. For example, you might photograph a racing car going from left to right with one shot, and the next scene might be photographed from the opposite side of the track showing the car going from right to left. This is perfectly permissible if you place one or two shots between to show how you got there or why the action changed.

How to Photograph People

We've included a whole section on this aspect of photography because we know from years of experience it's not easy to photograph human subjects and produce slides which are properly exposed, composed, technically accurate, flattering to the subject, AND realistic. We also know it's even harder to achieve all these qualities AND a well coordinated sequence of shots.

Using Models Will Make Your Job Easier

Production will go much more smoothly if you use professional models. Professional photographers use models for several different reasons:

The subject matter requires models. Sometimes you can't photograph the people who would normally perform the activity featured in your show. For example, if you were producing a slide show designed to teach salesclerks how to spot shoplifters, it would be much easier to stage the thefts with models than wait around hoping to get shots of an actual crime.

Models are good-looking. Commercial photographers and producers frequently use models because they are sexier or more glamorous than the rest of the population.

It's easier. Unlike most people, professional models don't mind having their picture taken. They're used to working with a photographer and they understand how to follow direction. By using models, photographers don't have to waste time persuading ordinary citizens to pose for them and sign model releases.

Unfortunately professional models often don't look like ordinary people. Audiences may have a hard time accepting your message when it comes from people who are obviously being paid to endorse your point of view.

Some photographers get around this last problem by hiring actors. Like models, actors don't mind being photographed. They know how to follow directions from a photographer and unlike professional models, they can often pass for an ordinary citizen.

If you live in a large community, local talent agents can show you pictures of the models and actors they represent and help you select the people you need. In a community too small to support professional models or actors, you may be able to find the people you need in an amateur theatre group.

If you choose the right models and shoot carefully, the audience won't know you used posed models for the shots.

If you can't afford to hire professional actors or models, you may be able to persuade a friend or someone on your staff to pose. Here are some points to consider in selecting amateur models:

- Choose people who don't mind having their photograph taken and, if possible, would actually enjoy it. The more relaxed and easygoing the better. Amateur photographers often make great models because they understand what you're trying to do and why you have to reshoot again and again. They may even suggest some good shots.

- Explain how you plan to use the pictures. Show prospective models your script and make sure they agree with how you plan to use them. Explain what you want them to do and how long the job will take. Tell them you'll have to shoot some scenes a number of times.
- Give them something they'd value in return for their time and effort. If they won't take money, perhaps you can give them some prints.
- Make sure your models will be available if you have to reshoot a few shots.
- If you're not familiar with the activity you're photographing, make sure your subjects are. It may be necessary to bring along a technical expert. Tell your models that you're relying on them to make sure they're wearing the right clothes, safety equipment, and performing the activity correctly. You wouldn't want to reshoot a whole section of your show again because some people weren't wearing their hard hats.

Even if your "models" are already being paid by your organization, you should still consider paying them extra or giving them time off. Posing for pictures isn't part of their job and they probably won't enjoy the experience very much.

Whether you're photographing a professional model or an "amateur," these guidelines will make the job easier:

- When making arrangements with your models, make sure they know just where you expect to meet them, how long the job will take, what you want them to wear and do, and what props you expect them to bring.

- If you're going to shoot in a drab or monocolor environment, you might ask your models to wear something colorful which will make them stand out against the background.

- Plan the shooting as much as possible. Ask your subjects to go through the actions you want to photograph. See how they do without any direction, then plan your shots while observing these "dry runs." When you know what you want, direct your subjects to modify their movements as required.

- Explain what you want your models to do as clearly as possible. Do unto your subjects as you would have them do unto you. Be polite and patient. If your "models" have never posed before, allow extra time for a practice session, so they get some experience following your direction. Shoot a few rolls of imaginary film so your models get used to the sound of the camera shutter.

- If you want natural-looking pictures, photograph your subjects while they're moving. Make sure you have enough light so you can shoot with a shutter speed fast enough to freeze their movements without a blur. If you don't have enough light to freeze their movements, use a tripod and ask your subjects to stop in the middle of their action.

- Make notes of what your models are wearing and any props used so you can duplicate these details if you have to continue shooting a second day.

- If possible, photograph your models in private; an audience could make them feel uncomfortable. And you may end up with smiles when you want serious expressions.

- Get your subjects involved in an action. If they're concentrating on what they're doing, they will feel less self-conscious.

- Talk to your subjects while you work. If they're engaged in an interesting conversation, they won't have time to feel self-conscious while you take time setting up each shot.

- Make sure your models look realistic. If they're supposed to be digging a ditch, have them actually doing the job so they're sweating and getting dirt on their clothes.

Close-Up or Portrait Shots

Good close-ups of people's faces are sometimes very hard to get. People who feel self-conscious when photographed from a distance may feel even more awkward when you move in close.

- Use a shallow depth of field to make your subject stand out against the blurred background.

- Position your subject so the main light source is coming from the side. Light from the front will give a flat lighting effect and backlighting will cause exposure problems.

- Use a portrait lens (70 to 100 mm). A 50, 55 mm, or wider lens up close to the subject will cause some distortions. A longer lens (135 mm or greater) will mean you have to stand too far away from your subjects to be able to talk and put them at ease while you work.

- Portrait lenses require careful focusing, so warn your subject that it may take you a few extra minutes to compose and frame each shot.

- Photograph your subjects in the shade so they're not squinting.

- Try varying your angle.

- You can prevent that frozen look people get when they're photographed if you ask a question. Snap the shutter just as they finish speaking when their faces relax. If you want a serious expression, ask a serious question. If you want a laugh, say something funny.

Learning to Photograph People

Practice on friends who want their pictures taken—new baby, small child, children's parties—but don't take on one-of-a-kind events like weddings until you're an experienced photographer.

Direct someone through a planned sequence of shots of some everyday activity—putting cream and sugar in a cup of coffee, operating a vending machine, putting gas in a car.

Try photographing strangers. Children are the easiest to photograph. Most will gladly ham it up for the camera. Grownups attending a public event (festival, sporting event, parade) usually won't object if you take their picture. If they're busy watching the action, they probably won't even notice.

The Model Release

With the exception of individuals who have chosen a profession or lifestyle that keeps them in the public eye, people have a right to privacy that you must respect when producing a slide presentation. To avoid potential lawsuits arising from the unauthorized use of someone's picture or voice, you should obtain written permission from anyone you photograph (on slides or movie film) or record, if the individual's face or voice will be recognized in a presentation to be shown to the public—regardless of whether or not admission is to be charged.

You don't have to obtain this permission at the time the slides are shot or the audio tape is recorded, but it's ususaly easier if you do. If you wait until after selecting the slides or editing the audio tape that will be used in the presentation, you must retrace your steps to obtain permission. This can become a time-consuming, inconvenient, or even impossible task, especially if you shot slides or recorded voices at a number of locations.

The simplest way to get permission is to have your photographer, sound recordist, or their assistants ask each person photographed or recorded to sign a model release (similar to the one shown above) prior to or at the time of shooting or recording.

EASTMAN KODAK COMPANY
MODELING • PERFORMING
NARRATION RELEASE

SUBJECT _____
PRINT
PROJ. # _____
HRS. WORKED

For value received and without further consideration, I hereby consent that all photographs taken of me and/or recordings made of my voice or musical performance

at _____ on _____ 19 ____

by _____ for the Eastman Kodak Company, may be used by the Eastman Kodak Company, or/and others with its consent, for the purposes of illustration, advertising or publication in any manner.

SUBJECT _____
SIGNATURE

SUBJECT'S SOC. SEC. No.

Street _____ City _____ State _____ ZIP _____

IF SUBJECT IS A MINOR UNDER LAWS OF STATE WHERE MODELING IS PERFORMED

GUARDIAN _____ GUARDIAN _____
SIGNATURE PRINT

Street _____ City _____ State _____ ZIP _____

Date _____

TWO-PROJECTOR DISSOLVE SHOWS

With some slide programs, you can turn a single-tray show into a two-projector dissolve presentation, just by sorting the slides into two trays (odd and even) and screening the show with two projectors and a dissolve control, such as the *KODAK EKTAGRAPHIC* Programmable Dissolve Control.

What Is a Dissolve Show?

A dissolve show is created by superimposing the images from two projectors on top of each other so that they overlap exactly. The dissolve effect occurs when the dissolve control fades the light down in one projector, while changing the image and fading the light up in the other.

The objective of a good dissolve is to have the images blend as smoothly as possible. In some shows, you may have noticed that some of the images do not blend smoothly. This problem occurs because elements in the slides conflict and proper planning was not given when shooting the sequences. All slides will not dissolve smoothly just because they are separated into two trays and projected with two projectors.

Basic Two Projector Dissolve Sequence

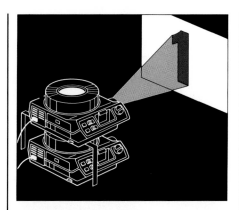

- At the beginning of the sequence, the top projector lamp is on and slide No. 1 is being projected on the screen. Slide No. 2 is in the gate of the bottom projector, but its lamp is off.

- When the Dissolve Control receives a command, either directly from the keyboard or from the programmed audio tape, it dims the top projector lamp at the selected rate. At the same time, it brightens the bottom projector's lamp, and temporarily both slides are projected on the screen.

- The sequence finishes with slide No. 2 being projected on the screen. The top projector advances to slide No. 3, but its lamp is not on. The next dissolve would end with slide No. 3 on the screen, and so on.

These illustrations are representational only, due to the difficulty of showing the exact appearance of projected light beams in a printed diagram.

Shooting Techniques

Dissolves add interest to your two-projector show and should be seriously considered and planned for at the time of shooting. For example, if you are photographing a paddle wheel boat, such as the "Mississippi Queen" preparing to dock, this would make a very good dissolve. Again, some planning is necessary. Set your camera on a tripod and establish the angle that you want for the entire docking sequence. Then, as the boat makes its approach, start photographing it at the various stages. Preventing camera movement will do much to improve the quality of dissolve sequences.

You may notice some slight alignment problems with dissolve shots that require very precise dissolves. If you look very closely at the framing of each shot, you'll see that even though the slides were shot using a tripod and a cable release to prevent any camera movement, the subject in frame A is slightly to the left of the subject in frame B. This misalignment occurred in the camera because as the film advanced, the camera sprocket mechanism does not always position the following frame in the same identical position as the preceding exposure. This slight variation means that supposedly identical slides will be positioned differently when they are mounted, and these differences will show when the slides are projected in a dissolve sequence. To avoid these variations, it's necessary to use pin registration.

What Is Film Registration?

A prerequisite for using pin-registered mounts effectively is using film shot in register.

Pin registration, as it applies to 35 mm sprocketed film, refers to the position of the image on the film in relation to the sprocket holes. The unexposed film you load in your camera is blank. Images are exposed as the camera transport system advances the film to the camera aperture and the shutter is opened.

After the film is developed, the image will have a direct relationship to the sprocket holes of the film. When film is in perfect registration, shown at right, we say that the image is "centered" in relation to the sprocket holes. The lower illustration shows the film shot "out of register."

Check to see if your camera exposes film in register by making a simple inspection of an exposed roll of film. The degree that you are out of register will determine whether or not you can use pin-registered slide mounts. Place the sprocket holes of the film on the pegs and inspect the short sides of the aperture. If the image is completely masked, the slide is usable.

If the black unexposed area between images as in the bottom illustration, shows into the mount aperture, the film is too far out of register to be usable in a pin registered slide mount.

Courtesy: Wess Plastic

A = A B = B

Film in perfect register.

Image is completely masked—both sides.

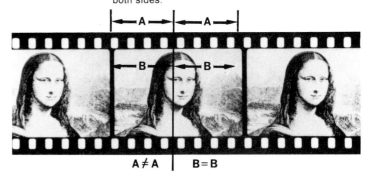

A ≠ A B = B

Film not in register.

Black unexposed area on right side extends into the picture area.

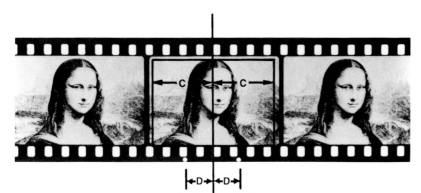

C = C D = D
Non-registered film corrected with VR-Punch.

WESS #2VR (Variable Registration) Mount.

To correct this problem, several photographic equipment manufacturers produce special types of cameras, generally utilized on copy stands, that provide exact framing for each shot by using pin registration. If you have a series of shots that require critical registration for dissolves, then you should send your originals to a laboratory with this capability and have your shots duped on a pin-registered camera.

Two additional factors to be considered for precise dissolves are

- Slides intended for precise dissolves should be mounted in pin-registered mounts such as those produced by Wess, Gepe, and Kaiser.

- These pin-registered slides should then be aligned carefully and projected in projectors such as the *KODAK EKTAGRAPHIC* III Projector. This projector has a precision gate that drops the slide in the same position each time it is projected.

Courtesy: Wess Plastic

Shooting Dissolves Without a Pin-Registered Camera

Although it's impossible to get perfect alignment without using a pin-registered camera, mounts, and precision projectors, many sequences don't require this critical degree of registration. If the subject of a sequence makes relatively small movements between one shot and the next, the slight variation will probably go unnoticed because the viewers' eyes are distracted by the movements of the subject.

You may also be able to avoid registration problems if the background behind the subject has no clearly defined lines. A blank wall, open sky, or a blurred background, all help to minimize the differences in framing which may occur from one shot to the next.

Dissolves can be fun and can add much interest to your presentation. They can be produced quite simply but if you want more precise results, follow the suggestions made in the previous paragraphs.

As an added note of interest, Wess Plastic of Farmingdale, NY, has produced a new, simple, reasonably inexpensive pin-registration method for the average user. The Variable Registration (VR) Mounting System, utilizing the VR-Film Trimming Unit, and the VR-HP (hand punch) allows photographers with nonregistered film to realign the exposed image and punch two round holes between existing sprocket holes and the edge of the film. Wess has also designed a series of VR mounts with round registration pins that correspond to the punched holes of the VR-Trimming Unit and VR-HP (hand punch).

The VR-HP (hand punch) and VR mounts make it simple to register film so that images will be projected straight, centered in the aperture, and held firmly in place to prevent moving. The design of these products enables easy registering of single-frame or strip film.

Superimposed images are mounted by punching and taping down an initial reference slide and then positioning a second (related) image over the top.

Once aligned, punch the second slide and mount both in Wess Variable Registration Mounts. (Wess Plastic, Farmingdale, NY)

The time required for cutting and mounting slides can be greatly reduced with the VR-Film Trimming Unit manufactured by Wess Plastic. Colored gels from Wess Plastic are precut and simplify the addition of color to black-and-white slides. (Wess Plastic, Farmingdale, NY)

"Welcome Aboard" A realistic view of life aboard a towboat. (Courtesy: Ashland Oil Co.)

ASHLAND OIL, INC.

By the time crew members start work on Ashland Oil's towboats in Ashland, KY, they have a realistic idea about the hazards involved in the job.

With a new approach to recruiting, the personnel department is able to screen applicants more carefully; the Marine Safety Division sees to it that new hands are prepared to deal with potentially dangerous situations on board.

One of the most successful methods of accomplishing both objectives is the sound-slide training programs Ashland produces for its own use as well as distribution within the industry.

The first program, WELCOME ABOARD, is shown to all new job applicants by the personnel department. The 22-minute program paints a realistic view of life on board a towboat and pulls no punches.

Seated in front of a *KODAK EKTAGRAPHIC* AudioViewer, the individual or group is able to see and hear exactly what the work is like on board the boats pushing barges from port to port along 3,000 miles on inland waterways on the Great Lakes. WELCOME ABOARD also stresses the element of safety. It is the first sound-slide program of its kind developed by the marine transportation industry. Thus far, Ashland has produced three sound-slide programs, each focusing on a particular aspect of towboat safety. In addition, the company has converted a filmstrip and a 16 mm film dealing with shipboard locks and lines to the sound-slide format.

"We have the flexibility to do these things," says Greg Blatt, Ashland's Marine Safety supervisor, "and we can be selective in what we want to include. We can skip those frames that may not be consistent with our objectives and maybe add a few of our own. We can tailor a program right down the line." Ashland takes its own photographs, records its own narration, writes its own scripts, and even prepares whatever charts or diagrams are required. Program content is the primary consideration. Blatt admits that productions may not always be considered "slick," but they are meaningful and that's what counts.

All eleven Ashland towboats have been equipped with portable audioviewers and a library of sound-slide programs. As many as 15 programs should be available within the next year or so, including several produced by affiliated groups, government offices, and educational organizations.

The flexibility of the sound-slide format in the production stage, as well as at the viewing end, is what makes these programs so valuable. Blatt says, "Programs can be kept up to date simply by replacing slides. Ease of operation of the AudioViewers means that programs can be viewed at the convenience of the individual or group either on the unit's built-in screen or, in the case of larger audiences, projected on a large screen."

Ashland's Marine Employment Department receives a copy of every sound-slide program produced so that the company can better screen applicants for jobs, eliminating at the outset many people who would sign on and then quit once they saw what the work was like.

"If they are still determined to go to work after seeing WELCOME ABOARD, then there's a good chance that they'll make it," says Blatt.

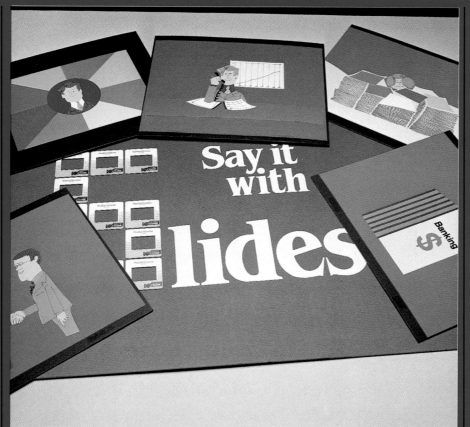

At some point during production, you'll have to decide how many title and illustration slides to include. Even if you've never drawn a straight line in your life, you can produce professional-quality titles and illustrations if you don't attempt anything too elaborate and you're willing to spend some time doing the job. On the other hand you may decide, like many professional producers, to allocate some or all aspects of the job to a specialist.

In this chapter, we'll help you decide when to use titles and illustrations and which techniques to select if you want to do the job yourself. Along with showing you how to prepare the artwork, we'll also tell you how to photograph it using a close-up lens and a copy stand. At the end of this chapter, we'll show you some special effects that you can use if you're willing to pay for the services of an audiovisual graphics specialist.

WHEN TO USE GRAPHICS

Title slides are customarily used at the beginning of a show to introduce it and at the end of the show to credit the people who produced it. They're also used to bridge sections, summarize content, and emphasize important points. Illustration slides are made from artwork with text material and used to show subject matter which would be difficult or impossible to depict otherwise. Maps, blueprints, diagrams, cartoons, and sketches are all examples of illustrations commonly used in slide shows.

Opening Titles

If possible, give your show a short opening title that users will be able to remember when they request the production. Try to choose a name that communicates something about the subject matter. If that's not possible, consider following the opening title with a longer one that explains more about the subject matter. The name of the sponsoring organization may also appear at the beginning of the show.

Opening title.

Credits

Titles can also be used at the end of the show to credit the sponsoring organization and the people who produced the show. Like the titles at the beginning of the show, these are usually limited to no more than two or three slides. If many people contributed to the production, find some other way to thank them besides listing their names in a long series of credit slides.

Credit slide.

Updating a Show

Title slides are also used to provide facts such as wages and prices that might need to be updated several times during the life of a production. Rather than go to the considerable expense of redoing a show's sound track and sychronization signals, experienced producers keep these changeable facts out of the script and put them on slides that are easy to update.

Updating a slide show.

GUIDELINES FOR GRAPHICS

Each illustration and title slide selected or prepared for reproduction in a show should convey a single idea. Like every other image in the show, graphics slides should match the horizontal slide format and suit the content of the show. The typeface chosen for titles and the style of illustrations should match the rest of the slides in the show, and all the elements should stand out clearly and be large enough to be seen by viewers in the last row of the largest audience.

35 mm horizontal slide format.

Advantages of Standardizing All Artwork

The preparation and photographing of titles and illustrations will be considerably simplified if you produce all the artwork on the same-sized artboard. Adopting uniform-sized 10 x 12-inch (250 x 300 mm*), artwork offers savings in cost and time and allows you to store your graphics on edge in a standard filing cabinet where they will be protected from damage and easy to find when you want to use them again.

Standardize your art on a 10 x 12-inch board for preparing art, photography, and storage.

This uniformity allows you to work with a few standard and readily available pens, brushes, and type sizes. If you always work within the same-sized area, you'll quickly become familiar with the type sizes and other elements that work best.

Standardization means you'll be able to photograph the artwork easily. When you have to photograph artwork of random sizes and formats, you'll have to continually adjust the camera-to-artwork distance, the focus, and the exposure settings. Conversely, by standarizing the artwork, you'll only have to set the lights, camera distance, focus, and exposure ONCE for each complete assignment.

*Where practical, metric figures used in this section have been rounded slightly to provide convenient working dimensions.

By designing all your artwork to fit within a 6 x 9-inch work area, you'll leave an ample border around the graphic to allow for safe handling, registration holes (page 94), or field marks for camera alignment, production notations, and attachment of acetate cels or other types of overlays.

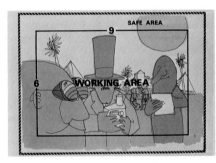

The art should be prepared in the same ratio as the finished slide. A 35 mm slide has a 2:3 ratio. On a 10 x 12-inch board there should be a 1-inch background around the 6 x 9-inch working area for safety.

Prepare a Graphics Template

To avoid pencil marks on the artboard when defining your 6 x 9-inch working area, take a 10 x 12-inch piece of artboard and cut out a 6 x 9-inch opening. Lay this template over the illustration while you're working and you'll have no problems staying within the prescribed area.

The usable area of the artwork, including the background, must fill a space somewhat larger than the recommended 6 x 9-inch working area so the background edges won't show when the graphic is photographed. When you're preparing an illustration with a colored background, extend the background an inch beyond the 6 x 9-inch area.

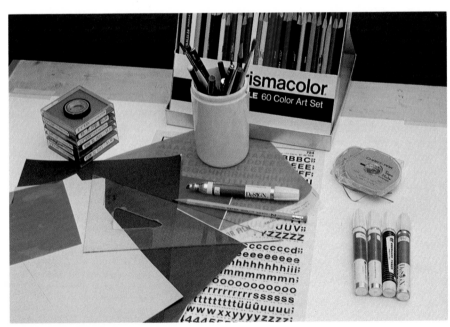

Pens, brushes, and transfer lettering for creating art.

Templates for Other Formats

The recommended 6 x 9-inch working area is the standard recommended for 35 mm slides that are going to be projected. If you plan to transfer your show to 16 mm or video cassette or you intend to use a rear-projection device such as a *KODAK EKTAGRAPHIC* AudioViewer/ Projector, you'll need to use a different-sized working area. For example, for video, titles, lettering, etc, should be confined to an area substantially smaller (4½ x 6 inches) than that possible with a projected 35 mm slide. If you don't keep titles and important parts of illustrations inside this "Safe Title Area," you may lose important parts of your titles and illustrations when the show is seen on video.

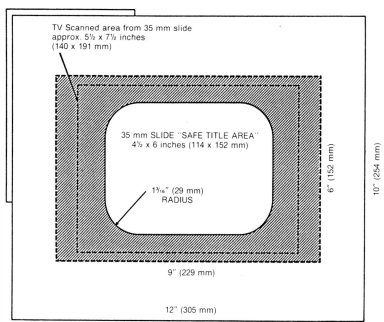

TV Scanned area from 35 mm slide approx. 5½ x 7½ inches (140 x 191 mm)

35 mm SLIDE "SAFE TITLE AREA" 4½ x 6 inches (114 x 152 mm)

1³/₁₆" (29 mm) RADIUS

6" (152 mm)

10" (254 mm)

9" (229 mm)

12" (305 mm)

Artwork template for television—loss of visual area (shaded portion) of a 35 mm slide projected for television.

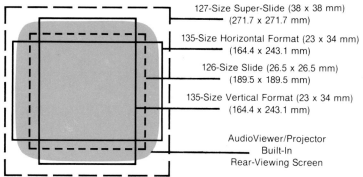

127-Size Super-Slide (38 x 38 mm) (271.7 x 271.7 mm)

135-Size Horizontal Format (23 x 34 mm) (164.4 x 243.1 mm)

126-Size Slide (26.5 x 26.5 mm) (189.5 x 189.5 mm)

135-Size Vertical Format (23 x 34 mm) (164.4 x 243.1 mm)

AudioViewer/Projector Built-In Rear-Viewing Screen

Artwork template for AudioViewer/Projector in the normal mode.

Template for Typewritten Copy for 35 mm Slides

When you are typing copy for slides, make a full-size template following the illustrations below. Use the appropriate format—a 1:1 ratio, 3:4, or 2:3. For 35 mm slides, use the 2:3 template: 9 double-spaced lines (maximum) and 54 elite (or 45 pica) characters wide. Upper- and lower case elite type will be legible up to 40 feet (12.2 m) using a projected image 5 feet (1.5 m) high; pica type, to about 60 feet (18.3 m). The use of uppercase letters only will extend the legibility distance somewhat but viewers may find it harder to read all uppercase letters.

Keep captions, lines, or other markings (added to illustrations from which slides will be made) within the rectangle.

Use the template as a guide for setting up your camera; the viewfinder should include about 1/8 inch (3 mm) outside the template area on all slides for a normal front-projected slide. The number of lines and lengths should be reduced for TV use (4 or 5 lines—36 elite or 30 pica wide).

You may find it helpful to trace the template on onionskin or clear plastic material that can be used to check copy area and to align the camera. (Be sure to remove the tracing before photographing the copy.)

Preparing Legible Artwork

Many factors should be considered if you want to make sure your graphic slides will be easily seen by everyone in the audience when they're projected.

Simplicity

Each illustration and title slide should convey a single idea. If the work you are photographing is complex, reduce the information to the essential elements, limit the text, and enlarge the letter size. Rearranging the information can help define the point you are making for the audience. If you have to present a number of points or a complicated diagram, produce a series rather than a single graphic. (See page 94 for guidelines to follow in producing sequences for two-projector dissolve productions and page 98 for directions to follow in preparing progressive disclosures.)

Letters and symbols should be bold and simple, with no small openings because these tend to fill in when they're photographed. Also avoid ornate typefaces because these are hard to read when projected for just a few seconds. Words set in upper- and lowercase letters are easier to read than those set all in uppercase.

Legibility standards for artwork will help you plan artwork to allow the entire audience to read the slides.

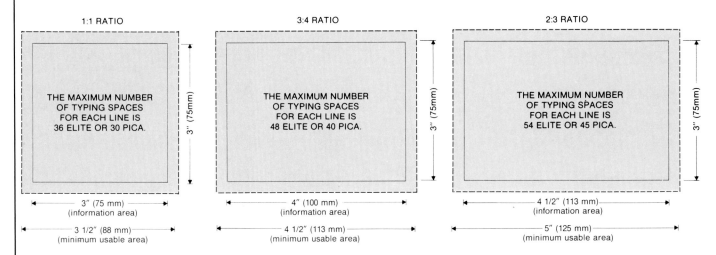

1:1 RATIO

THE MAXIMUM NUMBER OF TYPING SPACES FOR EACH LINE IS 36 ELITE OR 30 PICA.

3" (75mm)

3" (75 mm) (information area)

3 1/2" (88 mm) (minimum usable area)

3:4 RATIO

THE MAXIMUM NUMBER OF TYPING SPACES FOR EACH LINE IS 48 ELITE OR 40 PICA.

3" (75mm)

4" (100 mm) (information area)

4 1/2" (113 mm) (minimum usable area)

2:3 RATIO

THE MAXIMUM NUMBER OF TYPING SPACES FOR EACH LINE IS 54 ELITE OR 45 PICA.

3" (75mm)

4 1/2" (113 mm) (information area)

5" (125 mm) (minimum usable area)

Maximum size of information area for typewritten copy.

Contrast

To be legible, lines, letters, and symbols should contrast adequately with the background, and the colors selected should be strong and attractive. Don't produce graphic slides with predominantly white or very light backgrounds, because the amount of light reflected back from the screen will be hard on viewers' eyes. Black or dark-colored backgrounds with light graphics are the easiest slides to view.

Size

All elements such as lines, letters, symbols, and figures should be big enough to be seen by people in the last row of the largest audience.

In ideal viewing situations viewers should be seated no further from the screen than 8 times the height of the projected image. This maximum viewing distance, (expressed as 8H), can be used in determining the minimum size of significant material to be projected. The 8H concept assumes viewers have average or slightly less than average eyesight.

Testing Materials for Legibility

To judge whether material to be copied will be legible, look at the material from a distance 8 times its height. For example, if a printed table is 3½ inches (88 mm) high, it should be viewed from 8 times that height (28 inches or 0.7 m) to see if it is readable.

If you can read the type at arms length without a magnifying glass, it should be legible when projected.

Apply the same principle to larger work as well. A wall chart or a map 4 feet (1.2 m) high requires legibility at a distance of 32 feet (9.6 m) if it is to be acceptable as a projected image (4 feet x 8H = 32 feet). If the material is not legible at the test distance, it should either be redrawn or discarded.

It's a mistake to believe that enlarging the physical dimensions of a transparency will improve legibility. Transparency size is not a determining factor; it is the size of the detail on the screen that is significant.

Special Applications

When slide shows are screened inside small rear-projection cabinets for exhibits or point-of-purchase displays, they're often viewed from greater than normal distances. Quite often a projected image as small as 8 inches (200 mm) high will be screened for people walking by 20 or 25 feet away (approximately 30H).

To make sure graphics will be legible in this situation, lettering and other important details should be at least 4 times larger than the minimum for 8H viewing. For an artwork information area 6 inches (150 mm) high, the minimum letter height should be a ½ inch (13 mm). Remember, however, that rear-projection cabinets used in study carrels are usually viewed at only 2 or 3 times the screen height and therefore graphics prepared for these situations can be sized to 2H or 3H requirements.

Television

Television images are frequently viewed at distances greater than 8H. For example, an image only 12½ inches high (315 mm) on a 21-inch (533 mm) picture tube may often be viewed from 20 to 30 feet (7 to 9 m) in the home or in a classroom. Therefore, when material is being prepared for such use, legibility requirements for comparatively great viewing distances must be considered. 16H to 24H provides legibility at distances of 18 to 24 feet (5.5 to 7.3 m), 21 to 27 feet (6.4 to 8.2 m), and 23 to 30 feet (7 to 9.1 m) respectively from a 17-, 21-, or 25-inch (432, 533, or 635 mm) picture tube.

If the artwork is to be used for both TV transmission and regular projection, the lettering and title area should be designed to meet TV requirements. When the material is being photographed for projection as a slide, shoot an extreme close-up so that unnecessary background will be eliminated.

For more information about designing material for small-screen playback, see page 91.

The Importance of Continuity

Choose a production style that suits the content and purpose of your show. If you require a professional-looking production, don't ruin the effect by using amateur techniques to produce your graphics. On the other hand, don't include elaborate special effects if they'll overpower the rest of your slides.

When planning titles for a show, select a single typeface and use it throughout the show. The same advice applies to illustrations. Whether you adapt existing ones or prepare all the illustrations yourself, maintain the same graphic style. Don't use a cartoon-style for some illustrations, negative images for others, and then switch to chalk and construction paper for the rest. Mixing graphic styles will destroy the overall continuity of the show.

Write-On Slides

Write-on slides can be used as temporary slides in the planning and previewing of slide sets and synchronizing sound and music while the finished artwork and photographs are being completed. These preview slides can be shown to persons or groups that must approve the program.

Each slide consists of a 2 x 2-inch (50 x 50 mm) mount containing a square film with *ESTAR* Base film with a matte surface on one side. Three writing area sizes are available: 38 x 38 mm; 31 x 31 mm; 24 x 36 mm.

KODAK EKTAGRAPHIC Write-On Slides are available only through dealers in Kodak audiovisual products.

NOTE: These slides are not recommended for use in automatic-focusing slide projectors, unless the projectors are equipped with an autofocus on-off switch.

KODAK EKTAGRAPHIC Write-On Slides.

24 x 36 mm—Because this size matches the most popular slide format (film exposed in 35 mm cameras), Write-On Slides in this size will fit more conveniently into sets of the most often encountered slides.

31 x 31 mm—This size is designed for *KODAK EKTAGRAPHIC* AudioViewer/ Projectors and similar units manufactured by other firms. Everything written in the aperture area will appear on the viewer screen.

38 x 38 mm—This is the "super-slide" format, providing the greatest practical writing area within the 2 x 2-inch (50 x 50 mm) mount.

Designing Graphics for Two-Projector Dissolve Productions

Identically framed sequences produced for two-projector slide shows may not align properly if they haven't been shot with a pin-registered camera. When photographing regular scenes, you may be able to avoid alignment problems without using a pin-registered camera (page 86), but when photographing sequential titles or illustrations, you won't be as lucky. If you're planning a dissolve show or you intend to use dissolve equipment to transfer your show to video or 16 mm film, and you want to produce identically framed graphic sequences, you'll have to prepare and photograph the sequence on a peg-registered board using a pin-registered camera.

A pegboard (or register board, as it's sometimes called) is a wood or plastic board with several vertical posts for holding artboard, paper, acetate cels, or photographic film sheets in place. Slide show producers use them when preparing graphics for two-projector dissolve shows.

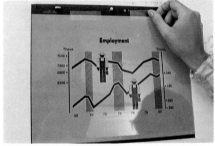

Register Board.

Vertical posts or pegs for positioning artwork.

Commercially made register boards are available from graphics supply companies, along with paper, cels, artboard, and the precise punches needed to prepare materials so they fit onto the pegboard. A pegboard and special punch could cost as much as $500, but if you plan to produce precise artwork, the equipment will be worth the investment.

Once you've prepared sequenced graphics, place each graphic in turn on the pegboard and photograph each one with a pin-registered camera.

If you don't have a pin-registered camera or access to one, you can have pin-registered work prepared by a commercial production house or laboratory. For names and addresses, check the Yellow Pages of your telephone directory under Audiovisual Production Services. See also pages 84-86 of this publication.

Legibility Calculator

The calculator on page 159 should help you to provide legible slides for the oft-forgotten individual in the last row. It is based on average legibility requirements and the standardization of artwork sizes as explained in the preceding pages.

Assembly of the calculator is a simple task. It is suggested that the entire page be dry-mounted or cemented to card stock before trimming. (A manila file folder is an example of suitable card stock.) Use care to trim the dial accurately, and be sure the centers are aligned perfectly before you secure the dial to the base. If an eyelet grommet machine is not available to provide the center pivot, a tie tack or lapel pin would make a good substitute.

You will find the calculator a useful tool in determining the minimum artwork letter size that will be legible for the entire audience. Or the calculator can help to determine the proper

screen size or farthest acceptable viewing distance when slides must be produced from existing artwork. For example, if you are using a 6 x 9-inch (150 x 225 mm) working area and wish to fill a 4-foot-high (1.2 m) screen that will be viewed from 64 feet (19 m)—the distance from the screen to the last row in the auditorium—set a "Total Projected Image Height" of 4 feet at the 64-foot mark on the "Distance of Farthest Viewer" scale.

You will notice that the "Minimum Artwork Letter Height" that lines up with 6 inches on the "Artwork Working Area Height" is ¼ inch. If both capitals and lower case letters are being used, the minimum height of the main body of the lowercase letters will have to be at least ¼ inch to be legible from the last row.

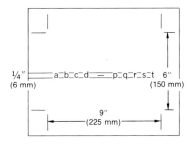

Another use of the calculator is to determine acceptable screen height when you are required to use existing art.

Assume you have a 6 x 9-inch (150 x 225 mm) piece of artwork on which the height of the lettering is only ⅛ inch (3 mm). Set the ⅛-inch mark at the 6-inch mark on the lower scale. Note that a screen image 8 feet high would be required for proper legibility from the last row of this same auditorium. Or using a 4-foot high screen, the farthest viewing distance would have to be limited to 32 feet, as shown on the "Distance of Farthest Viewer" scale.

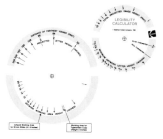

The legibility calculator shown here is reproduced full size on page 159.

PREPARING THE ARTWORK

Titles and illustrations can be produced by a tremendous variety of methods and for a wide range of prices that vary from inexpensive to very expensive. Which method you select depends on the style and purpose of your production, plus the time, facilities, and budget you have available.

Title Slides

It's possible to produce effective title slides from a number of ready-made title subjects available such as street signs, highway markers, billboards, nameplates, etc. If these titles do not meet your particular needs, you can make your own titles quickly and inexpensively.

Ready-made title.

Make your own titles.

Regardless of whether a title is written with colored chalk on a black background or on an acetate cel with transfer letters, consider the following:

- There may be special requirements, such as in preparing titles for TV application.
- Legibility—The copy must be large enough for the message to be legible.
- Plan your title layout with simplicity and clarity of thought.
- Titles should be simple and effective.
- Keep the background simple and uncluttered.

Adapting Existing Titles

If you have a close-up lens and the material meets the legibility standards previously outlined in this chapter (pages 93, 95), you may be able to produce titles from existing printed materials. However, be sure to keep in mind the copyright laws.

These simply produced titles can be very effective in the right place but make sure the subject matter is appropriate. However, if you want a professional-looking production, you'll probably have to use more elaborate title-producing techniques.

Three-Dimensional Title Letters

Three-dimensional title letters, ceramic or plastic, are available from most camera stores in many styles and sizes. They are relatively inexpensive and can be used repeatedly.

Three-dimensional title letters.

Title letters that have no pin or fastener on the back are easiest to use. Simply place them on colored-paper backgrounds for copying. The use of dark, soothing background colors will provide good contrast and avoid the dazzling effect that can be caused by brighter, lighter colors.

We suggest that you illuminate block-letter layouts with a small floodlight or a single spotlight equipped with a focusing attachment. The effect obtained from a sharp-edged shadow, usually placed at the lower right of each letter, is three-dimensional and less static than that of evenly illuminated letters or flat artwork. By placing the letters on a sheet of glass that has been propped 7 or 8 inches (175/200 mm) above the background material, you can control independently the levels of illumination on the letters and on the background.

Typewriter

You can produce titles with any kind of typewriter but the results will look much more professional if you use an electric machine with a good-looking typeface, and a carbon rather than a cloth ribbon. If you must use a cloth ribbon, place a sheet of carbon paper, carbon side up, behind your typing sheet. As you type, the additional buildup of the carbon on the back of the sheet will minimize some of the raggedness caused by a cloth ribbon. You may decide to produce titles this way, but type on colored paper because white will produce a title with a background too bright to view comfortably. To achieve a more professional-looking result, type on white paper but photograph the result with *KODALITH* Film or one of the other reverse-text films described later in this chapter (pages 105–109). See page 92 for a template to use when producing typewritten titles.

A typewriter offers one of the simplest and quickest means for producing legible copy.

Dry-Transfer Lettering

This lettering is produced by rubbing the back of a lettering sheet until the desired letter comes off and adheres to the background you've selected. If you want a wider typeface, a professional-quality title, or a type style not available with your typewriter, dry-transfer lettering may be worth the expense and effort. Dry-transfer letters are supplied in black, white, and colors. Consider using white letters because they show up better against a colored background.

Dry-transfer illustrations are available from some manufacturers along with a variety of type styles. Also many catalogs offer a variety of other symbols and graphics that can be used in slide shows.

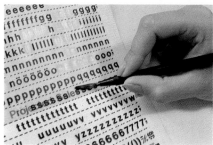

Dry-transfer letters can be transferred to the artwork by burnishing.

Typesetting

If you add up the amount of time it will take you to assemble materials and learn how to use them, the titling techniques we've just described may turn out to be more expensive than typesetting. Unless you require a special typeface available only in dry transfer lettering, a typesetter should be able to supply you with a wide choice of typefaces.

Select a typesetter who has produced audiovisual titles before if possible. Whether you use a typesetter with AV experience or not, plan the layout of the title yourself using the guidelines presented earlier in this chapter (page 89).

Lettering Machines

Like the typesetting machines, these produce photoready titles. There are a number of these machines available in varying price ranges. They are easy to operate, the letter spacing is automatic and adjustable, and character alignment is precise. The Kroy Lettering Machine offers typediscs with 61 positions in four popular type styles or 80 positions in 90 type styles, in sizes which range from 8- to 36-point. To produce a title, type in the letters, then peel the lettered tape from its adhesive backing and apply the tape to the artwork. If your organization produces a large number of titles, it may be worth the investment to purchase one of these lettering machines.

The KROY Lettering Machine creates type on tape.

The PROMAT Lettering Machine also creates type on tape.

Progressive Disclosure

If you have compiled a short list of statements, items, or graphic material that you want to present to an audience in a most effective manner, use the technique called "Progressive Disclosure." The first slide will show a single statement, an item, or part of a graph. The second slide will show an added statement, item or part of a graph, and so on until the final slide in the sequence will include all of the statements, items, or the entire graph. It is much easier for the audience to remember one thought at a time as it is added to the preceding idea. Also, the use of progressive disclosure keeps the audience from reading ahead of the speaker. Furthermore, this procedure steps up the pace of the presentation by avoiding the presence of one slide on the screen for the length of time required to discuss the entire subject.

Photographing a Progressive Disclosure

Assuming that there are four lines of information to be presented, prepare the artwork with all four lines and photograph the entire list. Then, cover over the last line and take another shot. Continue covering an additional line and shooting until only the first line of text remains.

If you are using *KODALITH* Film or *KODAK EKTAGRAPHIC* HC Slide Film, shoot five shots of the entire piece of artwork. After you have processed the film, block out each line of text with black tape or opaque on each successive frame. This will provide the same effect as above.

With peg-registered art, you can add elements to the basic art by means of clear acetate overlays (called "cels") and maintain accurate registration. Photograph the basic art and then make an exposure for each cel that is added.

While various methods of photographing progressive disclosures have been suggested, it should be understood that for the best possible results, all artwork should be peg-registered and the photography should be accomplished with a pin-registered camera. The frames of film should then be mounted in pin-registered mounts. Projection should be accomplished with a projector that has "precise slide registration" such as the *KODAK EKTAGRAPHIC* III Projector.

...Free presenter

...Free presenter
...Easy to run

...Free presenter
...Easy to run
...Continuous flow

...Free presenter
...Easy to run
...Continuous flow
...More professional

Preparing Original Illustrations

Although we suggest you have illustrations produced by a graphics artist, you can produce professional-looking illustrations yourself—if you don't have the budget, and you're willing to devote some time to the job.

Begin by selecting a suitable illustration to copy. If you don't think you're capable of copying freehand, trace it. When you've finished tracing the outline, turn the tracing paper over and cover the back of the entire outlined area with soft pencil. To transfer the outlined drawing to your artboard or heavy drawing paper, turn the tracing paper over and carefully trace the outline of the drawing. The lead pencil on the back of the tracing will act like carbon paper. You could put actual carbon paper between the tracing paper and the art board instead; however, carbon and smudges don't erase as easily as pencil. If you can't find an appropriate illustration to trace, sketch the drawing on a piece of scratch paper until you're satisfied with the results, then use the tracing procedure described above to transfer the sketch onto a clean piece of paper.

Complete an outline of the sketch on tracing paper.

With a soft lead pencil, shade the back of the tracing paper, covering each line of the drawing.

Place the drawing right side up, on the textured paper and retrace, leaving a penciled impression of each line.

Once you have an outline for the illustration, use colored pencils or felt pens to add color. If you've used a white background, cut the drawing out and put it on a colored background before you photograph it. Dark-colored backgrounds are a better choice than pastels which tend to look muddy when they're photographed.

Use colored pencils or felt pens to add color to the tracing.

Reverse-Text Illustrations

If you're not an experienced artist, you will find that line drawings are the easiest to prepare. Even simple stick figures look quite presentable when photographed on *KODALITH* Film, *KODAK EKTAGRAPHIC* HC Slide Film, or *KODAK VERICOLOR* Slide Film.

Preparing Charts and Graphs

These are the most common forms of illustrations produced for slide shows, and they're relatively easy for a novice producer to prepare.

There are several alternatives to producing graphs or charts yourself. If you draw the chart with black lines on a white background and then photograph it with *KODALITH* Film or *KODAK EKTAGRAPHIC* HC Slide Film and add color, you can produce a professional-looking graphic. But if you prefer a graph or chart with a colored background, simplify the job by utilizing graphic tape (available at most art supply stores) to create the curved and straight lines of the chart or graph and then photograph it with color slide film.

Black-and-white chart photographed with *KODALITH* Film.

Use color tape with a color background and photograph it with color.

Providing that you have the *legal right*, there's no reason why you can't use illustrations appearing in printed materials as long as they meet the minimum *legibility requirements discussed* in the previous section, Preparing Legible Artwork, on page 92.

Too often, novice producers assume that printed material will also be legible when it's projected on a screen. However, a person ordinarily reads printed material at a distance of 12 to 14 inches (305 to 356 mm). When slides are projected on the screen, the image is often only 4 feet high (1.2 x 118 m) and the viewing distance as much as 70 feet. Reading the text of a 4-foot-high image at 70 feet is like reading a miniature version of this page. Only the title will be legible. (See Legibility Calculator, page 159.)

Acetate Cels

A cel is a transparent sheet of cellulose acetate carrying a printed message or illustration that is placed over a color print, a color photograph, or some desirable background to be used as a title and then photographed.

A cel is a transparent sheet of cellulose carrying the word, message, or whatever, that is placed over a color print, photograph, or some desirable background.

These cels are usually punched to fit a peg-registration board (page 94). Successive cels can then be positioned accurately during artwork and photography. Dry-transfer letters are easy to apply and give the impression of a neat, professional printing job. Because the word message is on the transparent cell and not on the background, the same background can be used over again with different cels.

Acetate cels can also be used effectively if you have a map, chart, floor plan, cartoon, or picture that is too busy for satisfactory results for an original slide. Place a cel over the original; trace the outline of the desired portion of the subject material with a broad-nib pen and acetate ink. When the ink is dry, turn the cel over and color the opposite side. Use colored felt marking pens or special colors made for use on acetate. Colors can be added or completely removed without disturbing the crisp black

lines on the opposite side of the cel. When the cel has been completed, select a suitable background and photograph it.

The tools and materials necessary for preparing acetate cels are the same as those found in any commercial art setup. Included are a drawing board and/or table, a T-square, a 30-60-90-degree triangle, a drafting set, and an assortment of brushes, inks, watercolors, show cards, etc. Special inks for painting on acetate cels are sold by art supply stores. Colors should be selected with careful consideration of continuity, contrast, and legibility. Contrast should also be given special consideration if there is a possibility that the title might be photographed with black-and-white film. In this event, of course, color could not be relied upon for contrast. Metallic paint or foil should be avoided, as well as the excessive use of white in large areas.

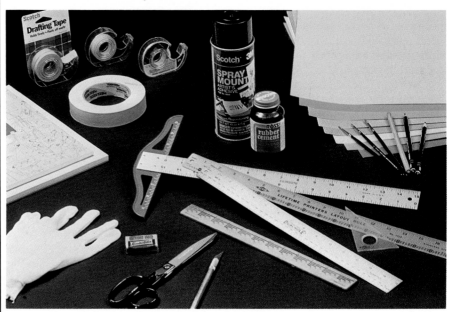

You'll need a basic inventory of tools to start art production.

Hot-Press Lettering

Hot-press lettering is produced by stamping heated printer's type on colored foil laid over a thin sheet of clear acetate. The hot type transfers the colored pigment from the foil onto the acetate in much the same way that ink is transferred onto the paper in the conventional printing process. The sheet of acetate containing the title can then be laid over a background and photographed as a title.

The hot-press method is particularly useful for producing bilingual presentations. For example, to produce the same talk in both English and French or Spanish, use the same artwork for both and merely flip down alternately the two different language cels.

Adding Color to Black-and-White Artwork

Enhance the appearance of black-and-white photographs and illustrations and make them easier to view by adding color. Graphics professionals do this by adding a special adhesive plastic film to the artwork. You can also add color to photographs and illustrations by photographing them on color film with colored filters.

Copyright for Illustrations

Most photographs and illustrations published within the last 75 years are covered by some form of copyright. Even if you're just going to use your show once or twice within your organization, you should still obtain permission to use copyright photographs and illustrations. If you're not planning to charge admission to your show, you can usually obtain the right to use material for little or no charge.

Copyright-Free Illustrations

Because it often takes weeks or months to obtain the necessary permission, many producers prefer to create their own illustrations or rely on those already in the public domain. You can also find books of old steel and wood engravings that are no longer covered by copyright. Some of the companies that manufacture dry-transfer lettering also include dry-transfer graphics in their catalogs.

PHOTOGRAPHING THE ARTWORK

With the right camera, lens, lights, and copy stand, photographing the artwork is a simple matter, even if you've never photographed artwork before.

Copy Stand

Because close-up work usually requires long exposures, you'll need some means of holding the camera steady. You can use a tripod, but it's much easier to keep the camera level with a copy stand designed specifically for this kind of work. A copy stand will lock the camera into position for photography and will allow you to move the camera up and down quickly to photograph different-sized artwork.

The stand should have a sturdy post for holding the camera on the same vertical axis when it's raised and lowered, and the camera bracket attached to the post should be counterweighted for easy operation.

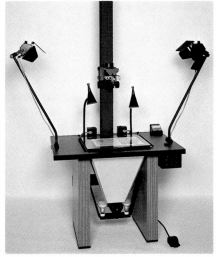

Copy stand with overhead illumination.*
(Photo: Kinex Corp., Rochester, NY)

The stands are designed for additional lighting and some even have light fixtures attached to them. A simple stand which will be adequate for most of the copywork discussed in this section, costs approximately $100 or one can be rented from a camera supply store.

Camera

As with other forms of slide-tape photography, we strongly recommend you use a reflex rather than a rangefinder camera since a reflex camera will allow you to see accurately most of what you're going to photograph. However, even the majority of reflex camera viewfinders have a tendency to have some slight cut-off (margin of safety). You should make a simple test to determine the margin of safety that your camera viewfinder has.

* Other sources of copy stands are Forox Corp., 393 West Ave., Stamford, CT 06902; Matrix Div./Leedal, Inc. 1918 South Prairie Ave., Chicago, IL 60616; Oxberry Div. of Richmark Camera Service, 180 Broad St., Carlstadt, NJ 07072.

Close-Up Accessories

Because most 35 mm still cameras are fitted with lenses of approximately 50 mm focal length and will not focus on subjects any closer than 2 or 3 feet from the camera, you need accessories to get close enough to fill the slide with your artwork—your title or illustration. You can adapt a standard 50 or 55 mm lens for close-ups in two different ways.

One approach is to use an accessory close-up lens. (This looks like a clear filter and screws into the filter thread on the front of your camera lens.) The other approach is to use extension tubes or a bellows unit that fit *between* the camera body and the interchangeable standard lens.

Both close-up lenses and extension tubes (also called extension rings) limit you to photographing at specific close-up distances. For flexibility when copying different sizes of artwork, you'll need a set of three or four. A bellows unit may be a better choice, instead, since it provides the convenience of continuous focusing throughout its range.

For the best sharpness with all these close-up accessories, try to use apertures of $f/11$ or $f/16$.

If you plan to do close-up copying on a regular basis, a macro lens will probably be worth the investment. This is a special 50 or 55 mm lens that replaces your standard lens. It has an extended focusing range that allows focusing anywhere from infinity to a few inches away. In addition, macro lenses are specially designed to provide sharp images at close distances.

Lights

Even light distribution is very important when copying. While you can use a copy stand illuminated with the light from a very bright window, you'll get best results if you use high-intensity photographic lighting (3200 K lamps in suitable reflectors or with built-in reflectors). To provide adequate and even distribution of light, you'll need two lights, one on each side of the copy stand, set at an angle of 45 degrees. Two lights on each side would be even better since the additional lighting will allow you to shoot at faster shutter speeds and thereby reduce the chance of camera jiggle while you're working. If the stand isn't equipped with lighting fixtures, ask your camera dealer to suggest comparable lighting stands.

Before you begin work, make sure the lights are lined up correctly on both sides of the copy stand. Test this out by putting a pencil directly under the camera in the middle of the copy area. Check to make sure the shadows are equal on both sides of the pencil. If they're not, adjust the lights until the shadows on both sides of the pencil are the same.

Light Meter

When using a through-the-lens meter to set the exposure for your artwork, you may not get an accurate exposure. Light-colored artwork will reflect extra light back at the camera, causing the meter to measure more light than is actually falling on the graphic. Unless you override the meter and compensate by using a wider aperture or slower shutter speed, dark artwork will absorb light and the resulting slide will be overexposed. To avoid both these problems, put a neutral gray card over the artwork, take your light reading from the gray card, and set the exposure manually.

If you can't override the camera's meter or "lock" the exposure reading from the gray card, turn off the built-in meter and use a handheld exposure meter instead. If the camera won't operate without the automatic meter, it's not a good choice for copy work— use another camera.

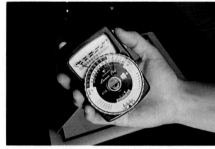
If a reflected-light meter is used, determine the exposure by using a gray card.

Place a neutral test card (gray card) over the artwork with the copy lights on and take a reading of the reflected light. Make sure that the meter is not casting a shadow and that it is only reading the light off the gray card.

With an incident-light meter, place the meter at the center of the artwork and take a reading with the light-gathering dome face up.

L-Shaped Guide for Copy Alignment

As you copy each title and illustration it's important to make sure it's lined up properly. To make alignment easier and less time-consuming, make or buy an L-shaped guide. After you've positioned your first graphic exactly by looking through the view-finder of the camera, position the guide against the upper-left corner of the artwork. Tape the guide to the copy stand's base or the tabletop, and use it to align the rest of your illustrations quickly.

Pane of Glass

If the illustration you're copying won't lie flat, put a pane of glass over it. To avoid picking up unwanted reflections from the glass, use nonreflective glass and the shadow board or polarizing filters described next.

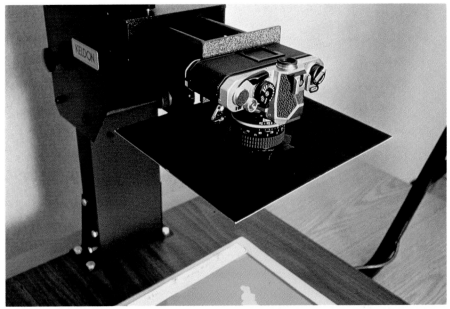

You can reduce potential flare with a shadow board or light baffle.

A sheet of clean clear or nonglare glass can be used to keep the acetate overlay in contact with the art.

Shadow Board or Light Baffle

If the artwork you're copying is curved or has a slight sheen to it, you can eliminate some reflection by putting a shadow board or light baffle around the camera lens. To make one, just cut a lens-sized hole in a black sheet of construction paper, fold the paper to crease it, and then slip the bent piece of paper around the camera lens and attach it with adhesive tape.

Polarizing Filters for the Lights and Camera

Although we suggest you avoid using artwork which has a highly reflective surface, you can diminish unwanted reflections by putting polarizing filters over your lights and a polarizing filter over the camera lens.

Polarizing filter over the camera lens.

Use a coin on top of the artwork to align the polarizing filters.

To orient the filter for maximum effectiveness:
- Put a coin on top of the artwork.
- Turn the polarizer on the camera lens until the index mark or arrow points directly toward you.
- Turn on the light to your left.
- Look through the camera viewfinder; rotate the filter over the left light until the coin looks darkest, without reflections.
- Turn out the left light and turn on the right light.
- Look through the viewfinder, rotate the filter over the right light until the coin goes to its darkest.

If the filters have arrows on them, simplify the procedure just described by rotating the filters until they point toward each other. With both lights turned on, rotate the camera polarizing filter slightly until the whole coin darkens with no reflections.

When using a handheld exposure meter, increase the exposure about two stops over the reading given by the meter to compensate for the filter.

Cable Release

Because copy work often requires long exposures, use a cable release to keep the camera from shaking when you release the shutter.

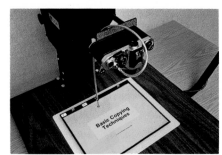

Cable release.

Viewfinder Framing

Remember that most cameras don't photograph the exact same framing you see. If you're not sure what the exact framing will be with the camera you're using for copy work, run a test.

Cropping Your Artwork

To photograph a section of an illustration, attach a piece of tracing paper to the illustration as indicated, and mark the area you want to photograph with a heavy line. Then focus the camera so only the area within the framed section is visible.

Occasionally the area to be photographed may be only a portion of the entire piece of art. This area can be indicated with an overlay.

If the desired area of the illustration doesn't have the same 3:2 proportions as a horizontal slide, and if you wish to block out the extraneous areas so they won't show, make a black paper mask to lay over the illustration. Prepare this mask by first putting a piece of tracing paper over the illustration and tracing the area you want photographed. Then remove the tracing paper and tape it to a piece of black construction paper. Using an illustrator's knife, cut the marked window out of the construction paper.

To take the picture, lay the black mask over the artwork so it frames the desired part of the illustration. If positioning is critical, place the mask in position on the artwork and tape it in place. Be sure the mask lies flat against the artwork or the copy lights may create shadows along the edges.

KODAK EKTAGRAPHIC EF Visualmaker

The *KODAK EKTAGRAPHIC* EF Visualmaker is a complete visual production kit that produces excellent color slides or color prints. It can be used for extreme close-ups of flat copy or of three-dimensional objects. The camera supplied with the Visualmaker can also be used separately off the copy stand.

The kit includes a *KODAK INSTAMATIC*® X-35F Camera, film, *KODAK EKTRON* II Electronic Flash, Model A, a carrying case, and two copy stands. Each stand has its own built-in, prefocused supplementary lens and a reflector that provides the necessary amount of light from the flash unit to illuminate your subject properly.

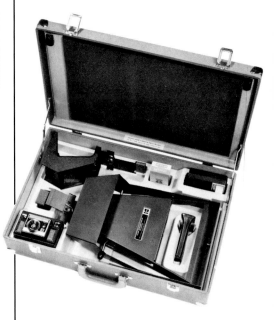

KODAK EKTAGRAPHIC EF Visualmaker.

Operation is easy. Just lock the camera into position on top of one of the copy stands either the 8 x 8-inch or 3 x 3-inch (203 x 203 mm or 76 x 76 mm size), position the Visualmaker on your subject, and shoot. You can photograph an almost unlimited selection of color visual materials without bothering with focus, exposure, or framing.

Further usage information is given in *KODAK* Publication No. S-40, *Simple Copying Techniques with a KODAK EKTAGRAPHIC Visualmaker.* A copy of this publication can be obtained by sending $1 and writing to Eastman Kodak Company, Dept. L-5, 175 Humboldt St., Rochester, NY 14610.

The Visualmaker is available from dealers in Kodak audiovisual products; see the Yellow Pages of your telephone directory under Audiovisual Equipment and Supplies for dealers in your local area.

REVERSE-TEXT SLIDES

Reverse-text illustrations and titles are produced by photographing black-and-white artwork with either black-and-white or color negative film. The resulting slides are easy to look at and comprehend, and the appearance is more professional than some of the other techniques described earlier in this chapter.

Reverse-text slides (white or light-colored text or art on a dark or colored background) are often more effective in a slide presentation than slides with dark text and lines on a light background because reverse-text slides offer the following:

Excellent legibility—When projected, bright text on a dark background is easier to see and read.

Less eye strain—There is no large glaring white or light-colored background area.

Increased visual interest—It is easy to add color to the lines, words, or symbols; gives further emphasis and variety to the slides.

Cleaner slide images—Dust, dirt, and fingerprints (common problems with light-colored backgrounds) are practically eliminated from the projected image.

Reverse-text slides are easy to make, and they produce highly legible images. They show up particularly well in semidarkened rooms, and thus permit sufficient light for the audience to take notes and for the speaker to see and respond to the audience.

This section discusses methods for producing reverse-text slides, each starting with artwork consisting of ordinary black lettering (or drawing) on white paper.

NOTE: Some of the methods suggested in this section involve nonstandard uses of films and processing chemicals. Because these films are neither designed for nor routinely tested in these nonstandard processes, variable and even unacceptable results may occur for which there is no coverage under any Kodak warranty. Therefore, we strongly recommend users experiment to determine if the film will perform satisfactorily in this special application.

The exposures, filters, and developing instructions given in this section are guidelines; an individual user may prefer the results produced by carefully varying these guidelines. For additional information on films and developers, refer to the books and technical information sheets listed in the *KODAK* PUBLICATIONS section, and check the instructions packed with the product.

If you don't want to bother processing the film, take it to a reliable laboratory to be processed; all you have to do is mount it.

Artwork

For best results, cleanliness and good contrast are important. Use black ink, carbon typewriter ribbon, black crayon, charcoal, or black transfer letters on a white background. Try to maintain an even density of black. Also make sure the lettering or artwork meets minimum legibility requirements. (See page 92.)

Copying Procedure

The best shutter speed and lens aperture combination for a given lighting setup and film emulsion should be determined by a trial-exposure series, using the suggested speed (ISO) as a starting point. Materials and procedures used to develop the film should also be recorded. The optimum time/aperture/developing combination obtained from such a test film can continue as a standard until conditions or materials are changed.

To determine the initial exposure time and aperture setting (*f*-number) for the test series, measure the illumination on the original material. Take a direct reading with an incident-light meter, or read a *KODAK* Gray Card with a reflected-light meter. You'll find that built-in camera light meters tend to underexpose white copy material because these meters give readings based on the large amount of white background. Reflected light readings from a gray card will be more accurate.

Method I

(Produces white lines on a black background.)

Black-and-white negative film.

Kodak manufactures a variety of different black-and-white negative films that can be used to produce black-and-white reverse-text titles. For variation these images can also be hand-colored.

In this section we discuss the black-and-white film most commonly used. This film and appropriate processing chemicals are available through most dealers in Kodak products.

KODALITH Ortho Film 6556, Type 3, is a high-contrast film on *ESTAR* Base particularly suited for making reverse-text slides. It is supplied in 35 mm, 100-foot rolls (CAT 168 6419) and **is also available from Kodak in 35 mm, 36 exposure magazines (*KODAK EKTAGRAPHIC* HC Slide Film CAT No. 159 8655).**

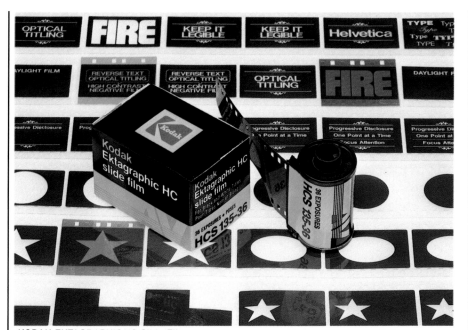

KODAK EKTAGRAPHIC HC Slide Film

The ISO for this film is 8. For your first set of trial exposures, take a shot at every *f*-stop on the lens and halfway between each stop. Record the *f*-stop of the best exposure and note the lens and lighting arrangement so you can produce good results again in the future. After this initial experiment you won't have to take a shot at every *f*-stop, but continue to bracket two stops on either side of the exposure that will produce the best results. You need to bracket because the exposure may vary somewhat with the width of the lines and the type size used on the artwork.

If you use four 150-watt tungsten lamps, two on each side of the copy stand, and set the shutter speed for 1 second, the best exposure will probably be between $f/5.6$ and $f/11$. If you use two lamps, with a 1-second shutter speed, the best exposure will probably be between $f/4$ and $f/8$.

Process the KODALITH Film or KODAK EKTAGRAPHIC HC Slide Film in KODALITH Developer. The separate A and B stock solutions have a long shelf life. However, the working solution (made by mixing equal parts of A and B stock solutions) has a short life; if it will not be used immediately, it should be discarded after a few hours.

Develop the films in KODALITH Developer for $2^{1}/_{2}$ minutes with continuous agitation at a temperature of 68°F (20°C). Rinse in KODAK Indicator Stop Bath or KODAK Stop Bath SB-1a for

KODALITH Ortho Film 6556, Type 3.

10 seconds at 65° to 70°F (18° to 21°C) with agitation. Fix for 20 seconds to 1 minute in KODAK Rapid Fixer. (If the film is to be hand-colored, it must not be overfixed or overhardened.) A 1-minute bath in KODAK Hypo Clearing Agent followed by a 5-minute wash in running water at 68°F will produce a long-lasting slide.

The film can be dried in 10 minutes or less by rinsing the film in KODAK PHOTO-FLO Solution or wiping surface moisture off with a KODAK Photo Chamois. To speed up the drying, use a film-drying cabinet, hair dryer, or heat lamp with a fan.

Opaqueing Reverse-Text Slides

One of the advantages of reverse-text slides made from high-contrast black-and-white films is the solid black background, which can conveniently cover up imperfections in the background of the original artwork. If, however, any dirt, sketch lines, or other unwanted marks on the art are reproduced on the processed film, these white marks can be easily painted out with opaque, a light-blocking compound, such as KODAK Opaque Black or KODAK Opaque Red. You can also opaque out any background imperfections caused by processing difficulties. Hold the processed dry film up to a light and use a wet artist's brush with a fine tip (size 0 or 00) to apply the opaqueing compound to any light spots in the background. Many of the black pens and pencils sold for marking overhead projector transparencies also work well in this application.

Coloring Reverse-Text Slides

You can color the entire dry transparency by dipping it in a water-soluble dye, such as *KODAK* Matrix Dye, Dr. Ph. Martin's transparent water colors, or ordinary food coloring. If you prefer, apply the dye to selected areas, words, or lines with a cotton swab or a sable-hair brush. Temporarily put transparent tape over those parts of the slide you aren't coloring, to protect them from the dye.

You can apply the dye to either side of the film. Because the background is opaque, the color need not be confined to the clear film areas. Apply the dye solution quickly and smoothly to obtain uniform color. For better color saturation and evenness, dye both sides. If droplets remain, blot or dry with absorbent cotton. A drop of *PHOTO-FLO* Solution in a bottle of dye will help it adhere to the film. If the film does not take dyes easily, it may be necessary to reduce the hardening drastically during processing or drying.

The Dr. Ph. Martin's dyes may need to be diluted slightly with water before they are applied to the film, since a too thick dye solution can dry to a powder that will be partially opaque when projected. In difficult cases, you may try "flooding" the slide with dye and letting it soak into the emulsion. The excess dye can be removed later with a cotton swab.

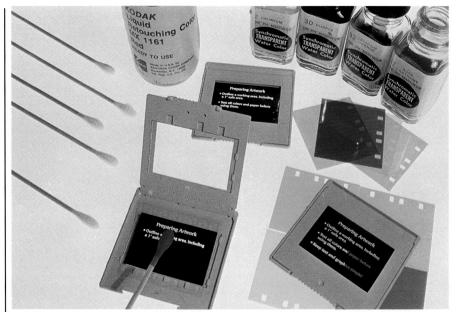

The finished *KODALITH* Film slide can be colored with dyes or sandwiched with color gels.

Colored Felt Pens

Some felt-tip marking pens will produce satisfactory results, particularly those sold for marking overhead projector transparencies.

Some felt-tipped marking pens will produce satisfactory results.

Colored Filters

Colored filters are an alternative to dyes. Theatrical gelatin filters are available in sheets in a wide variety of colors and shades. To use them, just cut them up into slide-sized pieces and put the negative and gel together in a glass mount. Some manufacturers such as Wess Plastic, 50 Schmitt Blvd., Farmingdale, NY 11735, sell gels already cut to size.

Color filters sandwiched with the black-and-white film are another method of producing color.

If you plan to use colored reverse-text titles, make enough to supply all the duplicate sets of your show because the colors of reverse-text titles may change when they're duplicated.

Make sufficient original slides because duplicate slides may not reproduce satisfactorily.

Method II

KODAK VERICOLOR Slide Film is a color negative film suitable for copying black-and-white line artwork to produce transparencies with white, or very light, images on a color background.

Equipment

- **Volume**
- **Type of Original Artwork**
- **Degree of Precision**
- **Budget**

KODAK VERICOLOR Slide Film.

KODAK VERICOLOR Slide Film SO-279 is available in 135 36-exposure magazines (CAT No. 162 2364) and *KODAK VERICOLOR* Slide Film 5072 is available in 35 mm x 100-foot rolls, Spec VS 663 (CAT No. 122 1217).

Color backgrounds are produced by photographing black letters or text on a white background with a color filter in front of the camera lens. Starting point exposure recommendations are based on using a 3200 K light source. Set your exposure meter at an exposure for ISO 8 and measure the light on the copyboard without filters. Use incident-light readings or reflected-light readings from a gray card of 18% reflectance, such as the *KODAK* Gray Card.

The table at right shows what change to make from the exposure indicated by the exposure meter in order to obtain the desired background color. Keep the exposure between 1 and 8 seconds and make an exposure series of at least ± 1 stop in ¹/₂-stop increments. The use of electronic flash is not recommended.

KODAK WRATTEN Gelatin Filter Values for Use With *KODAK VERICOLOR* Slide Film

Set your exposure meter for an exposure of 8, and bracket your exposures in ¹/₂-stop increments to plus and minus 1 stop. Keep all exposures between 1 and 8 seconds.

Desired Background Color	KODAK WRATTEN Gelatin Filter*	Exposure Increase (in stops)
Diazo Blue	12 or 15 (yellow)	2
Cyan	85B or 85 (orange)	4
Green	34A (deep magenta)	4
Red	38 (light blue)	4
Orange	44 (cyan)	4
Magenta	61 (deep green)	5
Yellow-brown	47 (deep blue)	4
Dark red	no filter	none

*Weaker filters give softer colors and may give colored lines or text. Stronger filters give more saturated colors.

This film can be processed using *KODAK FLEXICOLOR* ® Chemicals (Process C-41). Kodak Processing Laboratories provide a "process only" service for this film and the processed film is returned in 3- or 4-frame strips similar to the method currently used for processed color negatives. Many other photo laboratories can also process this film, including 1-hour minilabs. For the do-it-yourselfer, the *KODAK FLEXICOLOR* Processing Kit is available from your photographic dealer for small batch processing.

OPTICAL TITLES

Optical titles, or "burn-ins," as they are sometimes called, are produced when a black-and-white reverse-text title is combined with a background slide. The slide produced by this process appears with the clear letters of the title "burned-in" to the background slide.

The production stages for making optical title slides are composed of three steps:

1. Produce a high-contrast black-and-white negative slide from your artwork or text. (See page 105.)

2. Select or produce a suitable colored background slide.

The background-slide subject should complement the text or drawing. Although simple patterns such as coarse fabrics or textured screens work well, abstract or repeated designs and scenic subjects have also been used successfully.

Plain colors with soft gradation and subtle tones that contrast with the white lettering or lines are very effective. Although the darker and richer tones seem to work best, all the cool colors, and most reds, and certain shades of brown also work very well. Avoid pastel shades, particularly yellows—they tend to be muddy and dull when photographed and rephotographed (third step), making the white text or lines hard to distinguish.

Moderately blurred backgrounds (out of focus, camera lens "zoomed" during exposure, etc) emphasize the text or drawing and are usually very acceptable.

A good-sized black area in the background will show up reversed letters or lines well. In fact, the best combinations often make use of a background scene that would look slightly underexposed and unfinished without the text.

3. Photographically combine the reverse-text image and the background on slide film.

High-contrast black-and-white slide.

Color background slide.

Photographically combine the high-contrast slide with the color background slide.

Photographically combine the high-contrast slide with a darker and slightly blurred color background slide for more pleasing results.

There are several ways to combine the negative image and background slides:

1. Send your slides to a commercial slide service.

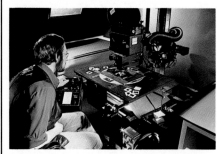

If you don't have the photographic capability, send your slides to a commercial laboratory.

2. If you have a single-lens-reflex (SLR) camera with double-exposure capability, you can use a light box or some other slide-copying device to copy the negative-image slide and, without advancing the film (check your camera instruction manual), the background slide. The order is not important; you can copy the background first and then the negative. We recommend that you use a slide duplicating film so that you will not increase the contrast in your background scene. For example, *KODAK EKTACHROME* Slide Duplicating Film 5071 (Process E-6) is available in 135-size 36-exposure magazines (CAT No. 126 8424) and 35 mm 100 ft rolls (CAT No. 162 9476), as well as other formats. In any case, to get white lines or text, make certain that the color temperature of the light source in your slide-copying device matches the color balance of your slide duplicating film.

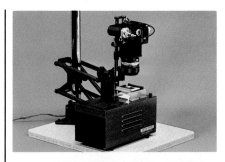

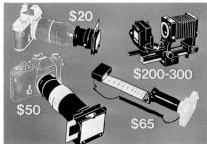

Slide copying devices.

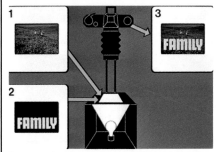

Suggested order for copying high-contrast slide and background slide.

KODAK EKTACHROME Slide Duplicating Film 5071.

3. If you have access to a camera with a fairly long focal-length lens and two slide projectors with the same length lenses, you can project and superimpose the two slides on a plain white surface and photograph them with the camera. The projection surface should be white; it can be a piece of high-grade white bond paper or just plain white wall.

Slide copying setup by projection.

To avoid keystoning (angular distortion), get your camera lens as close as possible to the center point between the two projector lenses.

If your camera lens focal length is equal to, or slightly longer than, the focal length of the projector lenses, you can keep the camera behind the projectors and still avoid getting the projectors in your picture.

If your projector lens focal length is	Your camera lens focal length should be at least
127 mm (5 in.)	127 mm
102 mm (4 in.)	102 mm
76 mm (3 in.)	76 mm

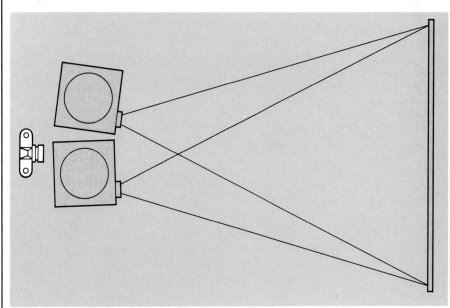

Line drawing of photographic setup.

Since the combination of projectors and projection surface will tend to reduce contrast and give you a comparatively low-light-level camera subject, you will not need a slide duplicating film for this application, but you will find that a fairly fast film (ISO 200 or 400) will allow you to use convenient exposure settings on your camera. Although you will get better reproduction of colors in your background slide when you use tungsten-balanced film, if there are people in your background slides you may still need to experiment with filters to reproduce skin tones satisfactorily. We suggest a CC10R as a start. You will probably need to bracket your exposures in 1-stop increments to plus and minus 2 stops until you become familiar with this project-and-photograph technique.

Position the two projectors, aiming them at the same spot on the projection surface, set the film speed ISO on the light meter and determine the initial exposure by one of the following two methods:

Method A

Start with one projector off, and the lamp switch on the other projector in the high position, with no slide in the projector gate . (If your projector has the dark-screen-shutter feature, open the shutter by inserting an empty slide mount.)

Using your camera meter, note the indicated exposure and increase it 1 stop.

or

Take a handheld reflected-light-meter reading at the projection surface and increase the indicated exposure by 3 stops.

or

Take a handheld incident-light-meter reading at the projection surface and increase the indicated exposure 1 stop.

Method B

Start with one projector off. Put the lamp switch on the other projector in the high position and project your background slide on the projection surface. If you use your camera meter, interpret your indicated exposure according to the nature of the projected slide. With a predominately dark slide, decrease your exposure 1 stop and with a predominately light slide, increase exposure ½ stop. If you use a handheld incident or reflected light meter at the projection surface, average your readings from several different areas on the projected scene, and interpret as above.

Projecting the two slides and photographing them is a technique that gives you several advantages:

- You can use a range-finder camera or an SLR which doesn't have double-exposure capability (necessary for other optical title methods described on page 110).

- You can vary the relative position and size of the text or drawing on your background by adjusting either projector position, or changing the focal length of the lens in the negative-image projector.

- As long as you keep the reversed-text or art portion in a black area of your background, you can color the reversed portion by sandwiching colored gel with your reverse-text slide, or by coloring that slide as described in Method I, page 106.

- You can control the relative brightness of your background with the background-slide projector. Move the projector farther from the projection surface or simply put a piece of tape over the front of the lens barrel. As the tape width increases, the image brightness decreases.

Control the brightness of the background slide projector by placing a piece of tape over the projector lens.

- You can emphasize the negative title or drawing by throwing the background image slightly out of focus. (See page 110.)

If you don't have two projectors, you can project the two slides in turn; and using a camera with double-exposure capability, photograph each one on the same frame of film.

Completed optical titles.

MOONLIGHT MUSHROOMS

Lack of consumer information, both at wholesale and retail levels, was the problem faced several years by the management of Butler County Mushroom Farm, Inc., who package under the Moonlight Mushrooms label. They didn't have trained marketing or advertising personnel to educate the public and increase mushroom sales. And they didn't have the budget to launch a major advertising campaign.

Butler County Mushroom Farm, Inc., is a family business operating in renovated limestone mines beneath the Allegheny Mountains in an environment ideal for cultivating mushrooms—constant darkness, steady 60-degree temperature, high humidity, and protection from the weather.

As the consumer appetite for mushrooms increased, the family-owned company found itself in head-to-head competition with large corporations with strong marketing programs.

Butler County Mushroom Farm grows produce in renovated limestone mines beneath the Allegheny Mountains, ideal for cultivating mushrooms.

Mushrooms are handled with extreme care and processed under exacting conditions.

Margo Yoder, daughter of the president, was appointed Manager of Consumer Relations and given the job of promoting mushrooms. "I was new at marketing, but I wanted to encourage the public to increase mushroom consumption and to tell produce managers, restaurant owners, and consumers who we are," says Yoder. Her first attempts weren't far-reaching and she searched for ways to reach broader audiences. Since food is a visual product, she thought of an audiovisual program emphasizing the proper handling, storage, and use of mushrooms.

"With a slide show I could alter the content of the program to meet the needs of particular audiences," says Yoder. "The only problem was I had never produced a slide show."

She attended an audiovisual training seminar at the Kodak Marketing Educational Center in Rochester, NY. The seminar included concepts, content, and technical instruction.

Armed with new expertise, Yoder went back to Pennsylvania and started working on her first slide show, writing and rewriting the script. She used free-lance artists for graphics and titles and hired local photographers for some location work. The American Mushroom Institute, the industry's trade association, provided the bulk of the slides she used to illustrate handling and preparing mushrooms.

To produce specific shows for different audiences, Yoder segmented mushroom consumer groups and defined their needs. A show for produce managers emphasized how to package, store, handle, and display mushrooms with technical information about exact temperature and humidity. A show for local consumer groups (women's clubs, high schools, 4-H clubs) informed the audience about the history of mushrooms, how they are grown, the nutritional value, and advice on how to wash, handle, and prepare mushrooms. A third show aimed at restaurant associations highlighted the versatility and profitability of mushrooms as a menu item, offering volume recipes for mushrooms as a side dish. Within a year, Yoder made presentations in 10 cities in six states.

Because the agriculture market is constantly changing, she chose not to record her script, but to read it personally, figuring that a spoken narration would be easier to update.

"I'm constantly updating the script," she says, "and I can encourage audience participation in the form of questions, so the presentation almost becomes a sales call."

With this in mind, she made five sets of slides for each show to be distributed to the sales force. "We can expand the reach of programs this way and still deliver a standard message that has been proven effective.

"The slide show is an effective medium for us to assist our sales force and to increase sales, even though it isn't expensive or highly technical. It personalizes our product, and the only viable alternative would be a film at a much greater cost," Yoder concludes.

Merchandising and storage is an important part of the business.

(Courtesy: Butler County Mushroom Farm, Inc.)

PUTTING THE SHOW TOGETHER

EDITING THE SLIDES

Assuming that you have shot your slides exactly to match a detailed script or storyboard, editing should be a very simple procedure. All you'll need to do is sort through a few boxes of slides and select the best exposure for each shot in the script. However, most slide shows very seldom come together this easily. Few subjects are predictable enough to allow you to plan every shot in detail, and even when they are, you probably won't have time to do that much planning.

Even if you develop a fairly detailed shooting script, you probably won't follow it exactly. When you are out on location shooting, things may not look quite the way that you pictured them, or conditions may have changed. Maybe you'll even find a better way to shoot some of the scenes. For all of these reasons, editing could still be a fairly simple procedure or it could become very complex. The job will be much easier to manage if you have the right facilities and equipment.

The facilities and equipment you select for editing your show are designed to do three things:

- Protect your slides from scratches, dust, and other accidents.

- Help you select and arrange the most suitable slides for the show.

- Organize the slides so that you can sort your way through hundreds or even thousands of them in a short time to find any image you may need.

Arrange to do your editing in a room set aside for this purpose.

Facilities

Editing Room—If possible, arrange to do your editing in a room that can be used exclusively for editing. Make it a rule to keep all food and beverages out and it's advisable not to allow smoking. These are the ideal conditions. However, if you do not have the space for a private editing room, make sure that your co-workers understand the importance of what you are doing and realize why you don't want your equipment borrowed or your slides handled.

Screening Room—The ideal slide screening room should be as dark as the one in which the show will be viewed and the projected image should be as large as possible. These conditions are most important because a slide that looks perfectly exposed in a totally dark room on a small screen may appear badly underexposed when it's projected on a large screen with some ambient light in the room. On the other hand, a slide that looks great on a sorting table may look badly overexposed when projected full-size on a screen. Also, any imperfections or scratches on the film that may have occurred during processing are more apparent when projected full size.

Equipment

Illuminator—An illuminator, light table, or slide editor, as it is sometimes called, combines a sheet of translucent glass or plastic with fairly low-wattage lighting. The selection of models is wide-ranging both in price and slide holding capability. If your space and budget are limited, consider buying several of the less expensive models that hold 40 slides each and fold up into their own box.

VISUALITE II Light Table and the 4010 Cabinet on a 4025 Base. (Courtesy: Multiplex Display Fixture Company, Fenton MO.)*

KODAK EC Stackloader—when mounted on either a rear-screen projection unit such as the *KODAK EKTAGRAPHIC* AudioViewer/ Projector or the *KODAK EKTAGRAPHIC* III ATS Slide Projector, with built-in viewing screen, the EC Stackloader is the most effective means of viewing large numbers of slides in the shortest viewing time. This device holds up to 40 (cardboard or thin plastic) mounted slides at a time and also allows you to remove unwanted slides while viewing them.

KODAK EC Stackloader mounted on a *KODAK EKTAGRAPHIC Slide Projector.*

KODAK EKTAGRAPHIC III ATS Projectors with built-in viewing screen.

NOTE: If you plan to use an AudioViewer to present your completed production, you should use one when editing the show to make sure that the slides you select meet the format requirements for playback on this equipment. (For more information about designing shows for small-screen format and playback, see page 91.)

Stack Loading Viewer—These viewers allow you to look at up to 40 slides at a time. If you don't own a projector or you don't want to work in a darkened room, this inexpensive viewer is a useful tool to have for checking the continuity of each sequence as you put the show together on the illuminator.

Slide Storage Box—One of the most useful and least expensive pieces of equipment are the slide boxes that the processing lab returns slides in. These boxes are an excellent way to store and organize slides.

*Suitable cabinets that hold hundreds of slides in frames, with incorporated light panels for direct viewing, are available from suppliers such as Multiplex Display Fixture Co., 1555 Larkin Williams Rd., Fenton (St Louis County), MO., 63026; Elden Enterprises, P.O. Box 3201, Charleston, WV 25332; Luxor Corporation,2245 Delany Rd., Waukegan, IL 60085.

Selecting the Best Slides

To some extent, quality is a question of circumstance. If you have some slides of a Sasquatch, a flying saucer, or some other equally rare phenomenon, nobody's going to object if a few of the slides are overexposed. If you're showing the audience how to improve their golf game or make a lot of money in the stock market, they probably won't quibble if a few shots are slightly out of focus. If the audience is made up of close friends and associates, they probably won't mind if some of your compositions are less than perfect. But if your slide show is designed to sell a product or a viewpoint and the audience is used to seeing high-quality audiovisuals, your slides should be the best you're capable of producing, even if that means taking some of the shots over again.

Unless you have specific requirements, all the images in the show should be **horizontal**. Viewers find it distracting when slides in a synchronized show switch back and forth from horizontal to vertical. Some viewing situations will not accommodate both horizontal and vertical slides. If you have your show transferred to video or 16 mm film (page 142), the tops and bottoms of vertical slides will be cut off.

If you're not sure exactly what constitutes a suitable slide for a slide show, when reviewing the slides, consider the following questions:

- Does this image help me achieve my communications objective?
- Is the slide properly focused?

- Is the slide adequately exposed? Avoid overexposed shots if possible since this fault will be magnified in subsequent copies. Slightly underexposed shots can be lightened when duplicated. If artificial lighting has altered colors, this too can be corrected if the slides are custom duplicated. (See page 141 for details.)

- If possible, select slides with a minimum of contrasting light and dark areas such as that produced by a combination of bright sunshine and shade. Slides with extremes of contrast lose detail when they are duplicated.

- Are important details large enough to be seen by people in the last row of the largest audience you expect to have? If you're not sure, check the legibility guidelines we gave you in the graphics chapter beginning on page 88.

- If you expect to transfer the show to video, 16 mm motion picture or film strip, will important detail at the edges of images be lost? (See page 142.)

- Is the composition pleasing and suitable for the style of production?

- Has the photographer eliminated all unnecessary detail so the subject stands out clearly against the background?

- Is there good continuity between the slide and ones which precede and follow it in the show? If required for a two-projector dissolve show, will the slide dissolve smoothly with others in the sequence?

Improving Poor Quality Slides

If you duplicate your slides yourself or have them custom duplicated, you can substantially improve the quality of some slides.

We recommend having duplicates produced by an experienced professional with appropriate equipment.

Underexposed Slides—Provided the slides aren't too badly underexposed, they can be corrected when they're duplicated.

Overexposed Slides—If you overexpose a slide there's not much you can do about it. In many cases duplication is likely to make the problem worse.

Blurred or Out-of-Focus Slides— There's not much you can do. If the overall effect is pleasing, you might be able to use the slide as the background for a title.

Poor Composition—Have your slides custom-duplicated and the camera operator may be able to correct some compostion problems by cropping the slides.

Incorrect Color Balance—If you are forced to shoot daylight film with incandescent or fluorescent lighting, or tungsten film in daylight, you can have the color balance corrected by having the slides custom-duplicated and having the operator use the appropriate filters.

Alignment Problems—If you've shot a sequence designed for two-projector dissolve playback and the slides don't align properly when they're projected, a custom duplicator using a pin-registered camera and pin-registered slide mounts may be able to realign the slides or you can try it yourself (see page 86).

Organizing the Slides

When you have large numbers of slides to sort through, it's important to organize the slides so you can find any slide you need in just a few minutes.

Discard the worst slides—As each batch of slides comes back from the lab, discard any slides which are badly underexposed, overexposed, out-of-focus, or in some other way substantially defective.

Sort the slides into scenes—As you weed out these rejects, sort the remaining slides by scene and location. Sectioned boxes used for filing slides are excellent for this purpose.

Roughly arrange each scene—When you have all the slides sorted into scenes, use an illuminator to arrange each scene into a rough order.

Screen each group of slides—Screen each group with a projector to select the best slides. If possible screen the slides full-size in a darkened room so you can realistically judge how they'll look in the completed show. (If you plan to operate the completed production on a small rear screen unit such as a *KODAK* AudioViewer/Projector, evaluate the slides with that equipment since projection requirements differ with a smaller screen.) (See page 91 for details.)

Put the slides in plastic sheets or filing racks and color-code and label them for rapid identification—When you've picked out the most suitable slides, put them into clear plastic sheets and label the sheets with colored labels you'll be able to recognize at a glance.

Put leftover slides into processing lab boxes and clearly label each scene—Put the slides you don't need back into the plastic boxes supplied by the processing lab, and label each box carefully by location and specific scene. Then put a line through each label to indicate the slides in the box are leftovers.

This careful organization of leftover slides is important because even though you think you'll never need these slides again, you may have to go back to them when some of the slides orginally picked don't fit into the show for one reason or another.

FITTING THE SLIDES TOGETHER WITH THE SCRIPT

When the slides for each scene in the show are organized in plastic sheets or filing racks, begin matching the slides with the script. Follow these suggestions for developing visual continuity.

Developing Visual Continuity

When developing slide shows, novice producers often treat slides as isolated images with no relationship to each other. As long as a slide is technically good and matches the sound track, it often goes into the show with little or no thought about whether it matches the slides that come before or after it. It's this lack of concern for visual continuity that keeps many slide shows from achieving the standard of quality possible with the medium.

While it does require more effort to achieve visual continuity throughout a show, there are a number of techniques that make the job much easier. As we explain in the photography chapter, the easiest way to develop continuity is to plan for it right from the beginning. Even producers with little or no previous experience can develop shows with good continuity if they focus their productions on a central character.

Continuity is achieved by developing sequences of shots that fit together. If you aren't following the actions of a central character, then look for other ways to build continuity and avoid the following errors that will destroy the smooth flow of images:

- Continual changes in background.

- Continual changes in lighting and therefore color balance.

- Continual changes in horizon.

- Using incompatible lenses.

- Mixing a variety of visual styles.

Continuity for Dissolve Productions

Continuity is particularly important when shows are produced for playback with two projectors and a dissolve unit. If you've seen a number of dissolve productions, you know how much it detracts from a production if the images don't dissolve smoothly from one slide to the next.

FINAL SCRIPT REVISIONS

As we explained in the script-writing section, you'll probably need to revise your original script once you get your slides back from the lab. In making these revisions, try reading the script aloud so you can judge what it's going to sound like. Aim for a conversational style, use short sentences, and avoid the use of undefined technical terms audience members may not understand. Avoid the use of male pronouns like "he" and "him" unless your script refers to males only. Don't explain the obvious by using phrases such as "As you see in this slide"

Putting the Slides and Narration Together

When you've arranged a short sequence on the illuminator, try reading the appropriate section of narration aloud while glancing at the slides to see if they'll synchronize properly with the words. Adjust the wording if necessary to improve the way the slides and narration fit together. As you complete each sequence, load it into a slide tray. When you've assembled the whole show, record a draft version of the narration on your slide-tape machine and play it back in synchronization with the slides. (See page 124 and following for recording guidelines and page 129 for slide synchronization.) If a few slides are missing, use *KODAK EKTAGRAPHIC* Write-On Slides as temporary substitutes.

Matching the slides with the narration.

KODAK EKTAGRAPHIC Write-On Slides.

SLIDE-TRAY LOADING

When loading slides into a tray, it's important that they project right side up and read correctly from left to right (words or pictures). The simplest rule states, "The emulsion side of the film should always face the projection lens." However, it is not always easy to identify the emulsion side of a transparency.

If the slides are duplicates, this rule may not apply at all because different duplicating systems yield slides with emulsions oriented either toward the projection lens or the projector light source. Even the printing on slide mounts is an unreliable guide except for duplicates made by Kodak, which always read correctly (left to right) when the plain side of the mount faces the light source in the projector.

If you add to the variables all the additional possibilities that can be encountered in situations where slides are projected in a rear-projection setup or in a front- or rear-projection system incorporating mirrors or prisms, problems with slide tray loading are very real. To help you minimize frustration and lost time, we will describe a systematic approach to slide handling.

ORIGINALS

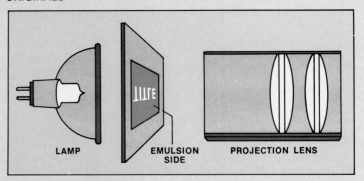

SOME DUPLICATES

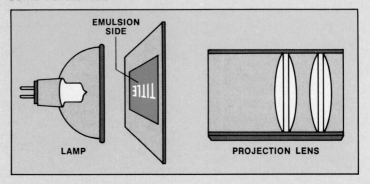

A Slide-Handling Habit

Begin by placing any new sets of slides on an illuminator so that all the slides look exactly the way you expect them to look when they are projected; reading correctly from left to right. Then, mark all the slides in the lower left-hand corner with a felt-tip pen or adhesive label.

Rotate the slides so that they are upside down (but do not flip them over so that a different side of the film faces you), and mark them individually with a sequence number. Stack them in sequence and make long marks along the top edge so that it is easy to spot one that is out of sequence or improperly oriented. When you have finished your marking, the slide set is ready for loading into a tray for *standard front* projection.

To adapt any slide set marked this way for rear projection or for front projection with mirrors or prisms, take the title slide and put it in the projector gate in different positions until it projects right-side-up and reads correctly left to right on the screen. Then orient all the slides in the tray the same way by loading them so that all the corner marks are oriented the same; for example, all lower left-hand-corner marks facing the lamp or all lower right-hand-corner marks facing the projection lens.

We also recommend that for professional presentations, that you use a slide tray such as the *KODAK EKTAGRAPHIC* Universal Slide Tray, Model 2. This tray has an 80-slide capacity and will accept slide mounts up to ⅛-inch (3.2 mm) thick (glass, plastic, or cardboard).

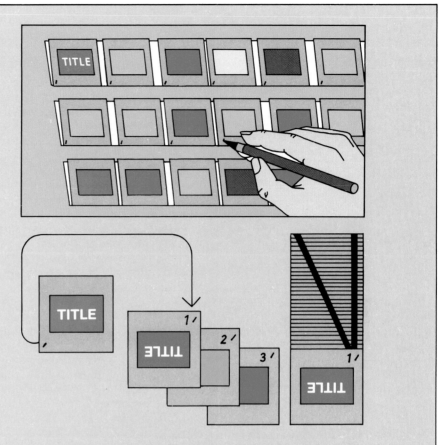

NOTE: Even though slides can be handled carefully by the mounts, it is a good idea to wear white cotton gloves to minimize the danger of fingerprints, smudges, etc, on the film.

EVALUATING THE SYNCHRONIZED SLIDES AND TAPE

Adding the synchronization signals to the tape will enable you to play the show back and look at it from the audience's viewpoint.

As you review the completed production look for the following:

- **Technical Quality**—Is each slide properly exposed, composed, and focused? Does the color balance of some slides require correction? Are all important elements in each slide legible? Are sound levels on the tape adequate and even? Is the tape free from distracting background sounds? Is each word clearly enunciated and correctly pronounced?

- **Content**—Is the meaning of each slide readily apparent? Have all distracting elements been removed from the slide? Does the style of each slide suit the subject matter? Do the slides portray the subject matter in a realistic manner? Are subjects wearing correct clothing and safety equipment if required? Are procedures portrayed correctly? Does the tone of the narrator suit the subject matter? Are all technical terms adequately defined? Are the sound effects and music suitable for the subject matter and style of the production?

- **Continuity**—Do the images in each sequence fit together visually and do they make logical sense? If the show is designed for two-projector dissolve playback, do all dissolves blend smoothly? Do the words in the narration flow smoothly?

- **Synchronization**—Do the words and slides fit together well?

- **Timing**—Are all slides on the screen long enough for viewers to see them and read any printed text? Are some slides on the screen longer than they need to be?

When you're satisfied that the show meets these requirements, screen it for others in your organization to get their feedback. If they approve, call in someone from outside your department—if possible from outside your organization—and ask them to review the production.

You need an outsider's viewpoint because after you've worked on a production for weeks, you won't be able to judge it realistically and neither will your sponsors. In selecting a reviewer, make sure you choose someone who's willing and able to give you an honest opinion, someone familiar with the demands of audiovisual media and who won't suggest changes that are beyond your capability and budget. Let your reviewers know this is the last chance you have to make revisions to the sound track or change more than a few individual slides without having to go to the substantial expense of rerecording the narration and remixing the sound track.

REVISIONS

Like death and taxes, revisions are inevitable in most productions, especially if your organization has never had a slide show produced before. Even if sponsors don't suggest changes, chances are you'll be less than satisfied with some of the sequences in the show and you'll want to reshoot them. That's why we recommend you reserve 10% to 15% of your total budget to pay the costs for substantial revisions.

PREPARING THE SOUND TRACK

Of all the jobs undertaken in the course of preparing a slide-tape show, sound production is one best left to experienced professionals. While it's possible to record narration on tape recorders, you can't easily mix in music or sound effects. Unless you're willing to spend several thousand dollars on professional quality recording equipment and facilities, and spend time learning some additional skills, you won't be able to produce a polished sound track. Even producers turning out dozens of shows a year find it less expensive to use a recording studio.

If your show is intended for sympathetic audiences within your organization, you may not require a sound track with anything more than narration. Even if you plan to hire a narrator and a recording studio to prepare the final sound track, you can still use a tape recorder with programming capability to record the narration and synchronization signals in order to screen the show for review by others in your organization.

For best results, record in a room with carpets, drapes, and padded furniture so your voice won't record with an echo. It is a good idea to put a sign on the door to make sure you won't be interrupted during the recording session. Read through the script a few times, mark any pauses and points of emphasis and read a few

A recording room should be identified with an illuminated sign while recording.

While it's possible to record sound on a tape recorder, best results are obtained with professional help.

Working With a Recording Studio

The sound track for a professional slide show is usually made up of three different elements: narration, music, and sound effects. As a rule these elements aren't combined together all the way through a sound track. Sometimes narration is the only sound, at other times music or sound effects take over, and occasionally all three are silent.

The process that combines narration, music, and sound effects in various combinations onto a single tape is called a sound mix. A mix is achieved by rerecording separate narration, music, and sound effects tapes together on another tape with each type of sound fading in and out as required.

lines into the recorder to determine your best distance from the mike. If you make a mistake when you're recording, go back to the beginning of the script and begin again. If you try to rerecord over your mistakes, you may erase more than you intend and you're also likely to record a popping sound every time you restart the tape recorder.

IMPORTANT: Before you begin recording, wind the leader on the front end of the tape onto the take-up reel of the cassette because narration and slide-changing signals will not record on the tape leader.

Wind the tape leader 8 to 10 seconds onto the take-up side of the cassette because narration and cues will not record on the leader.

Mixing console.

Before you book time in a recording studio, make sure that everyone in your organization agrees with the final version of the script. By the time you pay the narrator, pay for music rights, and pay the studio for recording and mixing the sound track, the cost could be several hundred dollars or more. If you have to change the narration after you've recorded the final version of the sound track, you'll have to pay all those costs

again. It's also important to make sure the slides are going to fit with the narration, music, and any sound effects you plan to use. If you have any doubts about the timing of all the elements, prepare a rough version of the sound track and make adjustments until you've prepared an exactly timed script for the sound engineer to follow when they mix the final version of your sound track.

Choosing the Right Studio

If you live in a community large enough to support a number of recording studios, find one that specializes in slide-tape production. If you can't find a commercial studio, see if another producer has the necessary equipment and technical staff; try large corporations, community colleges, school boards, and hospitals.

When selecting a sound studio, make sure that it's suitable for recording narration. Music studios sometimes have hard-surfaced walls intentionally to reflect sound. The echo that this kind of surface produces enhances music, but it won't produce satisfactory sound for a recorded speech. The ideal narration studio is a small soundproof room with carpeting on the floor, padding on the walls to prevent echo, and a comfortable place for the narrator to sit and spread out the script for easy reading.

Selecting the right sound studio.

If you want to test the soundproofing, shut the studio door and listen for traffic sounds, typewriters, and ringing phones.

Selecting a Narrator

Although some producers narrate their own shows or ask someone in the organization to do the job, the results are rarely as satisfactory as those achieved with a professional narrator. Inexperienced narrators don't usually have as clear diction as professionals and their voices don't carry the same tone of authority. Novices also tend to make more mistakes, and the time needed to edit out mistakes could add extra time to the recording session and the bill.

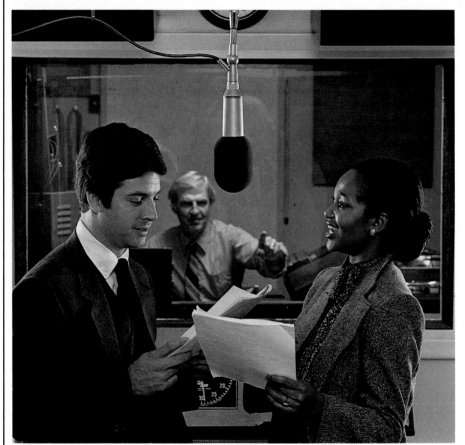
Selecting professional narrators.

If you don't know any professional narrators, ask the recording studio to recommend someone, or try a radio station. Either may have demo tapes prepared by a number of different people, and you shouldn't have much trouble finding a voice that suits the style of your production. If you have to use someone with no previous experience, look for someone who's an accomplished speaker. Teachers, ministers, and stewardesses are well qualified. So are members of clubs like Toastmasters and theatrical groups.

The fee will vary, depending on the length of the production and the experience of the narrator. If you want a well-known voice to add credibility to your show, expect to pay accordingly. Sometime a fixed rate may be less expensive than a per-hour-basis. Check with the studio for rates.

Recording Narration

Give the narrator a double- or triple-spaced copy of the script, but don't include the visuals. Mark any passages you want emphasized. Spell out all numbers (that is, nineteen thirty-five, not 1935) and put in phonetic spelling of all terms. Make sure all paragraphs end on the same page so the announcer will be able to change pages during the pause between paragraphs. If you want the announcer to pause at certain points, indicate the length of the pause by counting out the seconds in the script. (one thousand, two thousand, etc). Make identically marked copies of the narrator's version of the script for yourself and the recording engineer. Give the narrator a copy of the script a day or two before the recording session.

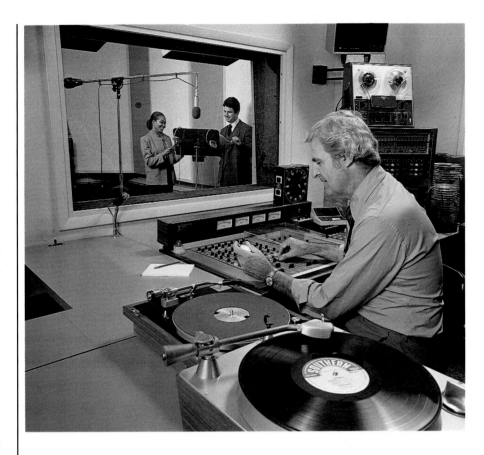

On the day of the session, ask the narrator to read through the script so you can suggest any necessary changes in emphasis. The technician can use this rehearsal to arrange the microphone and set the recording level.

Even an experienced pro will make a few mistakes during a recording session. When this happens, have the narrator back up to the beginning of the last paragraph after each mistake and then keep going. Make a note of each restart in your script so the engineer can edit mistakes out later. If the narrator makes several attempts at a section, note all of them and indicate which one you liked best.

When using an inexperienced narrator, let them know mistakes are natural and try to be as patient as possible. Caution the narrator to maintain the same tone, volume, and distance from the microphone throughout the production or the sound technician will have problems maintaining a consistent recording level.

Selecting Music

Most audiovisual productions, even those intended for instructional use, include a few minutes of music. Music can enhance a production when it's carefully chosen and mixed properly with the narration. As with printed materials and other media, music is covered by copyright, unless you get permission. It's against the law to rerecord even a few seconds of music.

Since it's usually too time-consuming to ask permission from commercial record companies and often too expensive to get it, most producers prefer to use original music or cuts from records prepared specifically for audiovisual producers. These records are developed with particular themes. Instead of the 10 or 12 songs found on most record albums, they contain dozens of short selections designed to introduce, bridge sections, or end a production.

Recorded albums.

You can't buy these records from record stores; you have to order them directly from the companies that produce them.

Check with local recording studios and other producers to see if they have a selection of records and someone on staff who can help you find the music you need. You'll have to pay for this assistance, but in the long run it can save you hours of listening if you have the advice of someone who's familiar with program music.

We suggest that you limit your use of music to a short composition at the beginning of the show and a short one at the end. Selecting suitable music takes some time, and the more you use the more difficult the job will be. Even though each individual music selection will only last 15 or 20 seconds, you can spend hours

looking for the right pieces, timing them, and figuring out exactly where to put them in your show. Once you've made the selection and have done the necessary paperwork to get approval from the record companies, it will take the recording studio at least 10 minutes to dub and mix each piece of music with the narration track. With studios charging over $50 an hour, an elaborate sound track can be expensive. Ironically the fee paid to the record company for the right to use each segment or "needle drop" will only be a fraction of the price you'll pay to mix your sound track.

Until you're familiar with the range of music selections available, limit your use of music to just the beginning and end of your show unless you can afford the services of a music consultant.

Sound Effects

Sound effects can add greatly to the realism and impact of certain kinds of productions; however, the cost of including them can be substantial. If this is your first show, don't use them. Unlike music segments, that can be used sparingly in a production, sound effects should be mixed through the entire sound track—the way they are in motion picture production. A few sound effects may not accomplish this objective. On the other hand, adding sound effects to an entire sound track can be time-consuming. Each new location in your show will require a different background sound. If your show includes a number of different locations, it could take days to go back and record all the necessary sounds. You can buy sound effects records but the sounds probably won't match your

images. Even if you record sound effects at the time you take the pictures, it will still take a lot of studio time to mix each effect in with your narration and music tracks.

Mixing Narration and Music

The mix takes place when you've chosen your music, figured out how you want to use it, and recorded the narration. Although you can just tag music onto the beginning and end of the narration, it will blend better and sound more polished if it is actually combined with the narration.

When you're ready to mix the narration, music, and sound effects, have each of these segments picked out so you can find them quickly. Give the recording engineer a copy of the script with all the inserts clearly marked. If you want the music to begin 15 seconds before the narration begins and fade out after the first minute, indicate that in your script. Preplanning is important when you're paying $50 or $75 an hour for studio time.

The sound mix is usually done using quarter-inch tape to provide maximum recording quality and to allow editing if required. But the final copy of the production used for recording the synchronization signals could be on either quarter-inch tape or cassette. Some producers prefer to have their master sound track and synchronization signals on quarter-inch tape because it produces slightly better-quality cassette copies.

SYNCHRONIZING THE SLIDES AND TAPE

By presenting your message with music, sound effects, and carefully coordinated visuals, you can make a much stronger impression on your audience than with just a verbal presentation. By synchronizing these elements to play back automatically, you can send your message to audiences you can't reach personally and have it delivered exactly the same way every time.

Synchronizing a slide-tape show is a fairly simple procedure. Tape recorders with sync capability make it easy to add signals to your sound track that will make the slides change automatically. In this section we'll discuss the different equipment options to consider and then describe how to do the job.

A synchronized slide-tape show can be a very powerful tool, but if your intended audience and objectives demand a professional-quality production and the elements of your show—the slides and the sound track—don't meet professional standards, synchronizing the show may be a mistake.

Once you automate a production, audiences tend to judge it by the standards they expect from broadcast television and movies. If you can't meet those standards, a slide lecture delivered informally by a "live" speaker may be a better choice than a synchronized show.

Before you attempt programming a show, make sure your intended audience has the necessary playback equipment. The presentation won't be as slick if you have to record the show with audible slide-changing signals, but if you want the show to reach audiences in remote communities, and you can't send playback equipment along with the show, you may have no other choice.

Before we describe the different alternatives for programming shows, we thought we should briefly explain how synchronized shows are usually produced.

The process is actually quite simple. Just hook up a slide projector to a tape recorder that has synchronizing capabilities. Play the sound-track tape, and press a button on the tape recorder every time you want a slide to change. This permanently records a 1,000 Hz signal on the upper half of the tape that automatically changes the slides whenever the show is replayed. The tape can only be used on *one* side because narration and sync signals use the entire width of the tape.

A 1000 Hz signal is recorded on the upper half of the tape.

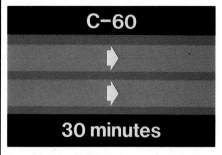

A normally recorded C-60 tape runs 30 minutes in one direction and 30 minutes in the other for a total playing time of sixty minutes.

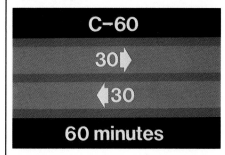

A synchronized slide-tape program uses both channels of the tape at the same time (for narration and slide change cues). Therefore the tape can be played in only one direction. A show that lasts 30 minutes can be played on a C-60 cassette.

If you're using two projectors and a dissolve unit, the procedure is the same except there's a dissolve unit in between the two projectors and the tape recorder.

Tape Recorders

Although you can use a stereo reel-to-reel tape recorder to program a slide show, many producers prefer to use cassette recorders with sync capability. Cassette recorders are portable and easy to use. In the last few years manufacturers have developed compact affordable recorders with stereo sound, dissolve, and special effects capability—features that used to be possible only with multi-image production. Along with models designed for programming, some manufacturers also make less-expensive machines designed for playback only.

KODAK EKTAGRAPHIC Slide Projectors, a Recordex* tape recorder, and a KODAK EKTAGRAPHIC Programmable Dissolve Control.

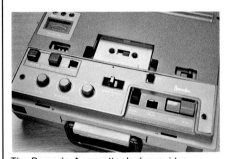

The Recordex* cassette deck provides monaural and an adjacent cue track.

The Cuesette, a self-contained stereo-cassette deck from Sauppe Media, incorporating a stereo amplifier, a separate cue track, and built-in speaker.

The model 144 Portastudio from TEAC is a unique four-track cassette deck and mixer that enables producers to create multitrack master sound tracks in the cassette format.

*Registered trademark of Recordex Corporation, Marietta, Georgia

Stereo Open-Reel Machines

You can use a standard open-reel-tape recorder provided you hook up a synchronizer such as the *KODAK* EC Sound Synchronizer, and the machine is capable of recording two separate tracks independently and playing both back at the same time. (You'll need one track for sound and the other for the inaudible slide changing signals.) Some stereo-tape machines have the required capability, and if you already own the equipment and you can't afford to buy or rent a cassette recorder, there's no reason other than portability why you shouldn't use reel-to-reel stereo. In general, the sound is superior.

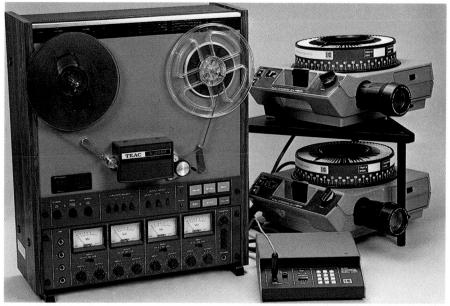

Four-track tape units, such as the TEAC tape recorder, are popular because they offer stereo sound plus two additional tracks for synchronizing cues.

Standard open-reel tape recorder.

KODAK EC Sound-Slide Synchronizer.

Audible Slide Changing Signals

If you don't think the people wishing to use your show will be able to find compatible playback-tape equipment, you can produce the show by recording audible slide changing signals on the narration sound track. These audible tones tell users when to change the slides. To play back a show produced this way, users need only a standard cassette tape recorder and a projector, both of which are likely to be available in most areas.

Selecting a Cassette Tape Recorder

We recommend that you program your show on equipment that is compatible with the playback system used to present the show when it's distributed. This doesn't mean that you have to use the same name brand of equipment, but the playback recorder should operate with the same type of programming signals.

If you're responsible for selecting playback equipment, choose a recorder that is lightweight, easy to operate, and sturdily constructed. Also consider buying models that can be used for playback only. These are less expensive than the ones that allow programming, but you should realize that you are limiting future uses of the equipment. If the recorder is going to do a lot of traveling, then buy one with a sturdy shipping case.

Projectors

Projectors such as the *KODAK EKTAGRAPHIC* and *EKTAGRAPHIC* III Projectors are designed to meet the demanding needs of both semi- and professional users and incorporate many special features necessary for slide-tape production and playback—such as a heavy-duty motor designed to stand up to continual use, and a projection gate that maintains precise alignment of slides necessary for two-projector and multi-image productions. The *EKTAGRAPHIC* Universal Slide Tray, Model 2, (80-slide capacity) allows reliable continuous playback in exhibitions and displays, and the projectors are designed to withstand rough handling and years of constant use. These features plus the wide range of accessories have made Kodak's products the most widely used by industry, educational institutions, and other organizations.

If the projector you select is used for playback as well as production, consider getting a zoom lens that will allow you to vary the image size to fit a variety of projection locations. Also consider getting a model with a fold-up viewing screen and an automatic timer.

Dissolve Control

There are many types of dissolve units available for purchase. Basically the dissolve unit creates the dissolve effect by fading one image off the screen and replacing it with an emerging image. This effect is controlled by the length of time that it takes to simultaneously turn projector lamps off and on. The majority of equipment on the market today offers dissolve rates from less than 1 second to more than 30 seconds. When selecting a dissolve unit for two-projector dissolve programming, choose equipment that will be compatible with equipment used by the people who will present the show. Dissolve units such as the *KODAK EKTAGRAPHIC* Programmable Dissolve Control make it easy to produce two-projector slide shows with sophisticated visual effects. You can choose from five dissolve rates, ranging from cut (a 1-second dissolve) to 8 seconds, plus special effects including flash, freeze dissolve, superimpose, animate, and reverse dissolve. (Reverse dissolves make it simple to go back to the previous slide, during either live or programmed presentations.) You can operate the Dissolve Control directly from its keyboard for live slide shows, or with a *KODAK* EC Remote Control (using a single dissolve rate); and you can record the dissolve signals with an audiotape recorder to create a programmed presentation.

KODAK EKTAGRAPHIC III Projectors.

KODAK EKTAGRAPHIC Universal Slide Tray.

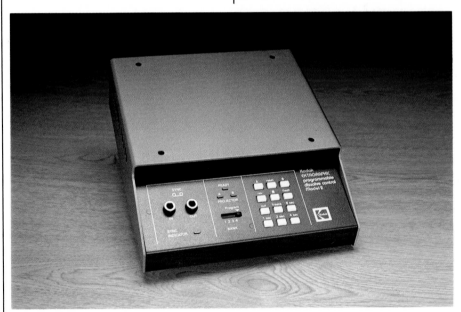

KODAK EKTAGRAPHIC Programmable Dissolve Control.

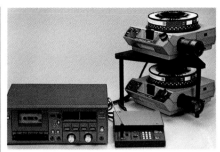

KODAK EKTAGRAPHIC Programmable Dissolve Control connected to two EKTAGRAPHIC III Projectors and a TEAC 124 Syncaset recorder.

If you're not familiar with the equipment you're renting, ask the dealer for an instruction booklet. If the dealer can't provide a set of instructions or you don't think you'll be able to follow them, ask the dealer to let you set up the equipment and try operating it before you leave the store.

Programming Your Show

To program a show you need a projector, a tape recorder with sync capability or a reel-to-reel tape recorder, and a synchronization device such as KODAK EC Sound Slide Synchronizer. You also need a master copy of the sound track and a finalized tray full of slides. The sound track should be in its final form since you'll use this tape to make duplicate copies for distribution.

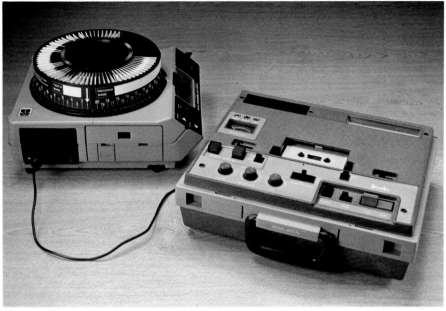

An EKTAGRAPHIC III Projector connected to a Recordex tape recorder for cassette programming.

If the titles and a few other slides aren't ready, you can program the show without them, provided you put a dummy slide in for every missing slide, and you know how long these missing slides should stay on the screen. KODAK EKTAGRAPHIC Write-On Slides make good temporary substitutes for the missing slides. (See page 94.)

You should also have a copy of the script marked with every slide change, and complete privacy. The last ingredient is included because it takes a great deal of concentration to program a show. If you're interrupted, you'll probably make a mistake.

Because most producers use cassette recorders with sync capability, the following directions have been written with them in mind. If you're using a reel-to-reel machine instead, read the directions that come with the synchronizer and adapt our directions accordingly.

IMPORTANT: Because some tape recorders record sound as well as syncronization signals, you will erase your sound track if you accidently push the sound recording button when you intended to push the slide synchronization button. Read the directions that come with the equipment to determine which button is for sound recording and which is used for recording narration. To make sure you understand how to record the synchronization signals and play them back, practice recording the signals with another cassette tape. Use any tape you have handy as long as you don't care what happens to it. Play your practice tape on the cassette machine and try recording some slide-changing signals. When you've finished recording a few signals, play the tape back and see if the slides automatically change to match the signals you've recorded.

If you or someone from your organization isn't going to be around every time your slide show is screened, leave instructions for the users to always start the show with a dark screen. This may seem like an insignificant detail, but if your show starts and ends with a glaring white screen, the show may create an amateur impression which the rest of the presentation may never quite dispel.

Blank slide.

If users have an *EKTAGRAPHIC* Projector manufactured since early 1979, you won't have to worry because the screen will remain dark until a slide drops into the gate, and it will go dark again after the last slide.

But if the models were manufactured prior to 1979, you'll have to start and end the show with blackout slides, otherwise light from the projector will shine on the screen.

Many producers get around this problem by putting a blackout slide in slot 1 of the slide tray, and another blackout slide after the last slide in the show. If you adopt this approach, make sure you inform users of this procedure in the instructions. Otherwise they may panic and change the bulb in the projector when they don't get any light on the screen with the first slide.

Other producers put the first blackout slide in an envelope taped to the inside of the projector box and the other blackout slide in the tray after the last slide in the show. Instructions telling users how to run the show should mention putting the loose blackout slide in the projector gate before putting on the slide tray. If you take this alternative, explain to the users that the dark slide will move up into the "0" slot on the tray, as the first slide in the show appears on the screen. The instructions should also remind users to return the loose blackout slide to the envelope when they're finished screening the show. Each method has its advantages and disadvantages. If you put the blackout slide in the first slot of the tray, you're taking up a slot you'll need if your show is 80 slides long. Also, some users may not read instructions carefully and they'll start the show from "0" instead of slide 1. Not only will that start the show with a white screen, but the show will continue to run one slide out of sync!

On the other hand, if you put the blackout slide in the envelope, users may forget to put it back in the envelope after the show, leaving future users to start the show with a white screen. Whichever you decide, you must make the decision now because the sound-track tape will have to be programmed with a signal for every slide in the show, including blackout slides. The new *EKTAGRAPHIC* Projectors, with the dark screen feature, eliminate these problems.

Marking Your Script

If you haven't already done so, mark your script to indicate each slide change. Since it takes a second for the projector to respond to a signal and change the slide, mark the change 1 second or two or three words ahead of the place where you want the slide to appear on the screen. Number each change to correspond with the number of the slide on the screen, but make these marks with pencil in case you want to change slides later.

Mark your script for each slide change.

Practice Programming

Although you may be able to program the show exactly as indicated in the script, you may want to make a few changes when you see slides actually synchronized with the sound track. Make your first programming effort a test run. If you program a few signals early or late, don't worry, just keep going and program the rest of the slides to match the script as closely as possible. When you're finished, play the tape back and watch the show to see if the slide changes marked in the script require any adjustment. If so make the changes on the script and program the tape again. As you program the new signals, the tape recorder will automatically erase the previous ones. When you've finished programming the second time, watch the show again to see if you still need to adjust some of the slide changes.

Programming for Keeps

These practice runs should help you get used to the equipment, so that when you come to make your final copy, you should be able to do the job with a minimum of mistakes.

If you make a mistake programming, you have two choices: You can either rewind the tape and reset the slides back to the beginning and start over, or you can back the slides and tape up just before the signal to be changed and start again. If you've made a mistake within the first 2 or 3 minutes of the show, go back to the beginning and start the job again. If you're close to the end of an otherwise perfect programming run, the fiddling required to backtrack may be worth the effort.

Correcting Mistakes

1. When you make a mistake, stop programming.

2. Using the reverse slide changing mechanism on your projector, back the slide tray up one slide at a time until you come to a slide that you know is on the screen for 7 seconds or longer (slide X).

3. Disengage the slide-sync mechanism, so you can replay the tape without the signals triggering slide changes.

4. Rewind and forward the tape until you find the words that match the slide on the screen.

5. Back the slide tray up to the slide just before slide X and back the tape up a few more seconds.

6. Engage the slide-sync mechanism and allow the tape to play just enough so it triggers the signal for slide X.

7. As soon as the slide has changed to slide X and you're sure the slide is correctly synchronized with the tape, begin programming again.

8. If you make another mistake, back the tray up again a few slides until you find one that stays on the screen for 7 seconds or longer and repeat the procedure just described.

9. When you reach the end of the show, replay the slides and tape to make sure you haven't accidently erased any of the signals.

NOTE: We suggest you back the slides up to a slide that is on the screen for 7 seconds or longer because you'll need that much time to get the tape rolling at the correct speed before you have to program the next signal.

When you've finished

When you have finished programming your show, remove the small plastic tab from the edge of the cassette.

programming the tape and replayed it to make sure the slides are correctly synchronized, remove the small plastic tabs from the edge of the cassette (see illustration). By removing these tabs, you prevent anyone from accidently erasing the tape. If you decide in the future that you want to reprogram the cassette or even rerecord a new sound track, put small pieces of pressure sensitive tape over the two holes.

Label the cassette clearly indicating the title of the show and that this is the master cassette. As with original slides, use this cassette only for making the duplicate copies required for distribution.

Place a small piece of tape over the opening if you want to reprogram your show.

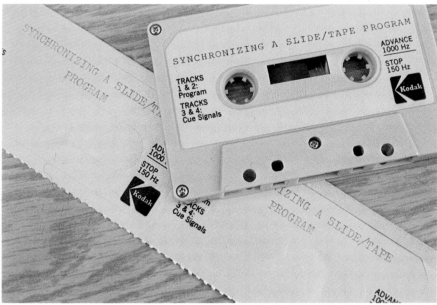

Label the cassette clearly.

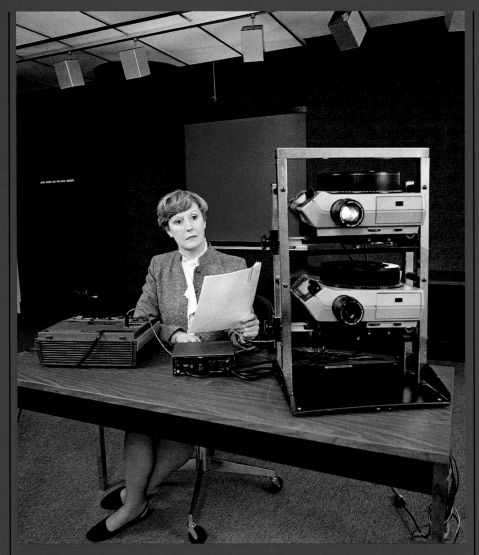

EVALUATING THE PRODUCTION

If you ask most audiovisual producers whether they adequately evaluate their productions, most would answer "yes." When a production is finished they always screen the show to make sure all the slides are properly exposed, and focused, every word on the sound track is clear and distinct, and all the slides change on cue. When they're satisfied the show is technically perfect, they call in the sponsors for a screening to make sure it matches the original specifications.

If everyone's satisfied, copies are produced and distributed. From then on if no one complains loudly about some aspect of the production, the show is deemed to be a success.

The problem with this kind of evaluation is it doesn't go far enough. While producers and sponsors are capable of judging the technical quality of a production, they are usually too familiar with the content to judge whether the show's going to be effective.

Even members of the organization who had nothing to do with planning or producing the show usually know too much to be objective reviewers. If they do think revisions are needed, they're often too polite to say so.

Usually by the time a show's finished, all the budget has been spent, producers have other jobs waiting, and sponsors are anxious to distribute the production. For all these reasons it's frequently impossible to revise a show after it's been completed and approved.

Even if the show is right on target, further evaluation should still take place, or the show may never achieve its intended objectives. If the people presenting a production aren't the same ones who produced or sponsored it, a few things can go wrong:

Faulty Copies—Unless every single second of every copy is checked from beginning to end, errors are bound to occur. Even if copies are perfect at the time of distribution, they must be checked periodically to make sure the audiotape hasn't stretched, jammed, or been erased; the slides are still in the right order; and the show still runs in synchronization.

Distribution Problems—Unless intended users know a production is available and they understand how to obtain and operate equipment and present the show, copies may never leave the shelf.

Presentation Problems—Shows sometimes fail because the people running them don't choose adequate facilities or understand how to operate the equipment.

Even if they manage to get the slides and tape running in synchronization, they may not introduce the show properly or allow time for intended follow-up activities.

In the last 20 years, researchers in a variety of disciplines have developed very effective evaluation strategies, but so far few of these have been adopted by audiovisual producers. This is hardly surprising, however. The word "evaluation" conjures up quite negative associations for many people who assume evaluators are tight-lipped outsiders who stand at the sidelines making unfavorable judgements.

While this fear of evaluation may have been valid 20 years ago, current evaluation is a great deal more than just after-the-fact judgment. If a series of evaluations are conducted right from the time a production is first discussed and continued for as long as the production is in use, evaluation procedures can do a great deal to make sure the production achieves its intended objectives.

Formative Evaluation

This type of evaluation is conducted to help keep a production developing along the right lines. The term "formative" means the evaluation is conducted while the production can still be changed if the evaluation indicates it's necessary.

In the case of an audiovisual production, formative evaluations should be conducted at the following stages:

- When a treatment has been produced.
- When the first draft of the script with proposed visuals has been developed.
- When a rough version of the narration has been recorded and synchronized with the slides.
- After a final mixed version of the sound track has been prepared and synchronized with the slides.

You're probably thinking these are the points to have evaluated when the sponsors review the production. But for reasons we've already explained, neither you nor the production's sponsors are capable of judging much more than technical quality. You need an outsider to determine whether the production's objectives are likely to be achieved.

If you're serious about conducting a thorough evaluation, and you ought to be if you want your production to be a success, consider asking someone from outside your organization to review the production at all of these stages.

Pilot-Testing

Once a production is completed and it's ready for distribution, some organizations pilot-test the production with sample audiences to determine what kind of introduction, follow-up activities, and handouts should be developed to reinforce the production's impact.

Ongoing Evaluation

This is conducted several times per year after a show has been distributed to make sure copies are getting presented as intended and they're still functioning properly.

This evaluation can be conducted by the person responsible for distributing the production, but if the producers and sponsors are wise, they'll check to make sure this kind of ongoing evaluation is being done.

For more details on how to arrange for follow-up evaluations, see the following chapter on distribution.

Summative Evaluation

This kind of evaluation is conducted to see if a production has achieved it's intended objectives. Funding agencies often demand a formal evaluation and require that it be carried out by an evaluation specialist. Even if you don't have to prove what your show has achieved, consider doing so if you want to continue producing shows.

MAKING DISTRIBUTION ARRANGEMENTS

As the producer of a show, your responsibility usually ends after the copies have been prepared and distributed, but if you're wise you'll monitor the show every 6 months for as long as it's in use to make sure everything is functioning as intended.

Remember the show has your name on it. If the show doesn't get proper distribution or isn't properly presented, your reputation as producer may suffer.

All too often the details of distribution are overlooked and an otherwise excellent production gathers dust for one or all of the following reasons:

- Potential users don't know the show exists.
- Potential users don't have the necessary playback equipment.
- Potential users don't have the expertise needed to operate playback equipment.
- The show has broken down because some of the slides are warped or missing; the synchronized tape has jammed or is lost altogether.

In other cases users don't present the show as intended, and as a result

Making distribution arrangements.

- The show is screened for the wrong audiences.
- The slides and sound track are allowed to run out of synchronization.
- The show doesn't get a proper introduction so audience members don't understand what's expected of them.
- Follow-up activities designed to reinforce the message don't take place as planned or don't take place at all.
- Important handouts don't get distributed.

Planning Distribution

Often truly excellent shows don't get adequate distribution because nobody knows they've been produced. If possible, figure out exactly where you're going to distribute copies of the show, and how you're going to let people know copies are available BEFORE you begin production. You need to plan in advance so you can accurately budget the cost of making copies and distributing them.

These are some of the other important points you have to consider in developing a distribution plan.

- How many copies will be required?
- Will your organization be responsible for shipping the copies? If so what will this cost?
- Who will be responsible for distributing the copies and maintaining them?

- What will be done to make sure potential users know the show is available and have the equipment and instructions required to operate it?
- Are there funds available to pay for additional copies and update them if required?
- Will copies be prepared in other formats such as two-projector dissolve, video tape, 16 mm or filmstrip?
- Where will the master set of slides and tapes be stored, and who will be responsible for seeing that the master show stays intact and is used only for making duplicates?

Designating Someone in Charge of Distribution

Since you probably won't be responsible for maintaining copies of the show once they've been produced, make sure someone agrees to take on this responsibility. This person should be as familiar with the operation of the equipment and the requirements for the production as you are, and equally dedicated to seeing that the copies are always presented as intended and that they're maintained in working order.

Whenever possible this person should be assisted by others in the organization who are also familiar with the operation of the equipment. These backup people are important because users should be able to contact someone if they have problems running the show.

Even if the people designated to handle distribution and troubleshooting are entirely familiar with the equipment, you should hold a training session to make sure they're familiar with your particular show.

Make an arrangement with the person in charge of distribution to keep a record of each time the show is used, who used it, why they used it, how many people were in the audience, and whether they found the show useful. This record should also indicate if users had any problems running the production and summarize suggestions they have for revisions. To make the gathering of this information as simple as possible, include a form on which this information can be recorded whenever the production goes out. Make this form as easy to complete as possible. If users don't fill it out, ask the person in charge of distribution to call and obtain the information.

If accurate records like these are kept, you'll be able to determine quickly if the show is being used often and if it's being presented to the intended audiences. These records will help you justify the cost of the production and alert you to a need for further action if it turns out the shows aren't getting distributed as widely as intended.

Make sure the copies are replayed from start to finish every time they're loaned out to make sure they have not been mishandled.

Publicizing the Existence of the Production

Publicize the production in a memo to all staff members, and if possible arrange screening sessions for all the people you think might want to use the show. If you keep these groups fairly small (no more than 30), you could combine the screenings with a training session to show users how to present the production and conduct follow-up activities. If you can round up enough sets of equipment and copies of the show, give users the opportunity to practice setting up and operating the equipment.

Keep track of who attends these sessions so you can check in the future to see if they actually use the show.

Conduct screenings once or twice a year to make new staff members aware of the production's existence.

If your organization has a reference library, catalog the production. Consider producing a poster publicizing the show that can be permanently mounted on a wall in the reference library, training area, or other suitable place.

Instructions

Even if you're fortunate enough to get all users to attend training sessions, you should still include a detailed set of instructions with each copy of the show because users probably won't remember all the directions given in the training session. In preparing instructions, make sure you include the following:

1. A list of what's included in the package—tape, slides, copy of the script, evaluation form, discussion guide—and handouts if provided. Ask users to make sure that all these elements are included before they check out the copy.

2. Provide the names and numbers of several people who can be called upon if the user has problems running the equipment.

3. Specifications for the equipment required to run the production. If possible, include brand names and model numbers.

4. Tell users where they can obtain the required equipment and how much it's likely to cost if they have to rent it. If you can't provide the names of reliable rental companies, list the organizations which might supply the equipment—that is, audiovisual dealers, photographic dealers, school board, community college.

5. Provide users with step-by-step instructions for operating the equipment, changing a bulb if required, introducing the show, and conducting follow-up activities.

6. Suggest to users that they set up the system and get it operating before they leave the place where they've obtained it to make sure it's running properly.

7. Remind users that equipment borrowed or rented by a number of different people is quite likely to break down and they should have fast access to a backup system if the presentation is critical.

8. If there's any chance users may screen the show for audiences larger than the equipment was designed to handle, tell them to get auxiliary speakers and a high-intensity projector.

9. Remind users to make sure the room they select has adequate power, accessible outlets, and can be blacked out. Tell them to rehearse the show well in advance of the arrival of the audience.

10. If copies of the show are available in other formats—two-projector dissolve, video, filmstrip, or 16 mm, let users know these options are available.

If possible condense all this information on a single sheet of paper that can be attached to the top or inside the top of the slide tray box. If you're having problems getting all this on one sheet, try photo reduction. Label the tape and the slide tray as well and add any pertinent notes like "show starts here" with an arrow pointing to slot #1.

Cover the instructions with plastic so they don't get stained and stay securely attached to the box. We recommend you attach the instructions because if you include them on a loose sheet of paper, they're likely to get lost.

Look over the sample set of instructions we've provided and adapt it to your own requirements.

Although there's a good chance it will have to be replaced again and again, include a copy of the script with descriptions for each slide. If possible, use photo copies of the slides instead of verbal descriptions. You can reproduce these by putting the slides into plastic sheets and laying them on top of a photocopy machine. This process will produce black-and-white copies of the slides that you can cut up and paste into a master version of the script.

The slide copies won't look that great, but they should provide enough detail for users to tell if the slides and tape are properly synchronized.

NOTE: The *KODAK EKTAGRAPHIC* Universal Slide Tray, Model 2, box is capable of holding two cassette tapes plus a copy of the script.

DUPLICATING THE SHOW

Once you've produced your show, you should have at least one duplicate set of slides made. Wise producers never project the original slides. There are many reasons for this, but if some unforeseen situation should occur, you can always have another set made and all of your weeks of hard work won't be lost.

Preparing the Slides for Duplication

- Carefully clean the slides before you have them duplicated.

- Use a pencil and indicate on each slide mount exactly what you want done. If you want special cropping, exposure correction, different color balance, enlarging of the image, make sure that all of this information is clearly indicated with each slide. It is also a good idea to record this information on a separate sheet of paper for later reference.

- Specify the number of duplicate sets that you require. Smaller orders are produced by duplicating them on reversal film. With larger orders, it may be less expensive to have the slides duplicated on a negative stock and use the negative to make the copies. Check with your lab on pricing.

- Duplicate slides are usually mounted in cardboard mounts unless otherwise specified. If you have other needs, specify them to the lab. For example, slides that have been shot with a pin-registered camera should be duplicated with a pin-registered camera and mounted in pin-registered glass mounts. The width of the slot in the slide tray that you are using will also dictate the kind of mount you use. Trays such as the *KODAK EKTAGRAPHIC* Universal Slide Tray, Model 2, or Universal Deluxe Covered Slide Tray will hold slides up to ⅛-inch (3.2 mm) thick (glass, plastic, or cardboard).

- If the lab is going to number the slides, have them numbered so that they match the original order. If the lab has the facilities for numbering the slides and loading them in trays, it might be to your advantage for the slight additional cost to have the lab perform this service.

- If you are using a custom duplicator because some slides need special attention, provide a detailed list of what should be done with each slide.

- Be careful *not* to mix duplicated slides with original slides. Magnification differences may occur and this will be noticeable during projection.

It takes a fair amount of experience and some expensive equipment to make duplicate slides in a hurry, and many producers prefer to leave this work to a laboratory. However, if you plan to produce shows with a lot of "burned-in" titles and other special effects that involve duplicating slides as part of the process, you may decide to invest in duplicating equipment and use it to make both titles and copies.

We recommend that you investigate the services provided by your local laboratories and that you become familiar with them. You will probably save both time and money by using these facilities.

Duplicating the Sound Track

If your show is "canned" or is run by a programmed tape, you will also have to duplicate the tape. Make sure that if you have a programmed tape with slide changes included that narration and slide change are duplicated at the same time.

TRANSFERRING A SLIDE SHOW TO ANOTHER MEDIUM

Transferring a Slide Show to 16 mm Film

Because compatible slide projection equipment may not be available, producers may decide to transfer their shows to 16 mm film for projection. Projectors using 16 mm film are widely available, standardized, easy to use, and unlike video, the image can be shown to groups larger than 100.

The slide show can be filmed while it's running on a front- or rear-projection screen or the transfer can be done by a lab using professional equipment designed for this transfer. You'll get best results with a professional transfer but the price is somewhat more expensive.

Video Cassette

Some producers have made the transfer to video tape as a distribution medium for their slide shows because

- Videotape cassette copies allow playback of two-projector dissolve shows in daylight conditions with a minimum of equipment.
- Videotape cassette copies are less expensive to produce and easier to ship than slide-tape copies.
- Transferring the show to video allows broadcast on television and cable systems.

Transferring your show to another format.

Transferring a slide show to video tape can be done by taping the show while it's projected on a front- or rear-projection screen, but you'll get the best results if you have the show transferred by a commercial lab using a telecine chain. However, be prepared to accept some loss of image quality, but you can minimize this if you tape on the widest tape available. Like recording tape, the wider the tape carrying the signal, the better the image quality. If you're going to produce a number of ¾- or ½-inch cassette copies, have your master copy produced on 1-inch tape.

Remember, the image proportions of video tape are different from those of slides. When you transfer a slide show to video tape, as much as one-third of the slide may be cropped. If critical information is located too close to the borders of your slides, it may be lost when the slides are transferred to video. When preparing graphics, use the template on page 91. If you have a camera with a removable focusing screen, mark the "TV safe" area on the focusing screen in order to use it as a guide when you're shooting photographic images and graphics (see page 91).

STORAGE AND CARE OF KODAK FILMS

Unprocessed photographic films are perishable products subject to damage by (1) moisture, (2) heat, (3) harmful gases, (4) X rays and radioactive materials, and (5) physical abuse. Color films are more seriously affected than black-and-white films because these conditions usually affect the three emulsion layers to different degrees, causing a change in film speed, color balance, and contrast. Adverse storage conditions usually cause much larger changes in the color quality and speed of the film than any permissible variation in manufacturing. Moisture at any temperature may also cause various physical defects such as mottle and abrasions.

To prevent detrimental effects on unprocessed film, proper storage is necessary both before and after exposure. When climatic conditions are moderate, the precautions are few and simple. Greater care is necessary under hot and humid conditions.

Storage In the Original Package

Kodak supplies rolls of 135, 126, and 110 film in water-vaportight packaging. The 135 films are packaged in snap-cover plastic cans; the other films in heat-sealed foil pouches. The vaportight packaging provides necessary protection from humidity in areas such as tropical regions or any other locality where high relative humidities (RH) prevail. You may encounter such conditions in a number of areas, especially during the warm summer months.

Protection from Humidity

Kodak films supplied in vaportight packaging require no additional protection against high humidities until you open the package. *So don't open the vaportight packaging until you are ready to use the film!* Otherwise, the protection originally provided is no longer effective.

You can determine the RH with a humidity indicator such as the type sold for home use.

Protection from Heat

Vaportight packaging is not heatproof. Regardless of the type of packaging, don't leave your films near heat registers, steam pipes, or other sources of heat. In warm weather, do not leave them in areas on the top floors of uninsulated buildings or in hot places in a car.

As we mentioned earlier, Kodak color-negative films and Kodak color-slide films are both available in films designed for general use and in films designed for *professional use.* The requirements for storing and handling color films for critical photography by professional photographers are more rigid than those for films for general use.

When Kodak color films for general use are made, the changes in speed, color balance, and contrast that will occur from natural aging are anticipated. The film is manufactured to have optimum quality when it is most likely to be used by the photographer. Kodak color films for general use are designed for storage at normal room temperature before use. The film should be protected from heat.

Kodak professional color films are designed for optimum performance to make the best pictures at the time of manufacture without regard for changes that may occur under general or nonprofessional use. To retain the original characteristics for critical photography where small color deviations would be important, professional color films should be stored under refrigeration before exposure.

Most Kodak films for professional use and for general use are equally as stable for photographic quality when they are used under identical conditions.

For normal temperature conditions, 75°F (24°C) or below, Kodak color films for general use and most Kodak black-and-white films do not require refrigeration.

The film carton and the instruction sheet packaged with some films tell how to store the film. The storage recommendations for Kodak films for general use say PROTECT FROM HEAT; those for Kodak professional black-and-white films say STORE IN A COOL, DRY PLACE; and those for Kodak professional color films that should be refrigerated say STORE AT 55°F (13°C) OR LOWER. A special-purpose film such as *KODAK EKTACHROME* Slide Duplicating Film 5071 requires storage at 55°F (13°C) or lower.

During summer heat, with temperatures over 75°F (24°C) for extended periods of time, we recommend refrigerated storage for keeping all Kodak films cool, provided they are in vaportight packages or in sealed cans or jars. To avoid condensation of moisture on cold film surfaces, remove unopened film packages from cold storage and allow 2 to 4 hours for them to reach approximate room temperature before you open the package.

When the ambient temperature has returned to normal, 75°F (24°C) or below, remove Kodak color films for general use from refrigerated storage so they can age normally as anticipated in manufacture.

If after testing some rolls of film you want to maintain the film at that specific color balance for an extended period, you can store other rolls of the same emulsion in a refrigerator or freezer. The emulsion number is printed on the film carton.

You can store unexposed black-and-white films under normal temperature conditions, temperatures that don't exceed 75°F (24°C). For storage over long periods of time, it's desirable, when possible, to maintain the following storage temperatures for black-and-white films:

For storage periods up to	2 months	6 months	12 months
Keep black-and-white films below	75°F 24°C	60°F 16°C	50°F 10°C

When you're traveling in a car, don't leave your film in a closed car parked in the sun on a warm, sunny day because the temperature can quickly reach 140°F (60°C) or more. If this is unavoidable, keep your film in an insulated container, such as an ice chest like those used for camping, or an insulated picnic bag.

Avoid keeping your film in the glove compartment, on the rear window shelf, over hot spots on the car floor, or in areas in direct sunlight inside the car.

The coolest area for protecting your film from heat in a car in the sun is in the passenger compartment with the air conditioner on or the windows open, especially when the car is moving. The best location is on the car floor in the shade away from hot areas over the exhaust system or transmission. With a light-color car parked in the sun on a warm or hot day with the engine off and windows closed, the car trunk is usually somewhat cooler and is a better storage area for the insulated container than the hot passenger compartment. With a dark-color car the passenger compartment, though hot, is usually slightly cooler than the trunk. However, if there is a buildup of heat from the engine and exhaust system in a parked car after traveling at highway speeds, it may be better to put your insulated film container in the trunk which, although hot, may be slightly cooler than the passenger compartment. It's good practice to limit subjecting your film to heat in a car during warm or hot weather to as short a time as possible.

If ice or cold packs are available, use them to help keep your film cool. If you use ice, keep the film packages dry.

Expiration Date

Use the film promptly. You should expose and process each roll of Kodak film before the expiration date printed on the package. Films kept beyond this date may be unsatisfactory due to changes in speed, contrast, fog, stain, color balance, and color reproduction. The last three effects, of course, apply only to color films. The magnitude of changes in a film is largely dependent on the conditions of storage. Proper storage conditions decrease the rate of changes inherent in films but won't eliminate changes entirely.

PROTECTION FROM X RAYS

X-ray equipment can fog your unprocessed film when the radiation level is high or the film receives several low-level doses. The effect of exposure to X rays is cumulative. Film that has been processed, however, is not affected.

For the protection of travelers, many airports, airlines, and law-enforcement agencies around the world are using electronic devices to check passengers and X-ray equipment to check their luggage for concealed bombs and weapons. If you travel by commercial airline, your luggage may be subjected to X-ray examination each time you prepare to board the aircraft. All carry-on luggage is X-rayed unless you can obtain a visual inspection instead. Checked luggage may also be X-rayed.

While some X-ray exposure can usually be tolerated, excessive amounts may result in objectionable fog and extraneous shadow images on film contained in the luggage. It is usually possible for passengers to avoid this danger to their unprocessed film by hand carrying their supply, including loaded cameras, and requesting a visual rather than an X-ray inspection of it. The walk-through and handheld electronic devices used at many airports to check passengers separately from their luggage are not X-ray equipment and have no effect on film.

In the United States, at the airport boarding gates for domestic airline flights, federal regulations require that X-ray inspection be conducted only with low-output devices. These subject the luggage to less than 1 milliroentgen (mr) of X-ray exposure per inspection which should not perceptibly fog camera-type films. However, since the effects of X rays on film are cumulative, it is possible for films to be fogged by repeated exposures of less than 1 mr each but totaling 5 mr or more. So for travel within the United States, requests for visual inspections should be unnecessary—unless more than five inspections are encountered with the same film.

Visual inspection of film is particularly important when traveling abroad, including traveling by airline from international air terminals in the United States. A wide variety of luggage-inspection systems may be encountered both for checked and carry-on luggage. Some of these systems are known to operate at relatively high X-ray levels. If you are unable to obtain a visual inspection, we suggest that you ask pertinent questions of airline authorities to determine in doubtful situations whether your film can be damaged.

If you plan to use *KODAK* Processing mailers, you can send your exposed film to a Kodak Processing Laboratory instead of carrying it with you and risking exposure to X rays.

If you're in doubt about the safety of the equipment in use, or if your luggage will be examined more than five times, or when you're traveling to a foreign country, you can minimize the possiblity of damage to your film in the following ways:

- Carry your film in hand luggage, arrive early, and ask airport authorities for a visual inspection at each checkpoint, stressing the fact that the sensitive photo material you're carrying might be ruined by X rays. Not all inspectors will cooperate; however, those who do will help reduce the possibility of film damage.

- Each time you pack your bag, arrange the contents so that the film is not always oriented in the same way. You can achieve a similar effect by orienting your bag differently each time it passes through X-ray inspection.

- Carry *KODAK* Mailers or other mailers provided by photofinishers on your trip, and mail each roll of film in for processing as soon as it has been exposed. As an added bonus, your processed film may already be waiting for you when you return home.

- If your trip will simply be from one city to another in the United States and back again, there's probably little need for concern. But the 12-countries-in-10-days, whirlwind-tour sort of trip may present a problem to your film.

Sometimes mailed packages are also X-rayed, so if you include unprocessed film in a package, label the package "Undeveloped Photographic Film. Please Do Not X-ray." Film mailed in processing mailers provided by processors— and clearly marked as film— usually is not subject to X-ray inspection.

MORE INFORMATION ON THE STORAGE AND CARE OF FILM

For more information, write to Eastman Kodak Company, Dept 412L, Rochester, NY 14650, and ask for a single copy of *KODAK* Publication No. E-30, *Storage and Care of KODAK Color Materials*.

APPENDICES

SUBJECT INDEX

IMAGES, IMAGES, IMAGES— The Book of Programmed Multi-Image Production (Third Edition)
(*KODAK* Publication No. S-12)

TAKE THE NEXT STEP

You will find that *SLIDES— Planning and Producing Slide Programs* provides you with a wealth of practical and creative ideas to use in developing your own presentation.

Take the next step in this exciting medium to extend your communications skills and purchase our advanced multi-image publication *IMAGES, IMAGES, IMAGES—The Book of Programmed Multi-Image Production* No. S-12 (Third Edition).

This comprehensive book is designed for both the decision-maker who has to know "when" and "why" to choose this new powerful communications medium, and for the communications specialist, who is looking for the "how" of multi-image technology.

It's all here—planning, budgeting, scheduling, selecting, and working with a producer, choosing your media and style, researching your message, shooting slides and films, mixing and editing sound, rehearsing and presentation day. There are hundreds of color photographs of today's equipment and production techniques, even eight in-depth producer interviews that reveal their successful philosophies and technical approaches to help the reader understand this exciting new medium. The newest information is on computer-generated graphics that describes how their various applications, including animation and transmission of data by telephone to create slides, have been integrated into multi-image production to revolutionize the industry; a new producer interview with Chris Korody from a very progressive multi-image production group called "Imagestream"; revised information on shipping your presentation overseas, features, and new color photographs of the latest production equipment; and detailed information on how seamless slide masks can help you produce high-quality wide-screen panoramas and montages. (264 pages; 384 color [64 new] photos; 8 1/2" x 11"; 4/83) (**$24.95 per copy**)

The Source Book— KODAK EKTAGRAPHIC Slide Projectors

(*KODAK* Publication No. S-74)

This is the book that is all about *EKTAGRAPHIC* Slide Projectors. Detailed specifications for 15 different projector models—some of which can be used "as is" virtually anywhere in the world—are highlighted in this valuable reference, along with techniques for modifying the projector for special applications. The book opens with a subject that should be particularly interesting to projector buffs; its a chronology of the 135-format Kodak slide projector that traces its evolution from the *KODASLIDE* Projector introduced in 1937 through the Carousel projector announced in 1961 to today's *EKTAGRAPHIC* Projector. Following this summary are topics such as the projector's controls, functions, basic operation, and maintenance; allied Kodak accessory equipment; continuous sound-slide programs; projector use overseas; heavy duty operation—effect on lamp life, voltage considerations, and recommended projection conditions; ready-made and special "do-it-yourself" plugs and receptacles; and maintenance of slides and slide trays. (150 pages; approximately 350 black-and-white photos/line drawings; 8½" x 11") (**11.95 per copy**)

The 1986 Index to KODAK Information

A comprehensive up-to-date catalog listing over 800 publications and visual programs—slide-tape formats and video cassettes published by Eastman Kodak Company. Contains descriptions, prices, and order forms. To receive this catalog, send $1 to Eastman Kodak Company, Department 412L, Rochester, New York 14650.

KODAK PUBLICATIONS (Continued)

Eastman Kodak Motion Picture and Audiovisual Markets Division produces a wide selection of fact-filled, up-to-date publications covering many different audiovisual related topics and audiovisual programs—slide-tape formats and video cassettes. Prices and ordering information are provided in the 1986 *Index To Kodak Information* (L-5), described on the preceding page.

In addition, Kodak offers a variety of publications that furnish information on products and photographic applications in many other fields. Prices and ordering information for these publications are contained in this index.

The following publications should be of particular interest to persons producing slide-tape programs:

Code	Publication Title
AC-72	*The Joy of Photographing People*
AC-75	*The New Joy of Photography*
AC-70	*More Joy of Photography*
AC-95	*KODAK Guide to 35 mm Photography*
AF-1	*KODAK Films—Color and Black-and-White*
AR-21	*KODAK Pocket Photoguide*
E-30	*Storage and Care of KODAK Color Materials*
E-66	*Printing Color Negatives*
E-77	*KODAK Color Films and Papers for Professionals*
H-42	*Television Graphics Production Template*
S-3	*Audiovisual Projection*
S-12	*IMAGES, IMAGES, IMAGES—The Book of Programmed Multi-Image Production (Third Edition)*
S-16	*KODAK Projection Calculator and Seating Guide—For Single- and Multi-Image Presentations*
S-26	*Reverse-Text Slides*
S-29	*Self-Contained Projection Cabinets*
S-60	*Presenting Yourself*
S-74	*The Source Book—KODAK EKTAGRAPHIC Slide Projectors*
S-85	*KODAK EKTAGRAPHIC Tray Bands (For Single- and Multi-Image Presentations)*
S-86	*KODAK EKTAGRAPHIC Tray Bands (For Dissolve Presentations)*

GLOSSARY OF AUDIOVISUAL TERMS

Acetate—Plastic sheet that permits a high degree of light transmission, resulting in a transparent appearance.

Acetate (matte or frosted)—A plastic sheet with one side etched or roughed; can be easily marked with regular inks/colored pencils.

Angle—Camera angle refers to the camera's view of the subject or its relation to the principal planes of the scene. Normally, the basic camera viewpoint should be from eye level.

Aperture (slide)—Internal measurement of slide-mount opening. Slightly smaller than the camera aperture, and thus the exposed film frame, it masks any imperfections at the edge of the picture.

ASA—Abbreviation for American Standards Association, also the American National Standards Institute later. An indication of a film's sensitivity to light (film speed). The higher the ASA number, the more sensitive the film is to light. The ASA scale is based on an arithmetical progression: for example, ASA 400 film is twice as fast as ASA 200 film which means it can be exposed with one half as much light. Now mostly replaced by the ISO system.

Aspect ratio—Height-to-Width proportions of image area. This varies with different horizontal formats. The aspect ratio for 35 mm slides is 2:3 while the aspect ratio for motion picture film is 3:4.

Audiovisual—Sound and sight communication—audio pertains to electronically produced sound, for example, records, tape recorder, or motion picture sound track; visual refers to slides, motion pictures, or video tape.

Automatic exposure control—A photoelectric cell that reacts automatically to light by producing an electric current that sets the exposure (f-stop) and in some instances the shutter speed on a camera.

Background sound—Music or sound behind a speaker's voice; synchronous or nonsynchronous, used to add realism to sound track.

Backlight—Light coming toward the camera lens from behind the subject.

Back (rear) projection—Projection of images on the back of a translucent screen.

Beaded screen—Standard front-projection screen coated with tiny glass or plastic beads—has high-level reflectance.

Blank slide—Used at the beginning and at the end of a presentation to prevent light from reaching the screen through the projector lens.

Bounced flash—Achieved by directing the flash so that it reflects off a ceiling, wall, or a card mounted above the flash so that it illuminates the subject with a diffused light.

Bracketing (exposure)—Taking identical pictures of the same subject by varying only the exposure (f-stop). For example if the light meter indicates an exposure of f/5.6, additional shots are taken at f/2.8, f/4.0, f/5.6, f/8, f/11, f/16. Exposures are bracketed in those situations where accurate light-meter readings are not possible. Professional photographers bracket their exposures in situations that would be difficult to rephotograph if a single exposure turned out to be wrong.

Cable release—A flexible cable that can be screwed into the shutter release to reduce any camera movement during the exposure.

Capstan—A power-driven metal shaft that presses tightly against the tape in the recorder as it moves past the recording and playback heads.

CC Filters (color compensating)—Filters available in several tints, ranging from pale to strong, in six colors (red, green, blue, cyan, magenta, and yellow). Used to change overall color balance or to compensate for deficiencies in the color characteristics of the light source used for photography.

CdS cell—A photoresistant cell (see photoelectric cell).

Cels (or cell)—Cellulose acetate sheets. Transparent sheets on which artwork is traced and painted for animation or slide registration photography.

Close-up—A concentration of the camera on the subject, or a part of it.

Close-up attachment—Accessory which enables the camera to focus subjects nearer than the lens normally allows. The attachment may be an extension tube, bellows, or a supplementary lens.

Color balance—Adjustment in color photography so that neutral scale of gray tones is reproduced accurately and colors appear as they would when viewed by the eye.

Colored adhesive—A translucent or transparent color printed on a thin acetate sheet having adhesive backing for adherence to cardboard, paper, acetate, or film.

Color temperature—Measured in Kelvin. The color of a light source when related to a theoretically perfect (black body)

source of radiant energy. Daylight-type film is balanced for 5500 K. Tungsten-type films are balanced for 3200 K and 3400 K. The higher the number, the bluer the light source; the lower the number, the redder the light source.

Content specialist—Someone with a wide knowledge of subject content of a specific audiovisual production.

Continuity—The logical relationship of one scene leading to the next one and the smooth flow of events within the total production.

Conversion filters—Camera filters that provide a significant change in the color quality of various light sources, to match them to color films. Examples: the orange-colored 85B filter allows using tungsten-type film in daylight; the blue 80A filter matches daylight-type film to tungsten light.

Copy stand—A stand for vertically or horizontally positioning a camera accurately and holding it steady to photograph flat subjects very close to the lens.

Correction filters (light balancing filters)—Camera filters that correct small differences between the color quality of the lighting and the color balance of the film—for instance, a yellowish 81A filter can correct the bluish tones of a subject in the shade.

Coupled exposure meter—Exposure meter built into the camera and linked with the aperture or shutter speed controls, or both.

Credits—A listing at the end of a production of those who participated in or cooperated with an audiovisual project.

Cross-fade (segue)—In a sound track, fading out one piece of music while simultaneously fading in another; creating a smooth transition.

Cross-talk—In recording, the sounds from one track being audible while listening to another track.

Cue tone—A burst of sinusoidal tone used for cueing a slide projector to display a slide at a given point in time. Also known as a sync pulse.

Definition—Describes clarity of a photographic image—not only sharpness or resolving power of lens but also graininess, contrast, and tone reproduction.

Depth of field—Distance between nearest and farthest points from camera within which subject details appear with acceptable sharpness at any one focus setting.

Development—Chemical treatment of exposed film, to render the latent image produced when a picture was taken into visible form.

Diaphragm—Adjustable device (iris) that controls the amount of light reaching the film—may be in front of, within, or behind the lens.

Diaphragm shutter—Shutter mechanism that is also the diaphragm of the lens. Design allows set of leaves to open for the required time to the preset aperture when the shutter is depressed.

Differential focusing—Setting the camera controls for minimum depth of field to isolate a subject against an out-of-focus background/foreground.

DIN—Abbreviation for Deutsche Industrie Normenauschuss (German Standards Organization) which formerly established film speeds. A change of +3 degrees in the DIN rating indicates a doubling of film speed, for example, 21 degrees is twice as fast as 18 degrees DIN. (See ISO.)

Dissolve—Optical effect involving two superimposed images in which the second one gradually appears as the first one gradually disappears.

Dissolve unit—Apparatus for simultaneously dimming the light in one slide projector while fading up the light from another slide projector to produce the effect of dissolving images.

Distortion—Unpleasant sound caused by mismatch of audio components or the overloading of loudspeakers with more sound volume than they can carry; also, a misshapen projected image.

Documentary approach—Shooting pictures on location without preplanning or detailed script preparation.

Dropouts—Sections of uneven coating of oxide particles on recording tape causing sound to drop suddenly in level when they pass over the head. Dropouts can result in missing cues on multi-image tape control tracks.

Dubbing—Transferring recorded sound from one medium to another, usually from record-to-tape, tape-to-tape, and tape-to-film.

Dupe—From word duplicate; film or tape copied from an original.

Editing—Assembling, arranging, and organizing visuals after shooting, or sound after recording, to the best advantage for the purpose at hand.

Electronic flash—Light produced when electric current stored in a capacitor is discharged

across two electrodes inside a gas-filled glass or quartz tube.

Electronic mixer—A control mechanism through which a number of sound-producing units can be fed to combine voice, music, or sound effects at desired recording levels onto a single tape or film sound track.

Establishing shot—A medium or long shot that provides an overall view of a scene to orient viewers to subsequent close-up shots—cover shot.

Eye-level shot—Camera is horizontal with reference to the ground. With long and medium shots, the camera should usually be at a height of 5 to 5 1/2 feet (1.5 to 1.7 m). Shots should be made from the performer's eye level—standing, sitting, or on a ladder.

Expiration date—Date stamp on film packaging indicating date beyond which the manufacturer's warranty expires for satisfactory results.

Exposure—Intensity of light reaching the film (controlled by the lens aperture) and the length of time this intensity of light is allowed to act on the film (controlled by shutter speed).

Exposure index—EI (See ISO)

Exposure latitude—The exposure latitude of film is the range of camera exposures from underexposure to overexposure that will still produce acceptable quality pictures with that particular film.

Exposure meter—Instrument for measuring amount of light falling on, or reflected by, a subject. Usually converts measurement into a range of shutter speed and aperture settings for correct exposure.

Extension tube or ring—Metal tube fitting between lens and camera body on cameras with interchangeable lenses, to extend range of focusing for close-up photography.

Fade—Transitional effect—fade-out to black or fade-in from black to normal scene brightness.

Fade rate—Time taken for a projector lamp to fade up or down. Alternatively, number used to denote a particular rate of fade.

Feedback—Squeal or howl caused by high-volume sound from loudspeakers reentering an open microphone.

Fill light—Secondary light source that brightens dark shadowed portions of a scene created by the key light.

Film chain—The slide and motion picture projectors connected optically to a television camera usually known as a telecine chain.

Filmstrip—Series of horizontal images on a strip of 35 mm or 16 mm film, with or without recorded sound. A slide show can be copied and distributed as a filmstrip.

Filter—Transparent material, such as glass, acetate, or gelatin, that modifies light passing through it by selectively absorbing certain wavelengths of light and letting others pass through. Filters are frequently used to affect the color of slides and can be put in front of the light source as well as in front of the camera.

Filter factor—Number by which an unfiltered exposure reading must be multiplied to give the same effective exposure when the filter is put on the camera, to compensate for the light absorbed by the filter.

Fisheye lens—Extreme wide-angle lens with a view over 100 degrees. It has a large depth-of-field and requires minimal focusing, but the resulting photograph has considerable distortion.

Flare—Light scattered by reflections within the lens, lens hood, or the camera interior. Reduces image contrast and shadow detail.

Flash synchronization—Method of synchronizing the maximum light output of a flash source with the fully open period of the shutter. There are usually two synchronization settings on a camera, X and M. X is for electronic flash and M is for flashbulbs.

Flood lamp—Produces a broad spread of diffused, even tungsten illumination over the subject.

f-numbers—Number sequence on the lens barrel equivalent to focal length divided by effective diameter of aperture.

Focal plane—The normally flat plane at right angles to the lens axis—on which an image is formed when the lens is focused at infinity.

Focal point—Point at which all rays of light transmitted by a lens from a given subject intersect to give an image sharp focus.

Focus—The point at which light rays passing through a lens converge to give a clear, sharply defined image of a given subject.

Focusing scale—Distance scale marked on camera focusing mechanism.

Focusing screen—Ground glass or similar screen in camera allowing the image formed by the lens to be viewed and focused.

Fogging—Exposing film to a small amount of white light in

order to avoid buildup of contrast. Also called flashing.

Frame—Image on a strip or roll of film; area within a viewfinder indicating view received by the lens to be viewed and focused; composing a shot.

Frequency response—Degree to which audio equipment reproduces the entire range of audible sound without distortion.

f-stop—Adjustable iris-like opening in a camera lens admitting light as required and comprising a series of numbers expressed as f-stops such as $f/2$, $f/2.8$, $f/4$, $f/5.6$, $f/8$, $f/11$, $f/16$, $f/22$, $f/32$.

FX—Abbreviation for sound effects; any musical, nonvocal sounds added to AV sound track to add drama and realism.

Gate—Mechanism on projector holding slide in position during projection.

Gel—Short for gelatin. Refers to the various colored filters used in lighting.

Generations—In both audio and photography, each step in copying sound or an image is referred to as a generation. The term second generation means a copy of the original material. A third generation would be a copy of a copy and so on. The more generations, the more degradation of the original becomes apparent.

Graphics—Hand-drawn or printed charts, diagrams, graphs, and pictures used in audiovisual presentations.

Guide number—Number given to a film for calculating exposure when flashbulbs or electronic flash units are used; based upon film speed, the type of flash unit, and the shutter speed.

High-angle shot—The camera in position above the action (downward-angle shot). High angles will make the observer conscious of all the important elements.

Highlights—Brightest, lightest parts of a subject.

Hot shoe—Fitting on top of a camera body to hold a flash.

Hot spot—In rear projection, the brighter center part of the projected image. Caused by a combination of a "high-gain" screen material and short-focal-length lenses.

Hyperfocal distance—The distance nearest to the camera at which a subject is sharp when the lens is focused at infinity.

Inaudible slide advance signal—Electronic signal on tape—not heard but automatically activates projector to change slide.

Inches per second (ips)—The measurement standard for speed of a magnetic audio or video tape running past a recording or playback head.

Infinity—Focusing position (marked ∞) at which distant objects are in sharp focus. (Unlimited space.)

In-house—Work undertaken by staff personnel, as opposed to that accomplished under contract by nonstaff personnel.

Internegative—Negative film from original positive film used to prepare final prints or slides.

ISO—Abbreviation for film speeds set by the International Standards Organization. The higher the film speed the more sensitive it is to light.

Kelvin (K)—The unit of measurement used to indicate the color temperature of light sources.

It is numerically equal to units on the absolute scale (equals degrees Celsius (centigrade) plus 273).

Key light—The brightest light source on a scene; principal part total illumination.

Keystone distortion—Distortion of projected image caused by tilting projectors off an ideal 90° to the screen plane axis. Some keystone distortion is inevitable when more than one projector covers a single screen.

LED—Light-emitting diode.

Legibility—Requirement for lettering size so that the audience farthest from screen can see and read projected material satisfactorily.

Level—Volume of an electrical signal. In sound recording the "correct" level will lie between audible level and distortion level.

Lighting—Equipment and techniques for illuminating a stage, studio, or an auditorium. House lighting illuminates the audience area. Fill lighting provides general illumination to a stage or studio scene. Key lighting, usually located at one side of a scene, adds shadow and form to the subject. Backlighting, located above and behind the subject, provides visual separation between subject and background.

Lighting ratio—Relationship between intensity of key light and intensity of fill light when measured with a light meter.

Light meter—Device for measuring light levels, either incident (light falling upon) or reflected (light reflected from the scene).

Line-up slides (registration)—Special transparencies mounted in registration mounts for the purpose

of aligning projectors accurately. Usually showing a grid pattern for measuring definition and possibly tonal or color saturation scales. Attractive line-up slides can be produced in pairs with each slide showing 50% of a company logo. When the two images are projected in register, they show the complete logo.

Log sheet—A written record of all pictures taken including scene numbers, takes, camera settings, and special remarks—single page.

Long shot—A general view of a subject and its setting.

Low-angle shot—A scene photographed with the camera placed low, looking up at the subject. Gives strength and dominance; dramatizes the subject.

Low key—Photograph in which tones are predominantly dark.

Luminance—Measurable amount of light (in foot lamberts) emitted by or reflected from a source.

Macro lens—Camera lens designed for close-up and copy work that maintains a flatness of field and gives finest image quality without distortion.

Magenta—Purplish color composed of blue and red light. Magenta is the complementary color to green.

Magnetic tape—Thin plastic ribbon, coated with iron oxide particles, which when magnetized by an audio or video-tape recorder, will record sound/picture.

Magnification—Ratio of the height of the image to the height of the subject; or the ratio of the lens-image distance to the subject distance. When a subject and its image are the same size, magnification is 1:1.

Master—Original recording, picture, drawing, etc, from which copies are made.

Multi-image—Several images within a frame by using two or more slide projectors on one or more screens automated by a programmer/dissolve unit(s) from a recorded sound track.

Multimedia—Usually refers to any audiovisual presentation using more than one medium, for example, slides, video, sound, and movies.

Multiscreen—Working with more than one standard screen, or a superwide screen with more than one projector.

Multitrack recorder—A recorder with 4, 8, 16 or more tracks, that allows a separate recording to be made on each track and played back in any combination.

Narration—Verbal comments accompanying the visuals—off screen.

Narrator—Someone reading "live" or recorded commentary accompanying a visual presentation.

Negative opaque—Water-soluble carbon material brushed on high-contrast negatives such as *KODALITH* Film to eliminate marks, spots, and unwanted light areas.

Neutral density filter—Gray filter which reduces the amount of light entering the camera without affecting the colors in the final image.

Objective scene—Scene recorded with the camera aimed at the subject from the audiences' point of view; scene recorded from an impersonal basis.

Open-reel recorder—Tape recorder that uses magnetic tape on separate reels. Also called reel-to-reel recorders.

Ortho film—A special high-contrast black-and-white copy film (not sensitive to red) often used in title and graphics production. Two examples are *KODALITH* Ortho Film 6556, Type 3, and *KODAK EKTAGRAPHIC* HC Slide Film (HCS135-36).

Overexposure—The result of giving a light-sensitive material excessive exposure. It decreases density and reduces contrast.

Overhead projector—Projector that accepts transparent and translucent film and projects information from them onto a screen.

Panning—In still photography, the technique of swinging the camera horizontally to follow a moving subject so that, in the final image, the main subject is sharp and the background is blurred.

Parallax—The difference in viewpoint between the image seen through a camera viewfinder and that recorded on film by the camera lens. Except in cameras with a through-the-lens viewing system, there is a slight variance between the two views, known as parallax error.

Peg bar—Thin metal bar with three pegs used to hold artwork in exact registration on an animation table. Required for pin-registration. Also called a Peg-Board.

Photoelectric cell—Light-sensitive device used in exposure meters. There are two main types: a photogenerative cell which produces electricity when light falls on it; and photoresistant type that offers resistance to a battery-powered circuit according to the light received.

Photoflood—Trade name for a brand of incandescent tungsten lamp producing light of 3400 K.

Playback—(a) The reproduction of sound or picture from a record disk, audio, or video tape; (b) a device that reproduces sound or picture.

Polarizing filter—A light filter (containing optical slits) that transmits wave vibrations only in one direction, known as the plane of polarization. Used to remove or to control direct (specular) reflections from surfaces.

Programmer—A control unit to activate one or more projectors to change images on a screen or screens.

Programming—Using an electronic device such as a slide-tape machine hooked up to a projector to put inaudible signals on a tape which when played back will trigger each slide to change automatically.

Progressive disclosure—A series of slides that expose sections of an illustration or a series of points by increasing the amount of the total image as each subsequent slide is screened.

Projector—Instrument used to show slides or movies on a screen.

Prop—Short for property; articles used by performers to furnish a set in a theatrical or visual presentation.

Pulse—Term used for the slide synchronization signals programmed onto an audio tape to change a series of slides automatically.

Raw stock—Film that has not been exposed or processed.

Rear projection—Projecting on the back side of a translucent screen, the projector being behind the screen or off to one side and projecting onto a screen by means of a mirror.

Reflected-light reading—Exposure reading taken with the exposure meter pointing toward the subject so that it measures the light reflected from subject surfaces.

Reflex camera—Camera with viewing and focusing system using a mirror to reflect the image rays, after they have passed through a lens, onto a focusing screen.

Register board—Surface with two or more small vertical posts for holding paper, cardboard, or film materials all correctly aligned when more than one layer must be assembled for filming. Also called a Peg-Board or pinboard.

Registration pins—Fixed-pin registration is found in high-quality optical printers, professional motion picture cameras, and professional copy cameras. Part of the exposing mechanism for holding the film in exact register during exposure. Also in registration slide mounts for positioning the transparency in exact register to others in similar mounts.

Release form—Form used to obtain written permission or clearance for use of pictures taken of persons or of copyrighted materials.

Reversal film—Exposed film, when processed, yields a positive image.

Sans serif—Typeface with no serifs (feet). Such faces make the most readable title slides.

Screen distance—Distance between the projection screen and the front row of the audience. To avoid eye fatigue and discomfort, the nearest viewer should be two screen widths away from the screen.

Script—Written description detailing action, narration, and dialogue for an audiovisual presentation.

Selenium cell—Photoelectric cell that generates electricity in direct proportion to the amount of light falling upon its surface. Used in many older types of exposure meters.

Sequence—A series of shots characterized by inherent unity of theme, purpose, or action.

SFX—Abbreviation for "sound effects." Any nonmusical, nonvocal sounds added to an AV sound track to add drama and realism.

Shadow board—A device attached to a camera lens that prevents reflections travelling between camera and artwork.

Shutter—Mechanical system for controlling the time that light is allowed to act on film in a camera.

Shutter speed—Interval between opening and closing of camera shutter measured in fractions of a second, for example, 1/30, 1/60, 1/125, 1/250, and 1/500.

Single-lens-reflex camera (SLR)—Camera that allows the user to see the image formed by the picture-taking lens by means of a hinged mirror between lens and film.

Skylight filter—Pale pink color correction filter used to eliminate a blue color cast when photographing. Many photographers put skylight filters on all their lenses to protect them from damage.

Slide—General term for a positive image on film, usually mounted in

a card or plastic frame ready for projection.

Sound effects—(See SFX)

Sound-on-sound—In recording, the dubbing of one audio track onto another track of the same tape while mixing with a second source.

Sound track—Narrow strip of film or tape reserved for the accompanying sound or any recording so located.

Special effects—Shots unobtainable by straightforward photographic techniques. Includes shots requiring contour matting, multiple-image montages, split-screens, and vignetting. These effects are achieved optically in a laboratory.

Split-image focusing—Focusing system where an area of the subject appears bisected in the viewfinder. The two halves of the bisected area come into alignment when the correct focus is set.

Spot meter—Exposure meter that receives and measures light from a very small part of a subject.

Stacking stand—A piece of equipment used to stack projectors one above the other. These may be either simple tripod-type stands or the more professional kind where the direction of the projector beam can be adjusted. The second type is available for stacking two or three projectors, one above the other.

Standard lens—Lens whose focal length is roughly equal to the diagonal of the picture format it's used with. The standard or normal lens of a camera will give an angle of view and a scale that approximates human vision.

Stereophonic tape recorder—A recorder on which a recording is made on two tracks simultaneously and then played back together.

Stop down—Reducing the size of the lens aperture from a large stop to a smaller one (f/8 to f/11)—by adjusting the iris diaphragm.

Storyboard—A board holding a sequence of cards (storycards) with roughly drawn sketches or pictures with narration and verbal description visualizing an audiovisual production from start to finish—generally prepared after the treatment and before the script.

Storycards—Generally a series of 3 x 5 cards—each card representing one shot of a slide-tape show.

Subjective scene—A scene shot with the camera placed in the subject's position to show the scene from the subject's point of view. The effect is achieved by shooting over the subject's shoulder to the hands and immediate surroundings.

Superimpose—In projection, the overlay of one image onto another by projecting a second slide on the same screen area. With many dissolve-type systems, the superimposing slide must be taken off the screen before the show continues.

Super-slide—Square-ratio transparency 38 x 38 mm; will fit in a 2 x 2-inch (50 x 50 mm) mount.

Synchronization—Matching up sound and visuals. The synchronization of slides with a prerecorded sound track is used in all audiovisual shows.

Tape cassette—Enclosed feed and take-up reels of 1/8-inch magnetic-tape—used with cassette tape recorders.

Target audience—Specific identifiable group for whom audiovisual program is designed.

Telephoto lens—A camera lens that permits a closer view of a subject than would be obtained by a normal lens from the same position. Can be used to narrow or concentrate the field of view without moving the camera closer to the subject—85 mm and longer. (Up to 400 mm and more.)

Texture—The character of surfaces, their roughness or smoothness.

Through-the-lens metering (TTL)—A method of measuring exposure after the light has passed through the lens.

Track—Recording channel on an audio-magnetic tape that records the sound on an audio tape.

Transition—Passage from one episode to another. Usually film transitions are accomplished rapidly and smoothly, without loss of audience orientation, and are consistent with the established mood of the film.

Transparency—Positive image in black and white or color produced on transparent film.

Treatment—A descriptive synopsis of how the content of an audiovisual show can be organized and presented.

Tripod—Adjustable three-legged camera support with screw fitting for attaching small-format cameras.

TTL exposure meter—Through-the-lens exposure meter. It measures the image light within the camera that has passed through the camera lens.

Tungsten filament lamp—Lamp in which the light is generated by passing electricity through a fine tungsten filament that is enclosed in a glass envelope. It is the basic artificial light source used in photography. (Incandescent lamp.)

Tungsten halogen lamp—Tungsten filament lamp, contains

halogen traces to reduce lamp discoloration with age. (Quartz lamp.)

Type A color film—Color film balanced for tungsten lighting of 3400 K color temperature.

Type B color film—Color film balanced for tungsten lighting of 3200 K color temperature.

Underexposure—Caused when insufficient light reaches the film during exposure. A color slide appears dark and contrast is reduced.

Variable focal-length lens—Another term for zoom lens.

VCR (Video cassette recorder)—A television unit that records and plays back visual images and sound as magnetic-tape, on reels in a sealed container, passes by the record or playback head in the machine.

Viewfinder—Component for viewing subject; showing the field of view of the camera lens.

Vignetting—Printing technique where the edges of the picture are gradually faded out to black or white.

Visual—Graphic or pictorial image.

VTR—Abbreviation for video-tape recording or video-tape recorder.

VU meter—A recording-level indicator in a tape recorder that measures the volume of sound being recorded.

Washout—Loss of screen image caused by excessive ambient light.

Wide-angle lens—Camera lens giving a wider view of the subject and its surroundings than a normal lens from the same position. The viewer feels further away from the subject than it actually is—35 to 14 mm lens.

Write-on slide—Temporary slide used during production on which you can indicate the final photographed image.

Zoom lens—Variable focus camera lens giving variable focal lengths without disturbing focus or f-number. Allows varying picture sizes from one position.

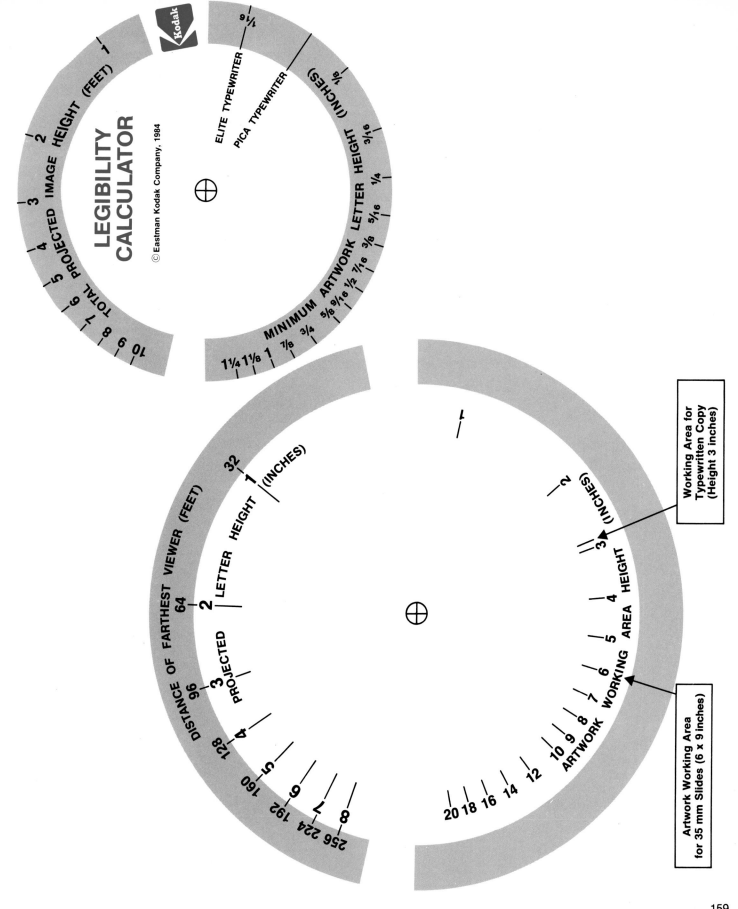

LEGIBILITY CALCULATOR

© Eastman Kodak Company, 1984

PROJECTED IMAGE HEIGHT (FEET)

TOTAL

MINIMUM ARTWORK LETTER HEIGHT (INCHES)

ELITE TYPEWRITER

PICA TYPEWRITER

DISTANCE OF FARTHEST VIEWER (FEET)

PROJECTED LETTER HEIGHT (INCHES)

ARTWORK WORKING AREA HEIGHT (INCHES)

Working Area for Typewritten Copy (Height 3 inches)

Artwork Working Area for 35 mm Slides (6 x 9 inches)